WOMEN'S GLASNOST VS. NAGLOST

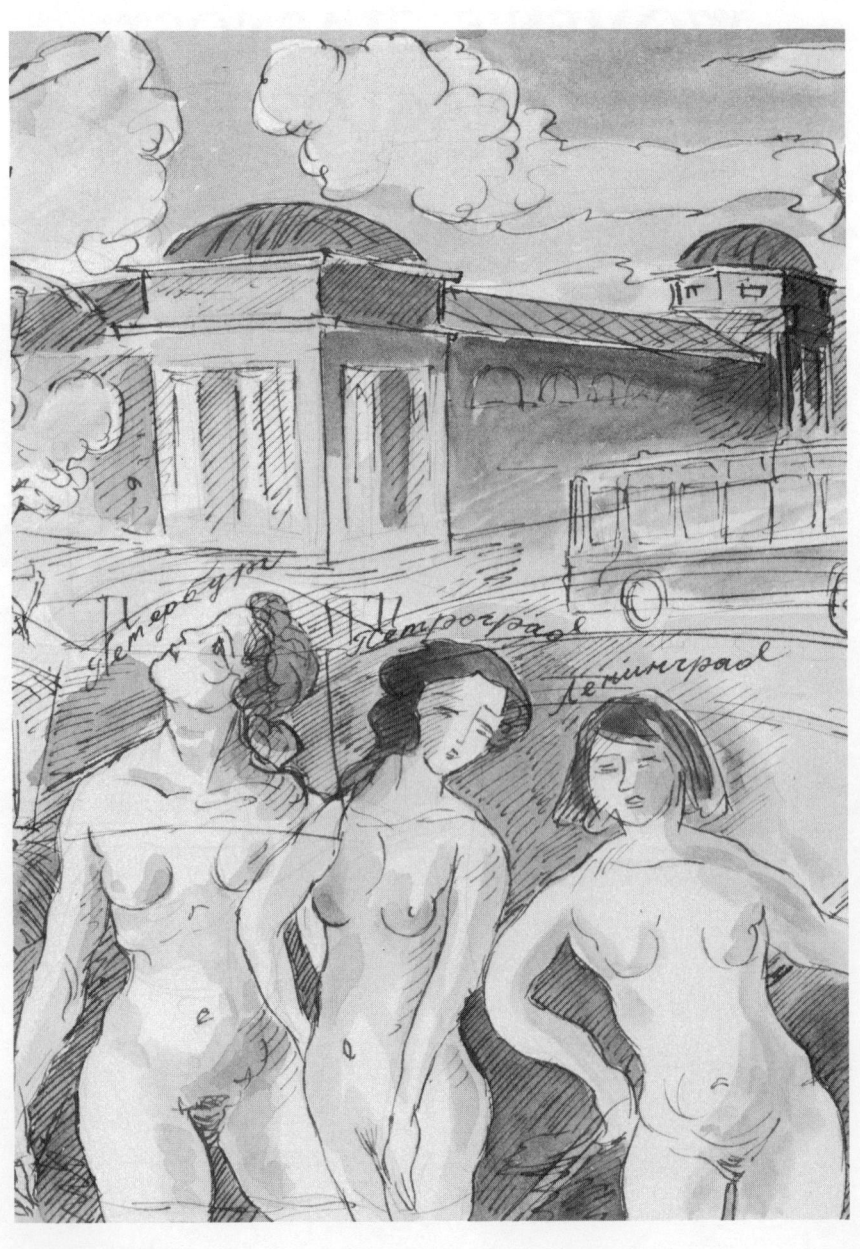

WOMEN'S GLASNOST VS. NAGLOST

Stopping Russian Backlash

Tatyana Mamonova

With the assistance of
Chandra Niles Folsom

Bergin & Garvey
Westport, Connecticut • London

Library of Congress Cataloging-in-Publication Data

Women's glasnost vs. naglost : stopping Russian backlash / Tatyana Mamonova ;
 With the assistance of Chandra Niles Folsom.
 p. cm.
 Includes bibliographical references (p.) and index.
 ISBN 0-89789-339-5 (alk. paper). — ISBN 0-89789-340-9 (pbk. :
alk. paper)
 1. Women — Russia (Federation) — Social conditions. 2. Russia
(Federation) — Social conditions. 3. Soviet Union — Social
conditions — 1970-1991. 4. Glasnost. I. Mamonova, Tatyana.
HQ1665.15.A6W66 1994
305.42'0947 — dc20 93-15181

British Library Cataloguing in Publication Data is available.

Copyright © 1994 by Tatyana Mamonova

All rights reserved. No portion of this book may be
reproduced, by any process or technique, without the
express written consent of the publisher.

Library of Congress Catalog Card Number: 93-15181
ISBN: 0-89789-339-5
 0-89789-340-9 (pbk.)

First published in 1994

Bergin & Garvey, 88 Post Road West, Westport, CT 06881
An imprint of Greenwood Publishing Group, Inc.

Printed in the United States of America

The paper used in this book complies with the
Permanent Paper Standard issued by the National
Information Standards Organization (Z39.48-1984).

10 9 8 7 6 5 4 3 2 1

Copyright Acknowledgment

Artwork copyright © Tatyana Mamonova and Gennadi Shikariov.

To my mother, whose name I took as my middle one, Valentina.

Tatyana Valentina Mamonova

Contents

Foreword *by Chandra Niles Folsom* ix
Preface xi
Introduction xiii

PART I: RUSSIAN WOMEN SPEAK OUT

1. Anna Kozoulina 3
2. Narina Sarounova 11
3. Lana Rozovskaya 17
4. Yelena Khanga 29
5. Ketevan Rostiashvili 35
6. Olga Tatarinova 41
7. Lada Smirnova 49
8. Anya Kirin 55
9. Galina Kolobkova 61
10. Ulyana Bostwick 69
11. Kira Reoutt 83
12. Olga Filippova 91
13. Galya Lanskaya 97
14. Svetlana Tabolkina 103
15. Galina Vinogradova 107

| 16. | Remo Kandibrat | 111 |
| 17. | Chanie Rosenberg | 115 |

PART II: MAMONOVA ON WOMEN AND GLASNOST

18.	Revisioning Our Women's History	121
19.	A Feminist Hope in Russia	137
20.	A Little Faith	151
21.	Ex-Soviet Porn-Talk Gets Louder	157
22.	Domostroika	167

| Recommended Reading | 175 |
| Index | 179 |

Foreword

Women's Glasnost vs. Naglost is verification that the exile of Tatyana Valentina Mamonova from her native Russia for establishing the neo-feminist movement was not in vain.

Tatyana's youth provided the vision for her future work on behalf of her countrywomen. Growing up in Leningrad, now St. Petersburg, during the liberal 1960s, Tatyana became familiar with the biographies of female protagonists. Her ideals of an egalitarian society were formed in those years, although she did not realize at the time that those principles had to be long fought for and won in order to become actuality. When later, in the 1970s, as a journalist Tatyana reported on the less than ideal lives of Soviet women, she was silenced by her editors. In response, Tatyana began her own magazine in *samizdat* (underground publication) form, which she, along with a precious few courageous women, hand-typed and distributed throughout the Soviet Union and, with the help of foreign diplomats, made available to Western countries. The KGB discovered her activities and warned Tatyana several times to stop publishing, but she persisted until finally, on her birthday, December 10, 1979, she was arrested. Ironically and luckily, this day turned out to be International Human Rights Day.

Her arrest was a faux pas that will live forever in KGB infamy, because the Western press, hearing the news, came from far and wide to cover the story. Although Tatyana had been threatened with prison in Siberia, the worldwide media coverage caused Secretary General Leonid Brezhnev himself to settle instead for stripping her of her citizenship and ordering her exiled to Vienna. Tatyana, who had struggled so heroically to restore to her sisters the promise of the 1917 Russian constitution which gave women equal rights with men, was now deprived of her own rights. Despite great inner turmoil, once in Vienna Tatyana made immediate contacts with women activists around the world and continued writing

and speaking about the conditions of women in her homeland. Her tour of the United States, with *MS* magazine, immediately following her exile in 1980, brought her the recognition for which she had fought for the women in Russia. In 1984 *Women and Russia*, an anthology from her *samizdat*, which had already been translated into twelve languages, was published in English. When Tatyana was invited back to the United States for the second time that same year, as a Bunting Fellow at Harvard University, she wrote her second book—*Russian Women's Studies: Essays on Sexism in Soviet Culture*. A second lecture tour of the country followed. This book has been printed twice and is now in its third printing.

When I, a journalist, met Tatyana in 1988, she was living in the United States as a writer and going through the laborious process of gaining permanent residency status. The bureaucracy was endless, for Tatyana was the only woman ever to be exiled from Russia to the West. We began to write together and gave lectures at many colleges and universities across the country. We reestablished her contacts with well-known American women and began producing a video series about them for Russia. Finally, in 1992, with the aid of Tatyana's friend Gloria Steinem and Attorney Vicky Yudenfriend, Tatyana received her American green card. At about the same time, *Woman and Earth* magazine, the revival of her *samizdat* printed in Russian and English, was published and distributed in both countries. With the women's movement alive and well in her homeland, Tatyana is now looking back at the legacy she created with great love and respect.

Women's Glasnost vs. Naglost brings the lives of Russian women to us once more—only now they are living free without boundaries. Their stories, fascinating in their similarities and differences with our own as Americans, were told in interviews taken by mail, fax, and phone, as well as in person, inasmuch as Russian women can now travel to the West almost without restrictions. This book is the result of Tatyana's unique perspective which allows her to view her people from outside the eye of the storm. Although a few books to date have reported on the lives of the Russian woman, only Tatyana Mamonova presents a wide cross section of Russian women, from judges to students, individuals who make up the vast mosaic of a country that has for so many years been shielded from the rest of the world. This enlightening book demonstrates not only how glasnost has changed the world of Russian women, since "openness" gave their lives validation, but also, sadly, how "naglost" or backlash always seems to follow an emergence of empowerment.

I introduce this book with pride in the knowledge that it will serve as a permanent link in the chain that unites East and West.

<div align="right">Chandra Niles Folsom</div>

Preface

I was fortunate enough to find many supporters of my ideas in America, Russia, and other parts of the world. Without their help, I would never have managed to make this book a reality.

Chandra Niles Folsom gave me inspiration when I began this book and has continued to be a great advisor.

I want to express my deep thanks to Margaret Maxwell, Elena Leonoff, Amy Rankin, Marian Schwartz, Corenne Stewart, Kathy Quinn and Amy Tatko, who showed me their faithful solidarity throughout the entire process.

All the Russian women and women from the new republics whom I interviewed, young and old, established and nonestablished, kept up my hope that the new society will be built with their efforts. It should be noted, that with my own discretion, their interviews have been edited and my lectures revised for consistency of style and overall, for ease of translation into the English language.

I'd also like to thank Sue Zalk, who offered me an office at the Center for the Study of Women and Society at the CUNY Graduate Center to write this book. I am certainly grateful to my partner Gennadi Shikariov for his support through his artistic endeavors. Thanks to my son, Philip Mamonova, for his understanding. My gratitude to my agent, Carmella Dio, and my editor, Nita Romer, for their efforts on my behalf.

<div style="text-align: right;">Tatyana V. Mamonova</div>

Introduction

When I invited a friend from Moscow to America, she told me, "You know, the airfare is so expensive now, that I think it would be more cost effective just to buy a plane and fly myself." She also told me an interesting joke about how the present recent Russian government goes about finding things it has lost:

> Yeltsin is crawling beneath a street lamp. Passersby ask, "Did you lose something there?"
> Yeltsin answers, "No, I lost it over there, in the dark."
> "So, why are you searching here?"
> "It's lighter here!" he answers.

Since glasnost, with the political and economic turmoil it has brought, Russia has become used to watching things fall apart. Is Russia experiencing catharsis or catastrophe? What is most dismaying about life there in the 1990s is not just the rampant crime, corruption, prostitution, smuggling, and drug abuse. There is also a widespread view that today people are out only for themselves and that anything goes. They use the word "naglost," meaning brazen insolence, to sum up the prevailing atmosphere. While the levels of crime are still well below New York City standards, the effects have galvanized a citizenry unaccustomed to a flaunting of criminal behavior.

Russian women are especially angered by the turmoil, for the new violence and unemployment have hit them first. As a result, they have been emboldened to write prodigiously and to create many new groups and organizations to help them deal with their anger and to search for solutions. For example, in March 1991, Dubna, a beautiful town located two hours from Moscow, welcomed about two hundred women from forty-eight different groups, associations, and parties as well as individuals from

twenty-five localities. This independent forum, sponsored by the Moscow Center for Women's Studies, took as its motto, "Democracy minus women is no democracy." The second independent forum was held at the end of November 1992, and this time, five hundred women came! Larissa Fedorova, Lidia Skoptsova, Yevgenia Kazarova, and others organized this second forum and probed issues of feminism and solidarity at even greater depth.

Boris Yeltsin perhaps best summed up the attitude of Russian males toward women in an interview by Barbara Walters at the end of January 1992. When she asked him if he discusses the most important issues with his wife, he answered quickly and precisely: "Never, I am boss!" This attitude, when combined with the weak female representation in Russian society, may well explain the nation's inefficiency in dealing with everyday practical problems.

The independent women's forum faced these problems head on, selecting four themes as its primary agenda: women and politics (Anastasia Possadskaya), women and the transition to the market economy (Zoya Khotkina), feminist critics of the totalitarian culture (Olga Voronina), and women and politics (Marina Pisklakova). This fourth theme was the most remarkable of all because for the first time in Russia women felt confident enough to speak out on this issue. Clearly, the forum demonstrates that the participants opposed the "good-old-boy" style hierarchical structure. Next, this forum created two more, absolutely independent women's groups from the center: the Nie Zhdi Association in Tataria and Kuzbass (a coal mining area of Altay in Siberia) and a new women's group in Dubna.

One of the most concrete achievements of the Moscow Center for Women's Studies, which initiated this forum, is that, according to the State Provision on Family, Russia now has introduced parental leave. Previously only maternity leave was available. This is clearly a victory for Russian women.

In supporting the transition to global thinking, glasnost permitted the infusion of fresh, new ideas relating to women's issues unknown to women under Stalin and Brezhnev. Until glasnost, Russia had only a small identifiable band of a dozen feminists, so when the media had cause to search them out, they knew where to look and would usually start with attacks on me whom they labeled a "western-style entrepreneur." In contrast, today the ideas of women's power and freedom, and even Greenpeace, are everywhere, including the Writer's Union, the Psychiatric Association, and the Cinematographer's Guild. Public opinion polls show a fairly steady growth in support of feminist issues. The women's movement in Russia is alive and well, though not always conscious. (In fact, it is not always called the women's movement.) Television now presents any number of topics of special concern to women that used to be considered

taboo: domestic violence, sexual harassment, rape, incest, battered and abused children, and the like.

Spreading its shadow over all these women's issues is one central problem in Russia: alcoholism among men. Vodka has traditionally served as a social outlet in Russia, but as a result of the dry law introduced by Mikhail Gorbachev in 1987, this is no longer so. While some manage to smuggle alcohol if they have dollars, in general those who want it now have to stand in line for six days taking turns to get their monthly allotment of two bottles, and only after they hand over their empty ones.

Disregard for the interests of women, who after all account for more than half of the population, is evidence of a lack of democracy. Both sexes should, of course, have equality within all parliamentary and governmental institutions at all levels. But when Peter Jennings during a satellite town meeting held in 1991 asked Yeltsin to comment on the situation of women in Russia, Yeltsin responded with a smirk that women live five years longer than men in Russia. Apparently Yeltsin has not read our almanac (*samizdat*) *Women and Russia*, because as we explained a long time ago heavy drinking and unsafe sexual practices among Russian males do not prolong their life span. In reaction to the pessimistic times the Russians are now experiencing, it has become the fashion to turn everything upside down: "Let's catch up and surpass Africa," they joke, paraphrasing the famous seven year plan that took on the Americans. "Even the future was better," they comment while watching television and reading the current newspapers.

But old habits die hard. The banquet with caviar and cognac thrown by Yeltsin to commemorate his days in office, while the country starved, speaks for itself. Anecdotes, which often substitute for food in Russia these days, spread the idea that, while the new government has privatized the people, the new market conditions have made everyone mental acrobats. Whereas communism meant waiting in line an hour to buy bread, capitalism means waiting a year to be able to afford it. When this economic deterioration is combined with ethnic conflicts, you have fertile soil for extremist ideologies—patriarchal fundamentalism and the like.

When the number of administrative personnel in the ministries and the universities was cut between 1988 and 1993, more than 85 percent of those eliminated were women. The closing down, or privatization, of factories has been particularly hard on single mothers who relied on them not only for income but also for child care facilities. Russian women in the 1990s are aware that socioeconomic, political, and cultural discrimination against them existed in spite of a wonderful constitution. During perestroika, many thousands of women's organizations sprang up around the country. Their founders are no longer afraid of being arrested for this kind of activity the way they were in earlier years when I was exiled for publishing a feminist magazine.

It appears that the present government in Russia does not yet know what direction to take. And being uncertain, it is instead expending its energies in changing the names of cities and streets. The people, who are always wont to cover their sorrows with humor, have a joke about this proclivity, too:

> A man in the street stopped another man and cried, "Vania, Vania, I haven't seen you for so long—but Vania, my how you've changed. You used to be tall and now you're short, you used to be thin and now you're stout, you used to be blonde and now you're bald. Vania, what the hell happened to you?!"
> The man in question replied, "But my name is not Vania. It's Volodia."
> "Oh," said the first man, "so you've changed your name too."

Some people express feelings of nostalgia for a time they never knew. They long for simpler times, certain that those earlier years were so much better. But *were* times ever simpler or better? They changed Leningrad back to St. Petersburg. But was Peter the Great really better than Lenin? Is anyone old enough to remember?

Despite these yearnings for the past, not everybody restores things in Russia; some look to a new era. Women from the Nie Zhdi group, for example, are working on building a new information-filled environment for their sisters. Since they are the main source of sociological data in gender studies, they must have the opportunity to benefit from the results of their research. The independent forum has developed a new plan to hold an open seminar—a kind of consciousness-raising group. The forum is also working on a women's entrepreneurship which is called "a new phenomenon in the Russian economy."

In this outburst of independence, women's organizations are posing such questions as, "Why is this country, which was the first to master space, unable to provide its women with sanitary napkins or drugs to relieve labor pain in maternity hospitals? Why, with the exception of Aleksandra Kollontai back in the 1920s, has Russia had no women diplomats, and why with the exception of Ekaterina Furtseva in the 1960s, have there been no women ministers?" Instead of liberating us, the so-called emancipation, distorted by Stalin's policies, became a joke:

> One woman called to another in the woods, "Masha, Masha, look I caught a bear!"
> "Good, Sasha, bring him here!"
> "He won't go, Masha!"
> "Then come here yourself!"
> "Uh, he won't let me go!"

Even in science where women account for nearly half of all the employed, 40 percent are mere assistants; it is estimated that less than 30 per-

cent have master's of science degrees and even fewer are Ph.Ds. After their paid workdays, women return home to face another 40 hours a week of domestic chores—twice what men face. This double burden constitutes one of the most obvious forms of societal oppression of women.

Because of this superhuman load, many Russian women are refusing to have children. Unfortunately, however, only 18 percent of the population has access to birth control. Existing contraceptives are not very reliable. Russian condoms, which the people call "galoshes," break at an astounding rate of one out of every two times. Diaphragms, which are more difficult to obtain than condoms, come in only three sizes: small, medium, and large. The Ministry of Health has now begun ordering condoms and diaphragms from the West. Russian women have already received 20 million packaged hormonal contraceptives from the West; however they worry about their potential side effects. So it is condoms that are still the most popular form of birth control in Russia. The magazine, *Nedelia*, advertised them on its cover, which would never have been allowed by the Soviet press.

Officially, Russian women have one to two abortions for every birth. But United Nations data reveal that when illegal abortions are taken into account, including teen pregnancies, this number rises to eight abortions for every birth. The choice of abortion is always a difficult one, but it is made even more difficult by the often insufficient medical services and inhumane treatment many women experience in abortion clinics. I was fortunate enough not to have any abortions, but all of my female friends and co-workers at the *Women and Russia* almanac did. One woman, Natalia Maltseva, told me that she fainted twice during an abortion. None of the clinics offer counseling services to the woman facing the psychological stress that is often associated with the procedure. Startling, too, is the fact that no attempt is made to relieve the physical pain of abortion.

As an answer to outraged women demanding change, a few Russian clinics have begun to use the vacuum method of abortion as opposed to the D&C procedure, which in the Soviet period was routinely performed without anesthesia. Actually, the Russian press wrote about the vacuum method of abortion as early as the 1970s, but it was available only at the Kremlin Clinic for the Soviet elite.

No one now denies the many problems that are part of the structural, societal, and economic reality of women's lives in Russia. The so-called women's question as covered in the Russian press encompasses a wide spectrum of philosophical outlooks, including feminism which seeks to foster sexual equality, as well as opponents to policy supporting women's interests, such as the populist writer, Valentine Rasputin, and most male Russian sexologists.

To the participants of the independent forum, women are more than

mothers; hence, they are pro choice, believing that women themselves should be able to decide how they are to organize their lives on a basis of equality. However, not everyone agrees on the best way to ensure real choice for women.

Many feminist projects have already been established. One of them Prologue, is an organization for women's initiatives located in the Zhukovsky Aviation Research Institute. Margarita Belova is its director. Prologue provides a flexible workday and stipend for parents who have to stay home with sick children. It has also launched an impressive drive for across-the-board health care, arranged through the best clinics; this activity sets Prologue apart from similar institutions.

Another growing association is the one established by Diana Madman, Olga Tatarinova, and Marina Stepanova with a cultural orientation. Although this group calls themselves feminists, we should understand that their concept of feminism is not identical to the Western concept, a major point of departure being the Russian feminists' dissociation from politics. Since they were raised in a society where government claimed to take responsibility for people's lives and then failed in that responsibility, this group no longer seems to be concerned about what society should do for women to better their lot. Rather, their emphasis is on what women can do to enrich and improve society. They are located in Moscow and in Pereslavl-Zalesski, and they call their group the Transfiguration. Their ideas are based on the beliefs of a popular nineteenth-century religious leader, Yelena Blavatskaya, who espoused a spiritual union of all humanity. Her philosophy represents Sophia, or divine wisdom as the bearer of universal unity and harmony.

Specifically, the members of Transfiguration believe that the woman's role is to "transform male brutishness into civilized behavior," says Olga Tatarinova, one of its organizers. While they may seem a bit naive, their opponents sound very cynical. The writer, Tatyana Tolstaya opposes Tatarinova rather harshly. At the conference, "Glasnost in Two Cultures," held in New York City in 1991, Tolstaya attacked both feminists and the Transfiguration, accusing them of "Marxism." It also seems that she didn't like American coffee either because she reportedly threw her coffee cup across the room at the Transfiguration group. Even though Tolstaya herself enjoyed Marxism quite well when she was a member of the Soviet elite, prior to perestroika, only recently has she found her bravery, putting down everything Soviet at a time when dissent is no longer dangerous. Her comments in *Moscow News* during 1991 and 1992 are most significant. She said, "Culture must not begin with democracy. Culture must be elitist." Moreover, she sardonically declares that the best Western universities allegedly teach that the white oppressors tried to stop any teaching of a black culture and feminist thought. She calls this teaching "vulgar Marxism." Actually, the elite, which Tolstaya repre-

sents, long ago lost interest in ideology and became purely a vehicle for acquiring and holding on to power.

In 1991 and 1992 Russia saw its first lesbian and gay pride demonstrations; they were held on the steps of the Bolshoi Theatre and near the Pushkinsky Theatre next to the monument of Catherine the Great. "Turn Red Squares into Pink Triangles!" the demonstrators proclaimed. The International Federation of Parents and Friends of Lesbians and Gays also came to Russia with their banners, buttons, and books. Many of Russia's young people clearly longed for this kind of affirmation from their parents and eagerly wanted help. Their expression of love and gratitude for PFLAG (Parents and Friends of Lesbians and Gays) was almost overwhelming.

The aim of the Russian-American women's summits in New York, Washington, D.C. and other major U.S. cities, attended during 1989-92 is to impart political vision to women's personal problems both nationally and internationally. The main concern of the participants was to ensure that during this transition period in Russia women would be able to raise their own voices rather than remain a silent and manipulated social majority. The summit continues in its work to sensitize policymakers into understanding that all decisions they make have a gender dimension. They agree that women's perspectives were not recognized under the Soviets' patriarchal structure.

Olga Podkolodnaya, who now lives in Prague, founded the East-West Center for Gender Studies in Czechoslovakia in 1991 as a bridge between Eastern Europe and the West. An East-West orientation is also characteristic of a two-year-old group called Gaia, whose goal is to teach women to become economically independent of society's limitations. The director of Gaia, Yelena Ershova, hired about twenty women workers, the majority of whom are Armenian refugees, who as a result of the conflict between Azerbaijan and Armenia had little opportunity for employment. Gaia has enthusiastically taken up the cause of promoting creativing among women, convinced that it is an uplifting activity. A people's deputy, Galina Starovoitova, echoed the notion promoted by other women's groups that social protection now depends more on women's activities than on government efforts. She recommends that more self-help chains be established. "Remember," she says, "you are not toys of society. You are writing the pages of history too."

Ludmilla Shvetsova, the head of the Committee for Family and Women at the Russian ministry, adds that women must resist being relegated to the home again. She believes that women must be wary not only of any revival of the old Domostroy (a strict religious orthodox code) that oppressed women in Russia beginning in the sixteenth century, but also of a tendency to avoid solving recent problems. Another people's deputy, Galina Semyonova, thinks that the roots of pseudo-emancipation are in

Russian culture where images of women are poor and flat. Although the stereotypes are changing, they are often replaced by new and improved ones—beauty contests, for example. And the media still do not show a strong woman, capable of saving the world from chaos, disharmony, and aggression.

Glasnost played a valuable role in making the women's movement mainstream. New women politicians now use a feminist language and claim that the media and mass stereotypes have distorted feminism. They are discussing the possibility of creating a group similar to the Congressional Caucus for Women's Issues in the United States. They are familiar with Representative Patricia Schroeder (D-Colo.) and Senator Barbara Mikulsky (D-Md.), who introduced the Women's Health Equity Act in the U.S. Senate. Female people's deputies in Russia are beginning to address the same issues within the arenas of medical research, prevention, and clinical services. Female scientists and politicians have warned Russian women that they are in danger of losing totally the social guarantees of free education and medical care, which were some of the few positive aspects of the fallen Soviet regime.

People who turned out to protest the Russian government in August, 1991, were mostly in their twenties—a new "Pepsi generation" that as yet is unattached to any ideas. One of the students expressed his vision of Russia's future, a vision that is rather typical for his peers: "It will be a healthy youth. We will smoke marijuana and make money. We will have hippies and yuppies. Just like in the rest of the world."

So this is how they imagine the rest of the world. They are no longer dissidents but so-called MTV Democrats, and they definitely want to be taken into account. Surveys conducted in Moscow show that young women want men in the year 2000 to be gentle and caring and that they see themselves enjoying work and intimacy on an equal footing with men. They have no intention of letting Russian society turn from glasnost to naglost. It gives us hope that women in Russia as well as in the United States will find their own way.

(Adapted from a lecture given at the Equal Opportunity Conference, Phoenix Arizona Civic Center plaza, at the International Women's Day, 1992.)

Part I

Russian Women Speak Out

С готовностью
с котомкой и котом
уходит в мир
что ни весна —
на поле
и в город
возвращается потом
хлебнувши вдосталь
и беды и воли

When spring comes
she's ready
with knapsack and tomcat
to go off into the world
into the countryside
and into the town
and she'll come back later
having drunk plenty of
poverty and freedom

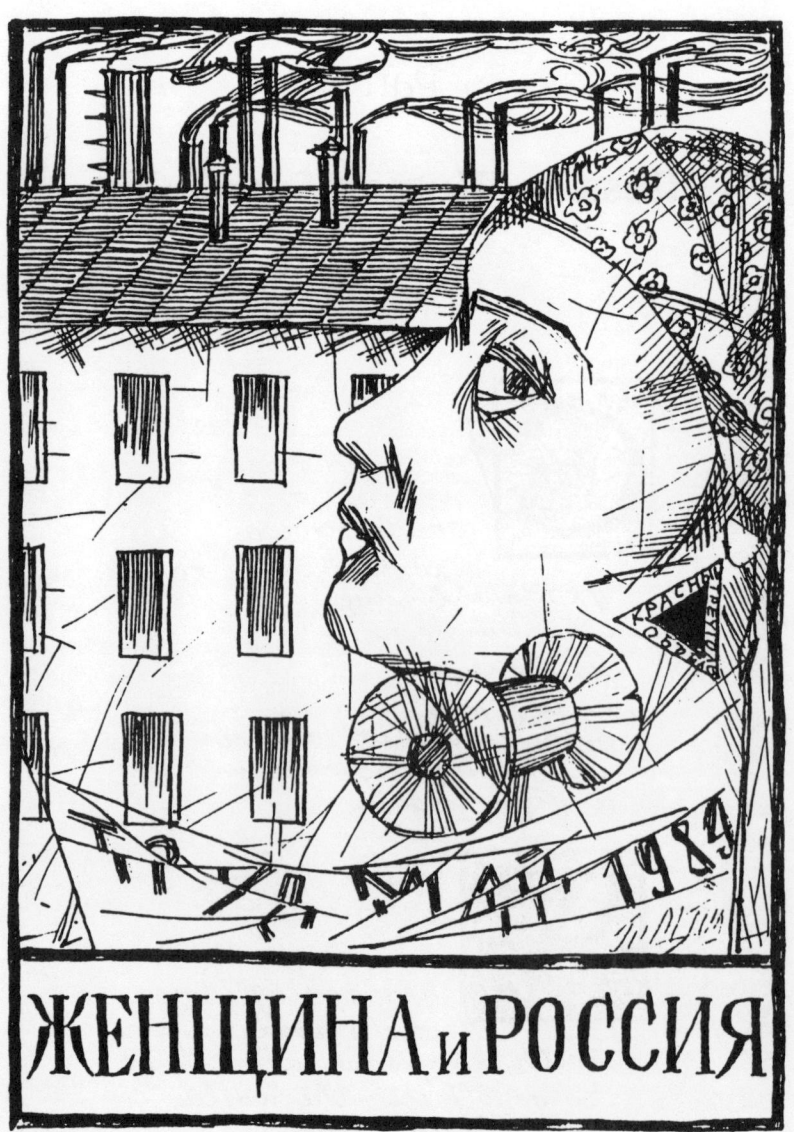

1

Anna Kozoulina

Anna Kozoulina is a philosopher from St. Petersburg.

TATYANA MAMONOVA: Anna, I know that you graduated as a philosopher in Russia. Now, in America, you decided to become a lawyer. Why?

ANNA KOZOULINA: When I came to the United States, invited as a visiting scholar by the Harriman Institute, I initially planned to stay only three or four months and to conduct my research on the history of Soviet science at the Bachmeteff Archive in the library of Columbia University. The invitation was then extended to October 1993, and this provided me with ample opportunity to conduct my research. As time passed, and I continued to watch the events that were going on in Russia, I realized that the economic situation, the economic crisis, would stay for some time. I knew that continuing my research in Russia would be very difficult because there was no certainty that the academic institute from which I had come would receive further financing. Additionally, the salaries of professors and research associates were not sufficient to cover living expenses. That is why I began reassessing my career in the face of this indefinite situation. Even if I return to Russia in October, 1993, I will probably have to switch my profession because the free market economy has changed the social structure and the whole style of life in such a rapid way that, not only I, but many researchers, many people who work in universities, will have to leave their jobs and find other work to provide for their families. Even as I speak, many people in Russia have had to leave their jobs, to leave their residences, and to move from one republic to another. Many scientists have had to do this because there are not enough positions as there are specialists.

The second question for me was, where to go, what specialty to choose, what kind of education to receive. I felt that I could receive the best edu-

cation in the United States. Many people come from Russia to the United States to take a course, for business, or for something else. I decided that entering an American law school would give me a good perspective and that I could apply my knowledge to different areas of Russian affairs. I will be very useful in Russia with this knowledge. That is the logic of my thinking.

It is a pity that I have had to leave my job. I spent a lot of time involved in philosophy development and philosophy research. All of my friends work in this field. Nevertheless, I think that it is better to analyze the whole situation rationally, not to be too emotional, and to find the best way from it.

TM: Tell me about your background and about your family. You left your daughter in Russia?

AK: Yes. I was leaving Russia for at least three or four months, so I left my daughter with my mother and the two of them live in my apartment in St. Petersburg. I'm divorced. My former husband went to Germany in 1991 as a refugee. It was very painful when I decided to continue staying in the United States and to extend my visa and change its status to a visiting scholar visa. I waited to receive all my documents from the Immigration and Naturalization Service so I could go home for a few weeks and see my family. I received the documents in the fall of 1992 and in October and November I went to St. Petersburg and spent as much time as possible with my daughter.

As for my parents, my father was a military surgeon, chief of the outpatient unit at the Military Academy in St. Petersburg. He was a very energetic peson, a very honest man, and a good administrator. I will try to evaluate his personality in an objective way. He was a communist, although his parents were exiled in 1933 and the whole family, including my father, was sent to the far east as a family of the gulag. They were a strong family in the South Urals. My father's father died within a year of arriving there. The family then moved to Tashkent, the capital of Uzbekistan. It was around 1937. There my father entered a medical school and graduated. He was mobilized during the second world war. He finished the war in Berlin and stayed in East Germany until 1951.

My mother was from a poor family. She is from Cossacks. This is not a social or a national group. She and her family lived near Rostov don. Sholokhov, if you know such a writer, wrote about Cossacks. He lived near where my mother was born. She spent her years in the second world war in the active army. She married my father and in 1951 they settled in St. Petersburg. My father died eleven years ago in 1982. My mother is still alive. She is almost seventy years old. As I mentioned, she is living in St. Petersburg and taking care of my daughter.

TM: You said that your father's parents were exiled. Could you tell me why they were exiled?

AK: My father rarely spoke about them. It was not very pleasant for him and it was some type of secret information. I don't know too much about this. In 1933 they were exiled to Magadan. They lived near Magadan and there was a famine among the community of such exiled persons and that is why his father died some months later. They were exiled for three or four years. When this term expired they received the right to go anywhere except some capital cities in the territory of the former Soviet Union. So they chose Uzbekistan and Tashkent. A few of my father's relatives still live there.

TM: Since my book is about women and glasnost fighting naglost, I would like to have your opinion about a new openness in Russian society, especially how it affects women.

AK: If all the political and economic reforms will be successful, many features of traditional society in Russia will be dissolved. That is because these reforms will induce the development of women's self-consciousness which is now only at its rudimentary stage. The success of these reforms would provide different opportunities for women to realize their potential in all different fields. When this happens, I believe that women will be connected and form organizations that will defend and protect their rights.

TM: As a person who is interested in sociology and law, what do you think about the recent Russian government and about the conflicts inside of the Kremlin?

AK: All the real structure of political power in Russia was formed during Gorbachev's perestroika in the end of the 1980's. During this time, Gorbachev's views were a special combination of liberal and socialist ideas. It has the remnants of communist ideology mixed with some liberal and democratic ideas. The Congress of People's Deputies, a huge institution which has great legislative power, still remains as a part of this political structure. It is a formidable institution.

The Congress of People's Deputies elects the Parliament, the Supreme Soviet of the former Soviet Union. This institution is a real model of a parliament and I think it should remain in existence and new elections for members of this parliament should be signed in the nearest future because all the people's deputies, from whom the members of parliament were elected, in 1989, when the communist party was still in power. That is why there are all these conflicts between the president, who was elected two years later, and this congress, and parliament, whose members were elected two years earlier. These conflicts were predetermined because two years during such an economic transition is a long time and they were at different stages of society.

As for the government, by this I mean the Cabinet of Ministers, probably two or three years ago, I was a real democrat and I was thinking as the majority of democrats that some kind of radical economic reform of a Polish type, a kind of shock therapy reform, was the best way for rapid

transformation from the Russian economy to a free market economy. But during the last few years, when I witnessed how painful it was, I changed my mind and I think that it's too hard for people to overcome such a transition — it's too hard to stand this transition. According to a recent lecture at the Harriman Institute, more than 80 percent are living below the level of poverty. They do not have enough sources or enough money to cover necessary living expenses. So in this situation, it is really hard to be a radical democrat and to call bravely and optimistically "go on," "go ahead," that the only way to help Russia is to follow this way. That is why I think that Egor Gaidar's government was probably a little more radical than necessary. Some kind of compromises were necessary to continue this reform. Nevertheless, I see myself as a definite proponent of these reforms because it is the only way to achieve some progress in the Russian economy. In this situation, where reforms are necessary but very painful, some kind of support from the West is essential and it can help people to accommodate themselves to overcome this transition.

Among the main institutions of political power in Russia now, I think that the Congress of People's Deputies is not necessary, ineffective and too huge to decide anything. I think that new elections to the parliament are necessary.

TM: Are you suggesting that the Congress of People's Deputies be eliminated and that there be a direct election of the Parliament?

AK: Yes. I also want to tell you about an idea that was discussed during Gorbachev's time. When this policy of perestroika began, there were a lot of discussions about what kind of constitution will exist. The prognosis of specialists in political science was that only strong political power, only some kind of authoritative power can protect the way of reforms. Some kind of strong power is necessary to exist in the country during the transition from one economic system. This idea was not very popular because everybody was inspired with democratic ideas and had an illusion that everything could be done at the same time and that pure democracy could be achieved from the best models, simultaneously with very difficult, painful, and expensive economic changes. Now, I think that the strengthening of the power of the government is necessary because it will help put forward economic reforms. I think the majority of people in Russia also feel the lack of power and they will endorse the strengthening of political power.

TM: The readers in the west are very confused about the structure of the Russian Government. What is your opinion about women in there? Can you discuss the Supreme Court which is a combination of liberals and conservatives. One woman is included, do you know her?

AK: I will add some more ideas about Congress and the Supreme Soviet. There were more than one thousand members of the Congress of People's Deputies. It is very difficult to calculate the exact number. It was

formed when the former Soviet Union was in existence. Now I think about one thousand three hundred deputies are in the Congress. It is impossible to discuss any serious questions in such huge company and moreover, to make any decisions. It is a very expansive and formidable structure. They elect from its body, the Parliament, the Supreme Soviet of Russia. As I stated, I think that elections should be direct and this present two stage method should be discontinued.

The Supreme Court was formed as a result of a compromise between the left wing and the right wing. It is difficult to say whether the Supreme Court now has any power because there is still a great tradition of neglecting the law and neglecting courts in Russia. I don't think that the situation will change in the near future.

The general situation is that few women were able to be elected to such governmental structures. Among the women who became people's deputies, noticeable figures during the last four years were, at first, former communist leaders, communist officers, who were rather traditional. Thus, we saw that several women were among the most aggressive opponents during the last Congress of People's Deputies. There are also some women of the left wing, famous journalists, such as Bella Kurkova from St. Petersburg television program who are radical democrats and, from my point of view, a little bit too radical.

TM: You have described the different types of women who are presently deputies. How are they treated? What opportunities presently exist for women within the structure of the government of Russia and what possibilities exist for women for the future?

AK: I think that women received more opportunities with this political and economic reform than they had before. Some of my girlfriends are now noticeable administrators in medicine and in St. Petersburg broadcasting, and such a rapid career became possible only during the last two or three years. If you want it, if you are involved in political or economic processes and are interested in this, you can participate. You have many opportunities to make a career and to do something useful. The main problem is that such active political participation is difficult because there are a lot of economic problems that are standing in front of each family. You spend a lot of time to raise something necessary for your family. That is why many people are tired of politics.

TM: Do you like the changes in Russia? Tell us about the positive (you can travel now . . .) and the negative (everything is expensive) sides.

AK: It is difficult to say that I like all these new things because the enthusiasm which is connected with perestroika and all these reforms has already past. The end of the 80's, and probably, 1987 was the best year when all people were inspired by the idea of reform but, since that time, the gradual worsening of the situation influenced them all, including me. You have a lot of opportunities now but all these opportunities are con-

nected with financial problems. For many people the whole situation is not any better but worse than it was before.

You can travel, you have some freedom of speech, you can write. It is very noticeable in our field in philosophy and in the history of science because many archives which were closed earlier are now open and there is a lot of work for historians of science and for philosophers. It can now be seen that much information was not available to you earlier and you have to learn and to absorb this information. You can assess your own level of knowledge and level of education. As a result, you experience some painful and unpleasant feelings. At the same time, everybody wants to go forward.

As for some minuses or negative sides of these reforms, all of the public services became more expensive or even unavailable for people. It means that medical services, day care, and schools that were once free, are now so expensive that many people cannot afford some necessary services. For example, I am now paying probably one fifth of my month's salary to my daughter's school. She attended a tennis center and sports school which became so expensive that almost all of her friends from her group had to leave the center. The only children who could continue their training were children whose parents could pay in hard currency. Government medical services in a hidden, secret, and disguised way require payment now. For the majority of people these reforms gave them more trouble than some of the acquisitions.

TM: Many women are worried now. Are you worried about your daughter's future?

AK: Yes, of course. The best universities have already become rather expensive, as have private universities. In some cases, you can't enter these universities without a bribe or without a tuition fee which is unaffordable to a majority of people. For women, it is very painful that day care centers became very expensive. In many cases, it makes no sense to continue working outside the home. Nevertheless, the whole network of daycare is well developed in the former Soviet Union.

To take care of children was made the major responsibility of women. If they cannot afford to provide some language lessons or some sports group for children it is rather painful and unpleasant. You cannot bring up your children in a way that you want. During most of the 80's these things were affordable.

TM: You talked about having to bribe people in order to get into the best schools. Is the ability to pay really the only connection now for getting into the best schools? Is there any opportunity for those that are talented but don't have the money to get into these schools?

AK: Formally there is such an opportunity. Some prestigious universities have two sections: a private one and an ordinary state one where usual competition exists. In reality, without a bribe, you cannot enter this

section. There still remains a formal competition which provides a slim chance to be admitted on your talents but it is really an accidental chance.

TM: The bribe then is in relation to the public section?

AK: Yes, because for a private section there is no question that you have to pay a fee and with some kind of "formal" and minimal amount of competition you will be accepted.

TM: Now, the future of Russia and its people. Are you optimistic? Russia has survived revolutions and wars and dictatorships and hunger. But will its culture survive in chaos?

AK: I am an optimist. I hope that in the best sense, the way of reform will be chosen and these reforms will continue. It will be very painful for many years but it is a way to progress. You have some hope. You have some future. It is really a difficult time for culture because in a situation when such economic problems exist, there is little money for necessities and nobody thinks about some humanitarian things, about culture. That is why many cultural institutions are involved in commercial things and it's not very good. It is a type of subculture.

For me there is no question about Russian culture. It will surely survive because I believe in the potential of Russian culture and the existence of a lot of people who can save this culture. I have no hesitation in this question. But now, the present economic situation isn't for culture, it isn't for the intelligentsia. It is a real tragedy for them to live during such a period and it will be a long period.

TM: As a result, many of the intelligentsia, and professionals are leaving the country. Could they have a reason to return down the road? If so, what is the reason?

AK: Some of them will surely return. You are right. The best specialists are now leaving the country, or at least their profession and field of service. They are going into business. They are looking for other occupations which can help them to survive so it is understandable. It is a very difficult and unfavorable situation for culture and for high quality qualifications specialists because the economy that is developing in Russia now does not need these high qualifications specialists. There are now only specified needs.

TM: But you think that their reason to return will be based on the fact that they want to re-identify with their culture. Is that right?

AK: Yes. Many people are simply brought up in this system and in this country and they feel comfortable and happy. They are brought up in Russian culture and will want to return in a better time.

2

Narina Sarounova

Narina Sarounova is a musician from Yerevan, Armenia.

Tatyana Mamonova: Please describe yourself and your background.

Narina Sarounova: My name is Narina Sarounova. I was born in the former USSR in 1969 in the Republic of Georgia, which is located in the southern part of the former Soviet Union. My father is an aeroengineer, and my mother is a chemical engineer. I didn't change my name when I married, so my family name is Sarounov. Although I was born and raised in Georgia, I am of Armenian descent and Armenian is my native tongue. Many Armenians live in Georgia, and almost all of them know three languages — Russian (the language of the country), Georgian (the language of the republic) and Armenian (the native language). We were very friendly with Georgians, and our cultures have much in common. Georgians are a very warm, hospitable people. Both republics have an ancient and interesting history and culture, and their landscape includes many castles, churches, and monasteries, along with many museums and theatres.

TM: What was life like in the USSR? Who were your family and friends?

NS: I had an extremely happy childhood in my country. I came from a large family that included both sets of grandparents, aunts, uncles, and my little cousin. We all lived together. It was a very cheerful family and a happy time. Everybody went to work, while my grandmother and I would stay home together. I attended school, music school, and took dance classes. So I was very busy and had much homework to do, but it was fun! I grew up with many friends, but my best friends were Dina and Veronica with whom I attended school together and had a firm friendship. Dina has just become a computer programmer; she is married to our mutual friend, Slavic, and has a beautiful daughter. Veronica just graduated from university with a degree in construction engineering and is also

a professional artist. We always liked to get together. I would play piano, Veronica would paint, and Dina would either listen to me or read. We also liked to go to museums, concerts, and the theatre which in Russia cost very little money or was sometimes free of charge.

We had a very interesting and happy life together. There was always something to do and someplace to go. Sometimes we would roam the streets of Antic Tbilisi (our home city) which has very colorful places and districts. We would often go to parties and meet other friends. Life was interesting and meaningful.

My parents and teachers did a lot for my education. I used to practice my music much of the time, and they would motivate me to participate in school and city concerts. Both rehearsals and recitals were very romantic. My first music teacher was named Medeia and spent a lot of hours with me working with my programs. She gave me my first sense of music and helped me develop a love for it. My mother, Jane, always attended my piano lessons, recitals, and rehearsals and knew everything about it. I'm really grateful to her for always supporting me and my goals. I owe her my musical education. Indeed, she devoted her life to me.

TM: What did you want to do in life? Did you have dreams of the future?

NS: Having loved music from childhood, I wanted to be a professional musician; my teachers wanted that for me too. I used to listen to records a lot, and I longed to play piano as well as professionals did. I wanted to be a real musician and participate in competitions. I enjoyed being among musicians because they were such unusual people—intelligent, cultural, and spiritually rich! I wanted to be a good person, to be smart and kind, and to help others as the people around me did. I wanted to grow up to be a woman with a strong personality and warm heart with many friends and many skills. I wanted. I hoped. I dreamed. . . .

I wanted all the people and children of the world to be healthy and happy. I was filled with love for everybody.

TM: I know you went on to higher education. Was it a regular university or a professonal music school?

NS: I attended the professional school of music in Tbilisi where I became involved with real music and musicians, people whom I wanted to be like. The level of education was much higher in this school than in any previous one I had attended. It was the first professional institution of music in Georgia. Those who completed this school were considered professionals and could either teach or perform with an orchestra. I learned a lot there. It was the period of my maturation, and I'm very happy that it coincided with my academic studies. I want to mention the names of two teachers in particular who not only provided musical skills but also passed along their love and soul: Merab Odzelashvily, my theory teacher, and Victoria Kalankarian, my piano teacher, unselfishly gave me their time in

order to help make me a good student. They told me many professional "secrets" which proved invaluable to me in later years.

They gave me countless numbers of extra lessons for free. I am proud and happy to have known such wonderful people because I don't believe many have the opportunity to do so. I am grateful to them for their love, teaching skills, humanity, and great personalities. They will always set an example of fairness to me.

Both my musical and personal life were very full and purposeful. I would often participate in concerts and competitions, and I played with an orchestra every year after I turned 10. That was the most pleasurable musical process in my life. Victoria used to practice with me a lot for concerts.

After four years of study, I went to the conservatory in Armenia. Victoria and Merab prepared me for the exams I had to pass in order to enter the conservatory. Everything went smoothly and I was accepted. My professor at the conservatory, Ivan Meliksetian, taught me new methods and opened a new musical world to me.

TM: Did you make new friends at the conservatory?

NS: In the conservatory I met many new people. My best friends were Irina and Zaroohi. We spent lots of time together listening to records of famous musicians, attended concerts, talked about music and musicians, prepared for exams, and had a wonderful time together. Sometimes we'd play together and correct each other's mistakes — that was fun! But we weren't friends on just a professional level. Since I lived in Tbilisi, both of them always welcomed me to their homes. I even lived in Irina's and Zara's apartments.

My relationship with my family was extremely warm and close. I love and miss my dear grandmother and grandfather who cared for me while my parents worked. Of course, my parents are also very dear to me — no question about it. In Georgia and Armenia people's relationships are usually much warmer than in Russia. Young people live with their parents a long time. My uncle, Sergey, and his wife, Diana, also lived with us. Sergey is an electrical engineer, and Diana lectures on Russian language and literature. They have two little boys whom I love like my brothers. The last member of our family is my dearest aunt, Emma, whom I love like my mother. I grew up with these people and everybody loved me, and as I think now, spoiled me a little. We miss and need one another very much.

TM: What did you like most about your homeland?

NS: To answer this question I have to say that I left Russia when I was 21 years old (two years ago). I never lived independently, even though I studied in Yerevan, the capital of Armenia. My relatives often visited me, and I often went back home. So I practically never faced any problems in Russia and therefore liked almost everything. I liked that people in Russia

were so warm-hearted and had such good relationships with each other. I liked that children didn't forget about their parents when they were grown up, that they supported each other when there was a problem and were happy for one another in good times. I liked it that education in the USSR was free and that you only had to pass the exams to prove your ability in order to graduate to a higher level. I can say the same about medical care: it cost no money. Books, records, museums, theatres, and other things and places were either free or cost almost nothing. Also, these things were accessible to everybody.

Another thing I liked about my country was its culture and traditions; people tend to hold on to their traditions, and they admire education and culture. There is so much I miss about the USSR. What I don't like now is the lack of food, clothes, freedom, and money. In the past, Russian people couldn't cross their borders as easily as other nations could. For a long time it was simply just prohibited. It wasn't easy to obtain anything, whether airplane tickets, vacation packages, or certain clothing. Almost everywhere you had to have "your people" who would do it for you at a cost. Today people don't even have food to eat. We have never had a situation like this since World War II.

There are other things that I didn't and don't now like about Russia. It's very difficult to explain to Americans; they would have to live in Russia in order to fully understand what I mean.

TM: Why did you decide to leave Russia and come to America?

NS: My boyfriend came to America three years ago, and then I came to visit him a year later and got married in the United States. So that's why I came to America.

TM: Did life here surprise you at all? Was it what you expected?

NS: I was very surprised by life in America. For one thing, I didn't expect to have so many problems. Most people in Russia think America is heaven, that nobody works hard and everything is very easy to reach and make. I thought the same thing. But after I decided to live here, I realized how wrong my impressions had been. In order to become something and reach a goal, you have to work very hard, especially if you are an immigrant. You must start again from the beginning—learn a new language, adapt yourself to a new system of life, get a new job. (People from other countries usually have to go back to school and get a new profession.) But everything wouldn't be so complicated if our family lived near us. This, I think, is the main problem in America for me—lack of friends and family.

TM: What are you doing now professionally? Is it what you had hoped for?

NS: All that I can do right now is to give piano lessons. It's not what I had hoped for, because I wanted to play piano myself. I sometimes play in ballet studios, but it's difficult to get work like that in America. First of all, I'm not permitted to work here yet, and second, music and musicians

have a different status here than in Russia. America doesn't have many music schools, and students don't usually want to train to a professional level. But it's still a good start for me. I like teaching a lot and have some wonderful young students, so I enjoy the work. I also take business courses in college, and I hope to get a degree in business administration. It's always hard to start, but since I've already started the hardest part is over. I hope everything will work out now.

TM: How has glasnost affected you personally? Has it changed your feelings about Russia?

NS: On the one hand, glasnost gave people the right to express their feelings. Many newspapers, TV programs, writers, journalists, and actors have begun to say everything they needed to say. It's very important to give people the freedom of the word. Many themes were prohibited for a long time. People would think one way and say the exact opposite because they were afraid and weren't used to the truth. After glasnost, people began to speak openly; the openness has two sides—one good, another bad. The good side is freedom to express yourself about everything, including the Communist party, Stalin, and Beria. The bad side is that people weren't ready for glasnost and aren't used to it, and so it sometimes became too much hollow talk. In other words, it became just criticism and nothing else. It gives me the feeling at times that people no longer have respect for anything.

TM: Do you think that Gorbachev's changes were good, and do you think that Yeltsin will carry out his vision?

NS: I think most of the changes Gorbachev made were good. By "good" changes I mean opening up the borders, introducing glasnost and democratization, and establishing good relationships between Russia and other countries. But I could say the same things about Gorbachev's changes that I did about glasnost. The Russian people weren't ready for democracy. All of a sudden here was this funny word "democracy," which doesn't really mean anything to us. Now Russia is in this awful situation. People are dying from hunger—about 10 people in Tbilisi die of starvation each day. Many people can't afford to buy the food they need to live. You also see many beggars on the streets who cover their faces and hold out pleading hands. Many of them are intelligent, well-educated people. We were never hungry before. It makes me wonder—what is more important, democracy or survival?

TM: What about the future for yourself? Will you stay in America?

NS: I have already started my new life in the USA. It would be too difficult to start over again yet a third time. I like it here, but in this country everything depends on you: you make the choice of what you will do and become. That is hard work. Of course, I love my own nation very much—both its culture and its traditions. I also miss my family very much.

Let's face it: There is no perfect country in the world, and there is no

perfect person. Many things could stand improvement in both Russia and America. In Russia, almost everything must be improved. We are very backward. First of all, we have to be able to afford food and clothing, and for that we need much higher salaries and much better productivity. The distribution system is also falling apart. And, of course, people have to learn to be fair and honest. My guess is that at least three generations will have to pass before Russia has a healthy atmosphere.

In America, as I see it, education and medicine are the most important matters that need improvement. They shouldn't cost so much money since they are both absolute necessities for almost everyone. Also, houses and apartments cost so much that people are often afraid of becoming homeless. I think it is every human being's right to have a home. We shouldn't have to live in fear that we might one day be out on the streets with no place to sleep.

I think that for someone like me life is not very different in the United States.

3

Lana Rozovskaya

Lana Rozovskaya is a teacher born in Riga, Latvia.

Tatyana Mamonova: Tell us a little about yourself, your background, education, and family.

Lana Rozovskaya: I was born in Riga, but most of my life, I lived in Minsk. I had an ordinary childhood. I went to kindergarten and after that attended the first specialized English school in Minsk where kids are taught English beginning in the second grade. It was a great school. Then I entered the Pedagogical Institute of Foreign Languages and graduated. When I was in my third year at the university, I married a student and in a year I had a son. We studied and raised our son at the same time, and it was fun. We realize how difficult it was, but he was really a very nice, very sweet, very quiet boy. He was with us all the time. We lived in a *one-room* apartment, not a one-bedroom apartment, with my grandfather, so there were actually four of us in the apartment. My grandfather was a positive and very intelligent person. Even though he was a blacksmith, he was tactful, very delicate, and understanding. Actually, we had a good life. So, I graduated from the university with a so-called Red Diploma. Diplomas are divided into Red and Blue. Blue is a regular one, and red means that you have only 5's (only A's).

Unfortunately for me, it was not easy to find a job. I don't know the major reason—Whether it was an overall job shortage in this part of the country, or the fact that I am Jewish. With my background, I was supposed to work in the so-called Ideological Front, but people didn't want Jews there because they were not considered reliable. So, I took entrance exams for the *Aspirantura*, which is a graduate school. I passed them and I had excellent marks, but, again, they didn't admit me because they required a quota of national students. So it was really tough to find a job and I wanted to teach because I felt that is what I really like to do, what I

was inclined to do. I started working in a library that was the first, probably the only, library of its kind in the Soviet Union. This was a special methodological, scientific library. I worked there for almost thirteen years. I started as a librarian and then I worked as an interpreter and chief editor. Finally, by the time we decided to leave the country, I had a pretty interesting job because I had to look through all the foreign editions of magazines and journals to translate the contents and to make a special index list so that every reader who came to the library would be able to open the magazine or the journal and to read in Russian what the main articles were about. And I also did some interpreting.

In addition to these jobs, I had, almost consistently, a part-time job teaching at a university, at the Pedagogical Institute, and at the Polytechnical Institute. But again, it was part time, and I had my hands full because I had to combine eight hours of working at the library with my work at the university. It was a rush just to get to the university. That is something that I liked to do, and I had to sacrifice some spare time to do what I liked to do. That is actually everything about my education. I also want to mention that when I was at the university, I majored in English and Italian. I love Italian a lot, and I like English probably even more, but you have to realize that we were taught very British English, very bookish English. Moreover, I didn't have access to foreigners. I didn't have a chance to speak, and no language is alive until you communicate, until you talk. It's like sports or music. Oh yes, I also graduated from music school and I can play some piano. I didn't want to do music, but my mom forced me. It was torture. I thought I didn't have my childhood. Right now, I am so thankful to her that she made me do that, and I have a strong feeling about it. Although I am a very hesitant person, I am absolutely sure that parents sometimes have to make children do what they think is appropriate, even if the children don't want it because any child would rather fool around and play outside, let's say, spend some time practicing a musical instrument, or reading a book, or doing something about the house. So, I can judge it by myself because I am very thankful to my mom that she was very consistent in that. I like playing the piano. I'm far from being a professional but sometimes it helps me relax.

TM: Briefly tell us about your relationship with your mother.

LR: I have a wonderful mom. I think she is an extraordinary woman. She did not have an easy life because my dad died when I was 10, and I had a sister who was 3 and she had to raise us by herself. She is a very attractive person, a very interesting one. I can't say I idolize her because I'm pretty sure that she has lots of flaws in her character. There is nothing ideal in this life, but some things I really do worship, especially her ability to overcome difficulties, her great viability, optimism, love of life, her ability to find beauty in everything and to adjust to everything. Not only that but right now, although she is over 60, she looks very young—not

because her skin is so soft and smooth, but because of her image, because, every morning she does her exercises. In addition, she is equally at ease with going to concerts and parties as making dinner and inviting guests. I also think that because she didn't have an easy life, she learned how to enjoy what was given to her, how to distinguish between what is really good and what is not. Some people probably haven't experienced anything bad. They mope and are very cranky and they're unhappy. Well, I think that's a talent — to be happy — at least to try to be happy — which I am trying to learn from her.

TM: Are you following in your mother's footsteps?

LR: I try, but I am not yet very successful at it.

TM: Have you encountered anti-Semitism?

LR: Of course, I have. Actually, I didn't understand that something was anti-Semitic until I was a little more mature because I was raised in a family, like probably the majority of Soviet Jews, that was absolutely a Russian family. I was raised as a pure Russian child. Nobody ever said to me, "Oh, you Jews are Jewish." Well, I was just a kid. But when you go to school in Russia they do have a special register with the names of all the children and, alongside your first and last name and your address you have this special form "nationality" which a teacher usually fills out. Across from my last name there was the word "Jew." I don't look very Jewish, which probably saved me from experiencing anti-Semitism when I was a child, but then, even during my school days, I could feel it. It was tolerable, though, because we had a pretty good school where the teachers and the principal had a good attitude and were intelligent and very well-educated people who understood. I also can't say that I felt it from teachers or from my friends who knew who I was.

In my third year at university, a group of Italians arrived and I was assigned to work with them, through the recommendation of my Italian professor. I was the only one selected from my group. But the Human Resources Department of the university rejected my application and didn't even bother to hide the reason why. They explained that since I was Jewish I couldn't work with foreigners; the university, which prepares the ideological "front" so to say for our future generation, wouldn't allow it. My Italian professor, infuriated by the university's position, tried to persuade them to let me work with the Italians. She argued that she knew me and could vouch for my reliability, and also that I was ideologically ready and mature to work with the foreigners — but to no avail. That was actually the first time that I was very upset by an anti-Semitic act: all the other students who had been assigned to the group were allowed to work with them, but I couldn't. It was a very depressing time for me. From then on the pattern repeated itself all the time. Working with languages, we were in demand because groups from abroad sometimes came to Minsk, which is a pretty big city. The Olympic Games were held there,

and sometimes professionals came on business trips, so, of course, there was some need for translators and interpreters. I was never accepted for these jobs, and nobody tried to hide the reason why. They were clear as to why they didn't want me to work; actually, there were very few Jews at the university in the Foreign Languages Faculty, and I could feel the prejudices.

The same thing happened later on, as I said, when I tried to find a job. Everything went beautifully until I started filling out the forms that indicated my nationality. Of course, I felt bad because those friends of mine who were not Jewish were hired to do scientific research and to work as full-time teachers and professors at the universities and schools, whereas I couldn't. It was very painful to me. Once, my husband and I even applied to go abroad to Poland to work, and were not admitted. Of course, I can't compare my situation to those Jews encountered earlier in the century when they were forced to leave Russia, but it is our duty to help our kids feel free in this country. I don't want to say that there is no anti-Semitism in the United States, but it is a little bit different. In Russia, I feel that anti-Semitism was part of state policy, and that was the worst part of it. For example, right now my oldest son is at the University of Connecticut majoring in physical therapy and business and if he wants to—and if he can afford it—he can go to medical school. Nobody cares who he is at this point. In Russia that was a very important issue.

TM: What work are you presently doing in the USA, and how does that compare with your work in the former Soviet Union?

LR: Right now I teach Russian at a university, which sounds wonderful, but in fact I am on the adjunct faculty and teach very few hours over there. I previously taught at two universities, but, because of the economic situation, everybody is cutting back in the number of hours being given, especially in the area of foreign languages. The status of foreign languages is very low here in America; people simply don't seem to care about foreign languages. They think that the only reasonable language to learn is English, and as long as you know English that is enough. I am certified here to teach Russian in schools, but, again, the economy determines everything right now. In addition to teaching, I have started working as an executive secretary at a commerce and trading company. I am doing all kinds of jobs. My dream is to be a full-time teacher at a school or even just adjunct faculty at a university teaching Russian and doing some kind of social work on campus or for the university because I'm more of a social person than a clerical person working in an office. But the company I work for is trying to start a business, and they needed somebody who can type, interpret, translate, and use a computer to do word processing. These are the things I'm doing.

TM: You have two sons who are studying here in the United States. What do you think of free education?

LR: My youngest son is at elementary school which we like a lot; he enjoys it, and it's fun for him to go there and it's really free. My older one is at the university which is far from being free. We are newcomers to this country, and, unfortunately for him, he has to handle the expenses by himself. Of course, we are trying to support him, but he is mainly paying for his own education through two or three jobs.

RM: Do you have any opportunities for travel?

LR: I have all the opportunity, but I don't have the money.

TM: What other interests do you have?

LR: I am trying so hard to find a good, interesting job right now that all my other interests like music, sports, and literature are suffering because of it. Although we had to fight for food in Russia, even though there were everyday problems, we were more or less set and I had time to do what I really liked. Right now, we are so concerned about being able to survive that very little time is ever left for what I like to do.

TM: What are your personal plans?

LR: Plan number one is to get a really good job doing what I like and being helpful to people. Trying to earn some money to survive is our primary goal. I know that, as people say, I am most suited to be a teacher, and I would probably like to do something in this field or work with people. At present it's very difficult to determine for myself: I know what I want, but I don't know what path I should take. I may have to choose between what I like to do and what I don't like to do but that may be more meaningful in terms of money.

TM: How do you relate to Americans here in the USA?

LR: I relate to Americans the same way I relate to Russians. I think that people are the same everywhere; they may simply have a little different life. I've made a lot of friends among Americans, and I feel that I've known some of them since I was born. I don't actually differentiate between Americans and Russians. I think that there are wonderful people among Americans who are able to understand me and whom I understand and feel at ease with; there are also some people I don't feel very easy with. It doesn't matter whether they belong to the American or the Russian "group." It's very personal, so I don't like to generalize. It's a notion I don't know how to define. What I want to say is that a person is a person.

TM: What is your attitude toward perestroika?

LR: I think we have to differentiate between the theoretical approach (i.e., meditating here in America on what perestroika is) and the practical approach. What I mean is that you have to be there to experience it, to see it, because theoretically you can perceive it and in practice when you are living there and you have to face all the manifestations of perestroika that's absolutely different. I personally don't think that perestroika, as it was, brought drastic, crucial changes in people's lives, except that it

opened the covers. A lot of books and literary works were published; a lot of facts that were unknown before became open to the public; television programs began to be interesting; some very compelling plays appeared; reading everyday newspaper articles became as obsessive as reading the most thrilling mystery because people were learning a lot of things they had never known before. I believe those are the only things perestroika brought to people. In terms of practical change, I don't think anything crucial happened; everything remained the same. It may have somehow helped to free the minds of people.

TM: How do you see society developing in the future, and how will this affect women?

LR: I think the most important thing is to change the mentality of people, the psychology, which is extremely difficult. I am here in America in a so-called democratic society, but I don't find it easy to be free in my mind. We have so many things inside us that, no matter how hard we try, we cannot easily get rid of them because they are deep within us. I think that several generations will have to pass before people are truly free-minded. It's a very significant thing, and it's not possible to change everything overnight. It takes a long time because people don't know what being free is. They think they are free; even I think I am free. But I am not because I don't know how to be free. Maybe that's about myself. You need to learn, to be taught, probably from your birth, to know what it means to be free, and it's a very complicated question.

TM: Do you think glasnost has helped Russian women?

LR: Somehow, yes, because Russian women, being part of the Russian people led the same way of life. People were taught what they were supposed to do, what they were supposed to think, what they were supposed to feel, and, suddenly, it turned out that everyone could have her own opinion and her own feeling, which might be absolutely different from the point of view of her boss or her husband or the person on television. Of course, at that point, some women probably started to think about their position and to think about their life and started to think about what was going on. But knowing how to be free, how to make your own decisions, how to be independent of things going on around you, and how not to be afraid of being different from everyone else is either something you have to be born with or you have to learn, and this is very difficult.

TM: A new term has been used to describe the prevailing atmosphere in the former Soviet Union today, and that term is *naglost*. This term is becoming current because of the increase in crime that has taken place, especially crime against women. For example, there has been an increase in rape, prostitution, and pornography, and a great number of beauty contests have been introduced in the country. It has also affected women's economic situation. Please describe your point of view as to the prevailing atmosphere called naglost. What is your viewpoint as to the meaning of

naglost and its effect on women?

LR: I want to emphasize that my knowledge is only theoretical. I don't know how it will affect women and people in general. Of course, I read newspapers, and I receive letters from a lot of friends. What amazes me in these letters is that they are very hopeless and so grey in their mood. They are ever so much more pessimistic than they used to be. There is no hope; there is nothing. There is an endless routine with one million troubles and problems and things they have to do. As for the crime and this new term *naglost*, I think that delicate and sensitive people were never very popular anywhere, not even Russia, especially right now. In order to prosper in this life and to do well, you have to be arrogant, pushy, aggressive in the negative sense of this term, and if you want to survive, especially right now, you will have to push with your elbows to be the first one. Right now everything is so out of control in Russia. People know that there is no actual punishment. Everything is so corrupt everywhere that nobody is afraid of anything. It is interesting that at first I thought that all the jokes and anecdotes about rape that seemed to be so popular in Russia were a cultural manifestation. When these jokes were told in company, people laughed at them because they thought they were funny. When Americans hear the word "rape," their faces change and they become very serious and don't laugh because they don't think it is funny. For Americans, it is something terrible. For Russians, I think this is the attitude toward women. This is the way women are actually treated in Russia.

TM: Can you describe any specific examples of the backlash that has taken place against women, perhaps some of your friends, in Russia today?

LR: When you apply for a job in Russia, for example, if the choice is between a male and a female specialist, of course, any boss would rather hire the man. It is justified on the basis that a woman often has a child, and when the child gets sick, the woman has to take a leave of absence. This kind of discrimination also exists in America, but to a lesser extent than in Russia. I think the reason is that mothers in Russia have a paid leave of absence of at least ten days. If you are pregnant, you have almost a year of paid "vacation" to stay with your child. This is the law that is supposed to protect women, but a boss will think twice about hiring a young woman who has just gotten married or a woman who has children because he will be concerned about how things can get done in the office. Here in America, if I am a mother and I have a child, even if my child is sick, I will do everything possible in order to be at my job, in order not to miss a single day. There are no leaves of absence. There is no pregnancy "vacation."

TM: Were you aware of any feminist or women's movement when you lived in the former Soviet Union?

LR: I did not know about any legal feminist movement. As to a hidden

women's movement, when women got together many definitely discussed feminist problems. In order to become a real movement, it had to be organized, and any kind of movement of this type was illegal in Russia. But it was normal for people and women to discuss their problems when they got together.

TM: How does the position of Byelorussian women differ from that of Russian women?

LR: I think there is no real difference because Byelorussia is a Slavic republic. Probably, the position of women in the urban versus the rural areas is absolutely different because in the village women have to work very hard. They have no hot water or any other conveniences. But there is no difference between Russia and Byelorussia. Differences are more a function of the place where women live. In the big cities like Minsk or Moscow, women have all the conveniences and all the utilities they need, whereas in the small towns of Russia and Byelorussia sometimes they don't even have the bare essentials.

TM: How do you perceive feminism?

LR: I don't think it's a bad thing because women have very special structures with a unique psychology, physiology, and way of thinking. In general, the very fact that they are women affects the way they perceive things and their position in life, and already makes them different from men.

TM: What do you think about the position of women in the former Soviet Union today?

LR: I don't think it has improved, although it's not worse. The prices for everything, including food, clothes, cosmetics, and medicine, have jumped up so quickly, I don't think it has become better.

TM: Do you see men changing in the former Soviet Union?

LR: I don't see any man there changing. I don't think that men have changed since the beginning of perestroika because nothing has happened to change them. A prominent person once said that society's welfare can be determined by the position of women over there. The way women are treated determines whether the society can be considered civilized and progressive.

TM: What could really help Russian women and women in Byelorussia and Latvia?

LR: I think that changes in a generation or two might help women and their own ability to try to be free, to be independent, and to analyze their own abilities, their right to be happy, to be loved. First, they don't know what it is and second, they can't realize it. Nothing can help a woman, and nothing can change until she realizes that she doesn't have to suffer with a husband she doesn't love, she doesn't have to do work that she doesn't want to do, and that she doesn't have to drag her existence.

TM: What do you think about the changes in the former Soviet Union?

LR: More changes are taking place than there are hours in a day. Every second they are adopting some new laws or are making some decision which in a day they could eliminate again. I cannot really follow everything in terms of laws being passed in Russia and Byelorussia today. I don't see any drastic changes judging by the newspapers I read and the letters I get.

TM: What do you think about the future of the former Soviet Union, particularly in relation to women?

LR: Even the specialists, the professionals, the sovietologists who have been investigating the history of Russia find a prediction complicated. I think that the political changes that develop might somehow change the position of women. Whether these changes will be the victory of democratic forces or a military dictatorship or perhaps even civil war, no one can predict. But right now the situation is very unstable and is awful for a lot of women. In Minsk, it is more or less okay, but in the center of Russia and in multinational locales, life is extremely difficult. What I have learned since coming to America is that Russian women have always been ignorant of what a woman is. I have learned that a woman is not only a mother and a wife, but also a human being and an independent one. She can have her own way of thinking, her own point of view, and she can be happy and can have a family; if she is not happy, she has a right to try to be happy and to decide how she wants to be happy. We were ignorant in the sense that we were considered to be a lot of shameful things.

In contrast, in America if you have problems with your husband and you are fighting with him and don't know why you are so irritated with him or why, all of a sudden, you hate him, there is no real problem because you can always go to a psychologist, an advisor, or a family service. There are so many ways that people can help you, and it is not a source of shame. It's okay because it is life, and these are normal things in family life and normal for any woman. In Russia, it was out of the question to find out why you had problems at home and you didn't feel good about your husband; so all of a sudden you started to hate him and you felt that you didn't love him anymore. It was out of the question to find out whether the reasons were in him, in you, or whether you needed professional medical advice to examine physiological processes going on. We did not know about these things. We thought that women did not know how to cope with such problems. I feel that this is utter ignorance on the part of Russian women; they do not have the simplest knowledge of their bodies and their physiological makeup. This problem has nothing to do with politics. The humiliation Russian women have to undergo when they give birth to babies and when they have to go through abortion is horrible. Nothing can compare to it.

TM: What's your advice to Americans?

LR: In relation to women's condition, my advice to people, in Ameri-

can—and to people in general—is to be more sincere, more open, and friendlier; they should remember when their ancestors—whether their parents or great grandparents—came here, and they were the first and had to adjust and survive and received a warm word and some understanding. Sometimes words of encouragement and sympathy can be more helpful than a hundred dollars. If that is advice, I think that is a piece of advice that can be helpful to everyone, including both Americans and Russians here.

TM: What have been the greatest influences on the development of your worldview?

LR: Here in America, I am learning how to love myself, how to be free. I am learning how not to be ashamed of my weaknesses. I am learning that it is not necessary to be perfect in all respects. I am an individual, and I can have my pluses and minuses, my strengths and weaknesses, and that's all right. I can have my point of view, and I can follow my principles. It is unfortunate that I came to the United States so late; I wish it had come much earlier since I am now almost 40 years old.

TM: Is there anything you would like to add?

LR: I wish good luck, love, and understanding to everyone. Be loved. It is very important when you are loved and when you are understood. When you can be yourself and you don't have to pretend because people know you and even if sometimes you are not in a good mood and you say something that is not very smart, people who love and know you will keep loving you. They know who you are and what you are like. It is very important to have a sincere understanding of people. That is the best and the most important wealth in the world. Having sincere, loyal friends and understanding people enriches your life.

4

Yelena Khanga

Yelena, author of "Soul to Soul," the story of a black, Russian-American family 1865-1992, was the first Russian journalist permitted to work in the United States following glasnost.

Tatyana Mamonova: You met my son, Philip, in his school where you gave a talk. He told me that he introduced you to the audience. Have you met many kids like him—Russians who live in America and speak both languages?

Yelena Khanga: I was glad to meet your son Philip. He's such a wonderful young person. I did not meet many Russian-Americans, but those that I did meet were in Connecticut and Massachusetts schools. What was funny, I remember one Russian boy in a Massachusetts class where I was speaking. I had asked the class if any of them knew anything about Russian literature. The boy raised his hand and answered: "I know Pushkin." At first he was so shy. But the other kids were looking at him as though they were surprised and impressed and so he went on and on with the list of Russian writers that he knew. It was as if, for the first time, he was a hero. And when I continued my talk, he did not sit down. He just stood, so proud to be Russian! In another school, there were two Russian girls. One asked in front of the class if she could read aloud a poem by Pushkin in Russian. She did, with such feeling, and wanted to try to translate it into English so that the class could understand why she loved it so. Russian students seem to have more knowledge and appreciation for their literature than American students.

TM: How does it feel to be multi-cultural? Does this diversity help or disturb you?

YK: I am a Russian who happens to be black. My color was never an issue. In Russia, when I speak on the phone with strangers, they don't know that I'm black. Then when they meet me, they are surprised to see

my color and hear my Moscow accent. In my view, Russians are xenophobic. But when they realize that I am Russian then it's okay, I'm no longer a subject of curiosity. I have Russian culture and Soviet upbringing. Being multi-cultural makes me more tolerant and accepting of differences in others. I understand that there are many traditions other than Russian. If someone is to make a bigoted remark I am not likely to go along with it, because I myself am different.

TM: What is the difference between being black in Russia and being black in America?

YK: Racism in this country is institutionalized. If you are black, no matter how successful you may become, you still feel discrimination in America. In Russia, while there are some racists, it is not institutionalized. Anti-Semitism, however, is institutionalized. Because there are many Jews in Russia, Jews became the blacks of the Soviet Union. A Jew has to work twice as hard as a non-Jew to be successful — the same as for blacks in the United States. But the difference between anti-semitism in Russia and America is that in Russia you are a Jew by blood, not by religion, because most Russian Jews are nonpracticing. Most are atheists. Discrimination against blacks seems to be more of a question of class. If you are successful, have a good job and live in a good neighborhood you can always avoid it. I never faced direct discrimination, even if someone disliked me they didn't show it openly. I went to the best school — Moscow State University — I got a great job at the Moscow News. Actually, I faced more problems because I had American ancestry. Blacks, because there are so few of them, are not considered a threat. Since the 1960s, a number of African students have come to Russian universities to study. If they are treated badly, it's not only because they're black, but because they are foreigners. Russians, generally, are ignorant of Africa. All the information they have is negative — AIDS, poverty, hunger, war. Russians feel that their country has been supporting Africa for many years, so Africans are much like a small brother. But when the small brother comes to Russia knowing three languages and with dollars in his pockets, sometimes the feeling changes. Anyone with dollars becomes quickly a first-class citizen. Interracial dating is another story, although very few Africans will date outside of their race in Russia. A white male can select a female of any race without much criticism. But when a black male selects a white female there is a scandal. It's very complicated. White males can't accept it and put the blame on a white female for choosing a black male. She may even be accused of being a prostitute. I had a white boyfriend, but that was considered to be acceptable — a white male choosing a black female. The same with the black market. If a white was caught participating in it, people would just say, "someone was caught in the black market." But if one black out of thousands was caught, people would say, "an African was caught in the black market. You see, they are the ones doing terrible things." But I have to say that all foreign students from

Eastern European countries were involved in the black market.

TM: You also have Jewish blood. Does that create any contradiction? Do you think that people will finally find a common bond, or are these conflicts unavoidable?

YK: I have some Jewish, Polish blood, but Russians think of me not as a Jew but as a black. In Russia if you're black, you're black. I am afraid that people will never get along, except maybe in thousands of years. Maybe if we all mix interracially and become brown, then no one will be able to tell the difference but, I think it's just the nature of people to find a scapegoat. And anything that makes you different — race, religion, language, sexual preference, will cause bigotry in others. We can pray and hope that people will find a common bond, but unless there's heaven on earth, people will always need someone else to blame for their problems other than themselves.

TM: Tell me more about your background, your family in Russia and America. Actually Poland, too.

YK: One great-grandfather was a former slave from Mississippi. When slaves were freed, he became a wealthy land owner and a minister. One great-grandfather was a Polish-Jew. He was also a rabbi. To make religious matters more complicated, another grandfather was head of a Muslim church in Tanzania. His ancestors were from Zanzibar. My mother was born in Uzbekistan. Her parents came to Russia in 1931.

TM: What do you think about the new Russian and American governments?

YK: I liked Gorby very much. I met him and gave him two kisses — one for myself and one for my mom. He was very shy about it. The beginning of glasnost was very exciting for me. I began to work at a newspaper just before glasnost. Then after glasnost, the difference became so clear, and I could really appreciate everything glasnost had done. For example, I became the first Soviet journalist permitted to work in America. I worked for the *Christian Science Monitor* because they happened to be having an exchange program with the USSR. Now I am for Yeltsin. Not that I am in love with him or agree with him, but I don't see any other choice. And in the United States, I was for Clinton. I was in love with Hillary, not Bill — but again, no other choice. I couldn't support Bush and was holding my breath during the election. But now, I'm very happy with Clinton. I was appreciative that he took on such tough issues in the beginning. Now we'll just have to wait and see what the outcome is. I tell people to give him a chance. He's given blacks and women more chances. He's courageous.

TM: The turmoils between Parliament and President in Russia are problematic. What is your feeling about it?

YK: The problem is that Parliament and Congress were also selected before the changes were made. But the President's problem, I think, is his personality. If Yeltsin were more flexible he could better handle the prob-

lems. No one is expected to be an expert on every issue, but he could certainly have chosen better advisers.

But, I'm afraid that if the Russian people become too disappointed in Yeltsin they will pick someone next time, for example, who's a nationalist or a chauvinist or a military man. They will never go back to what they had, but they can still make a bad choice. And I don't want to call what they had "communism," because it was never real communism.

TM: Did glasnost help women to have their voices heard?

YK: Absolutely. I became a member of the first official feminist journalist group in Russia. It included 33 females, who would choose one high male Soviet to interview. We interviewed the Prime Minister and the head of KGB, among many others. These men knew that the interviews would become known around the world and this fact caused female journalists to be taken seriously.

TM: So, did the changes in Russia bring mostly good news to women there?

YK: Mixed. The good news is that now women, theoretically, have all rights. So they more readily pursue an education and travel. But the bad news is that Russians have picked up the negative stereotypes from America. For example, if a woman is over 30, or not attractive, or a "little bit" overweight, she thinks that it will be extremely difficult to succeed. Also, there used to be quotas for hiring. Women had to be given jobs. But now that quotas are gone, women have to be almost perfect to be hired—beautiful, smart, plus they have the double burden of being wives and mothers. Mostly it is men who are in the position of hiring and when it comes down to it, they would rather hire other men. It's an old boys club.

TM: How do you feel about "Women go home!" proclamation?

YK: It's ridiculous. Women must have the opportunity to choose their life. It's not even an issue. It's the difference between Barbara Bush and Hillary Clinton. I'm with Hillary—I'm also the younger generation, but there is nothing wrong with Barbara Bush either.

TM: Are Russians losing free education and medical care?

YK: Legally, I'm not certain. But two years ago, when I lived there, education and medical care were still free. Whether it is free or not if you have money you are much better off than if you are without it and everybody knows that. In the hospital you can bribe a nurse for better treatment. In education, you can hire a tutor to help you with studies. So even if it's still free, money does play a role.

TM: What is your opinion about pornography, prostitution and beauty contests in Russia?

TM: That's an interesting question. At this point, I don't believe porno is any longer a big problem. Before glasnost, it was strictly forbidden, right after glasnost it was everywhere! But now people are just yawning, bored with it. They see that there are so many other much more important things. With prostitution, back in the "good old days" girls wanted to

grow up to become lawyers, doctors, teachers. Now, they want to become high class "escorts." The problem is one of economics. "Escorts" make more money in one night of prostitution than in a year of teaching school—that is the myth. They saw it in the movie "Pretty Woman." But we know that's not the way of the real world—the poor woman becomes a prostitute, gets a rich, handsome man who marries her—come on! That's the "Cinderella Syndrome." I compare this problem with that of poor black kids in Los Angeles who are selling drugs. If you tell them to go to school and get a job, they say, "yeah, you pay for me to go to school!" I interviewed a prostitute once, who came from an intelligent, good family and asked her why does she do it? She explained: "I, at the age of 19, being a prostitute for one year will make enough money to buy my mom a house and make a good life for myself. Can you say the same?" I saw her logic, although I didn't agree with her. I think the new generation has lost its values. They realize that their parents were fooled and they were fooled. So now, they think there are no longer any rules. It's too bad. As for beauty contests, I was in Russia watching TV, during the years when the economy was going way down and the prices were going way up, and I saw this contest where girls were being given cars and money for beauty when people are starving! When somebody is hungry, it is not the most pleasant thing to see pretty faces winning fortunes. Before the economy went bad, that would be one thing, but now, when there is such a contrast between rich and poor, the contest becomes terrible. Even though the pageant itself was actually funny, especially with the priests sitting as judges. It wasn't the contest that was immoral, in my opinion, but when people are in desperate times and the country has the nerve to advertise someone getting a million for good legs, THAT is immoral!

TM: What do you think about the future of Russia?

YK: On the new year, in Red Square Russians were asked what they thought 1993 would bring. They answered: "The bad news is that it will be worse than 1992. The good news is that it will be much better than 1994." I personally think that in the long run we will survive. But the short term will be very difficult, especially for women, because they have to take care of themselves as well as the males, who are drinking, protesting, and running their mouths. I have much more pity for females than males.

TM: What are your own plans for the future?

YK: My favorite heroine is Scarlett O'Hara. She always said, "Tomorrow is another day." My life here in America is so dramatically different. New job, new friends, new language, even *I love you* is different here. In Moscow, I had a great job, big apartment—everything. But I wanted to prove that I could make it here, in America, too. And I wanted to find my roots. That is why I wrote my book. Now, I am negotiating for a movie deal. So in answer to your question, "I'll think about it tomorrow, after all, tomorrow is another day."

5

Ketevan Rostiashvili

Ketevan Rostiashvili is a researcher from Tbilisi, Georgia.

Tatyana Mamonova: Tell us a little about yourself: your background, education, family.

Ketevan Rostiashvili: I am Ketevan Dorianovna Rostiashvili (a Georgian), born in 1959 in Tbilisi, educated at a Georgian school. In 1978 I graduated from a college of music (in Tbilisi), in 1983 from Moscow State University's Faculty of Recent and Contemporary History, and in 1987 I completed graduate study at the Institute of U.S. and Canadian Studies of the USSR Academy of Sciences, where I wrote my master's thesis on "American Trade Unions Within the System of State-Monopolistic Capitalism during the Carter and Reagan Administrations." In the four years since then I've been living and working in Tbilisi, being a senior research fellow at the Center of Scientific Information for the Social Sciences of the Georgian Academy of Sciences. I take an active part in selecting the most interesting translations and synopses of Western works in political science. At the same time, I'm working on my Ph.D. thesis on "Government Regulation of Labor Relations and U.S. Trade Unions." I believe that in-depth study and widespread dissemination of political science (politology) in the national republics are very important; for decades political science has been repudiated in the USSR and treated as a bourgeois pseudoscience.

I am single and unfortunately, live with my parents—since our reality is that even highly paid specialists have great difficulty in getting a place to live. My mother is Nino Adamidze, a teacher of French; my father is Dorian Rostiashvili, a lawyer.

TM: What is your attitude to perestroika?

KR: My attitude to perestroika today is in sharp contrast to my attitude during the pre-1988 period, when I supported it, understanding that the

CPSU had no alternative to deep reforms in the sociopolitical structure of the whole country and the party itself. I wanted to actively participate in the country's political life and have maximum impact on the existing political structures, with the aim of democratizing and transforming them as soon as possible.

The subsequent turn of events—in part, the Nineteenth Party Conference in the summer of 1988—became my first shock, since careful analysis of officially accepted documents clearly showed the reality of perestroika to be a cosmetic reform of the existing system, with unconditional retention of the CPSU's monopolistic power. This view was fully supported by subsequent events—elections and congresses of the USSR People's Deputies and the Twenty-third Party Congress. Today I see perestroika as only a manifestation of the convulsions of an agonized totalitarian system. The question is only how it will fall apart, by what means, how long the transitional period will last, and when economic stabilization will begin. In any case, antidemocratic forces are doomed to fail since they're incapable of carrying out radical economic and political measures to ensure the country's stabilization. This means they'll lose real political power.

What's interesting here is that the Georgian attitude to perestroika has been highly skeptical from the start, since not only the intelligentsia mistrusted it, but the workers too. There was always a silent protest in Georgia, especially by the intelligentsia, with regard to the communists. This is explained by the annexation and occupation of the republic in 1921, and the many errors permitted in the management of the country under their rule.

The incredibly easy victory of the opposition in the repubic's first democratic elections stemmed from the utter discrediting of the CPSU in Georgia, as did the rather apathetic condition of Georgian communists, who understood perfectly well that the people would psychologically and morally reject their party. Even in the republic's parliament, the communists do not form an opposition these days, since they have practically merged with the ruling "Round Table" faction.

TM: Is glasnost helping women express themselves? I recall our meeting in New York in 1990 at the Russian-American Women's Summit—wasn't that a result of glasnost?

KR: Glasnost is helping women express themselves, but freedom of speech would be a lot more help. They're forced to defend their principles and convictions at the cost of their careers and even their blood. The bloody events occurring in my republic, other parts of the former Soviet Union are a splendid confirmation of this situation. As for the meeting in New York, top government and party functionaries have always made frequent trips to the West, but their visits had little effect on the administrative-bureaucratic system in the USSR. On the contrary, these official trips became a marvelous lure and source of profiteering for the administration.

Even our delegation to the Conference in New York reflected the real balance of power in this country. Fifteen of the women represented the old Committee of Soviet Women, standing for the antidemocratic, command-administrative system (though there were a few progressively minded people among them); and ten women were independent, allowed to attend the Conference only on the condition that the "ardent supporters of perestroika" would also be present.

One real achievement of perestroika, in my opinion, is the freedom to have one's own independent scientific theory, a liberation from the old methodology that was tied as dogma to each and every kind of applied and theoretical work.

TM: How did you come to be interested in women's issues?

KR: It was only at that conference in the United States that I seriously began to pay attention to women's problems. Russian publications on this topic are at the level of pulp literature, useful only in the way that second-rate raw materials are useful in production. As for Western books, I've been too involved with my work to really take an interest in them. It was a revelation to me to find in America a well-organized, closely knit network of women's groups, with their solidarity and thirst for participation in that country's politics. Although I did get the impression that the current generation of women who are most active in this movement (those aged 40 to 60) cannot be a leading force in politics. That will be possible for later age groups, those who are now 10 to 20 years old. They will grow up in a different psychological and moral atmosphere, in the information age, when it will be essential to have a high level of professionalism in order to achieve financial independence in life (regardless of one's family situation). This will directly change their status in society, it will give them a chance to lead lives filled with participation in public affairs, and it will have a direct influence on the country's politics via official and parallel government structures.

TM: How does the position of Georgian women differ from that of Russian women?

KR: One must first take into account the specific cultural traditions of our countries, their particular histories of development, the undoubtedly progressive role played by the 1917 Revolution in women's emancipation, the creation of an overall legal base for equal rights. Even today, ex-Soviet women have much greater protection under the law than American women do.

I would say that the most striking distinction between American and ex-Soviet women is the Americans' sense of independence and freedom: they are able to change their lives according to their own interests, change their jobs, go into business; they can choose an activity, a partner, or the style and color of their clothes; they don't have to take their family or their age into account; they can get maximum convenience and satisfac-

tion from their work; and they can choose where they want to live. All of this is in contrast to ex-Soviet people, whose particular characteristic or stereotype is inner inhibition and a constant feeling of self-control, with the aim of complete submission to external circumstances.

Russian and Georgian women have much more in common with each other than with Western women, through centuries of closely linked cultural traditions, not to mention their common sociopolitical circumstances. All the same there are some highly significant differences. In my opinion, the most important are the moral/psychological customs and traditions. Georgian women are much more subordinate to the family, to their husband and children, which in many ways restricts their moral freedom and independence. Even when a woman is single, she must, according to ethical standards, live at home with her parents, which unfortunately is encouraged by the poverty of our country and its citizens. When she marries, she often becomes fanatically devoted to her husband and family. Her basic function is seen in terms of reproducing and educating the next generation, and creating the comfort of home and hearth. This applies even if her choice of husband has been unfortunate, for the idea of marriages being made in heaven is widespread. Georgia is an incredibly traditional society, which in many ways predetermines the social role of women. Significant changes are observable between the older and middle generations. Although the middle generation of women is still cruelly dependent on family, husband, and parents, they are sharply aware of their subjection and condemn it — but they are still controlled by moral traditions.

Women's financial and psychological liberation is also held back by the country's highly unfavorable economic circumstances, under which any entrepreneurial activity meets with huge difficulties. Women also lack essential experience and basic knowledge of business, while the government completely ignores these issues.

TM: Has the situation changed at all, for better or worse, over the past ten years?

KR: The position of women has undoubtedly improved over the past ten years, due to scientific and technical progress, more information from the West, and a significant increase in women's educational levels and professional activity. But in order for real improvements to occur in their lives, and for their level of independence to increase, there has to be a favorable, stable situation in this country with regard to politics and the economy — and this stability is being slowed down by resistance from conservative forces.

TM: How do you see the future of Russia and Georgia?

KR: It's hard to picture the future these days; maybe it's important to define what we mean by the future — the next few years, or the longer term? It appears that the next few years will be very painful, even if

there's no "explosion from below." The disintegration of the decrepit organism will have an effect on all the national republics. Nationalist conflicts will drag on and on. If a strong democratic opposition existed, we could have looked for radical changes in favor of democracy. Its absence leaves only the evolutionary path, not excluding the possibility of a consolidation of all democratic forces leading to an "explosion from below," the ground for which is practically ready.

Whatever the turn of events, the transitional period for the formation of new socioeconomic relations will pass with great difficulties, since any break implies pain. In the long term, I see the future in terms of a common market, with all its nations being economically integrated but completely independent politically. Such a union would preclude pressure from any country with the aim of enforcing its own political regime, any intent to make Moscow the unconditional center of government, any coordination of the community by one particular party, or the retention of the supremacy of one nation's armed forces over all the others, who are forbidden to maintain their own armies. I think the basic principles of the reformed economic community (no republic can do without the Russian market— and none will reject economic cooperation) will be voluntary union, completely equal rights, and free expression of intent to join or leave the union, in the event participation has a negative effect on the economy of any member nation. The union couldn't be equal and fair if the most important constitutional rights were violated, including the right to leave. Gorbachev was trying to substitute for this right another democratic institution—a general referendum on preserving the USSR. But this ignores the will of the republics. Even if an entire national republic vote in favor of leaving the Union, it would have no effect on that republic's future. Centralized Soviet power has been completely discredited and in many cases rejected in practice; the only idea uniting all of Georgia today is that of independence. The future is seen only in terms of restoring the independence lost in 1921.

TM: What about Shevardnadze?

KR: Having organized a parallel structure in the form of an extrapolitical association, Shevardnadze will presumably start uniting democratic forces in Russia and be able to create an opposition to the conservatives. He will probably start correcting the errors of the democrats, whom he accused at the Fourth Congress of People's Deputies of "running off into the bushes."

Georgia now finds itself in an extremely difficult situation. Because it has refused to sign the Union Treaty, it is being persecuted. On the one hand, this finds expression in an economic blockade and sharp cuts in all subsidies, including energy and vital food products. (The republic is now essentially living on credit through its direct contacts with other republics and Western countries.) On the other hand, nationalist conflicts within

Georgia are being stirred up. Georgia is practically at war with its Ossetian population—people are dying every day. In Tbilisi alone there are over ten thousand refugees; overall, there are sixteen thousand Georgian refugees within their own homeland. Relations with the Abkhazian Autonomous Republic are becoming very strained. Like the former South Ossetian Autonomous Region, it wants to sign the Union Treaty separating from Georgia.

The Center makes good use of these ethnocracies and their ties to the CPSU, placing them in opposition to the first democratically elected Georgian government since 1921. The Center is waging open moral/psychological war against the Republic of Georgia. The only future for the Republic was in the restoration of its independent status, as declared in 1918.

TM: And what are your personal plans?

KR: To complete my Ph.D. thesis. In order to do so, I plan to work in Moscow for a year, at the Russian Academy of Sciences Institute of U.S. and Canadian Studies.

6

Olga Tatarinova

Olga Tatarinova is a woman of letters from Moscow.

Tatyana Mamonova: Please tell us about your literary activity. We know you head the *Kiparisovyi Larets* (Cypress Coffer) association.

Olga Tatarinova: Yes, I direct the Cypress Coffer, a literary circle for young people. It now seems that my path to this group was a completely natural development. But the beginning was quite unexpected and accidental.

At one point in 1981 I was invited to give a reading of my poetry and translation at the Moscow Physico-Technical Institute. I have no idea how they learned of my existence. "Underground" life in Moscow was full of mysteries, sorrow, and surprises—rarely nice ones. You'd be sitting at home, isolated from the world, of no use to anyone, one to one with the problem of your own existence—by that time I'd long parted with my first profession of radio engineering and was getting by on casual translations, work as a night-guard and dispatcher at a garage, and things like that—when suddenly someone would call, asking you to come and give a poetry reading somewhere, meet some member of the unofficial writers' brotherhood, support yet another hopeless attempt at a literary "breakthrough," appear at an art exhibition, and so on. And the greater part of these events, even the art exhibitions, would simply be held in Moscow apartments.

Well, this particular invitation was also semi-official; the students had invited me. I was aware that by this time, the MPTI—a stronghold of Soviet dissidents in the sixties and seventies—had been harshly combed down, trimmed short, and shaved clean across the board. But I still hadn't expected to find there what in fact I found: the fairly large student audience that evening had no idea who Sakharov was, or what relevance, even tangential, he had to their educational institution. I was horrified,

but not at all irritated by such "hickness"—since I myself had once been pitifully provincial, a student at a technical institute, deprived of any cultural and civic information whatsoever, speaking in the repellent dialect of the province where it had been my fate to spend my school years. Such intellectual and spiritual deprivation was very close to me. And to some degree this set the mood for the evening. In any case, we sat in that hall for a long time, and after the poetry reading I was asked the most sincere, trusting, "childlike" questions—such as: what does modernism mean; are you by any chance a modernist; how are you repressed; do we have an avant-garde in this country, and how does this differ from modernism; what do you think of existentialism, feminism, homosexuality, romanticism, and so on. All in all, the audience opened up completely about their own lack of information and greed for knowledge.

As a result of this evening, the young people extracted a grant for me from their superiors—21 rubles and 50 kopecks—and requested that I conduct a literary circle for them. I spent a happy three years of Fridays with them. My reward at the end was seeing a young man become a fully fledged poet over that time—Igor Bolychev, who has already been published in the United States in the *New Journal*.

But at the same time I came to understand that by the age of 20, children, our clever, talented children, are so neglected in their development with regard to the humanities and aesthetics that it is necessary to start working with them much earlier. Therefore, when friends suggested I transfer my work with the circle to the so-called Pioneer Palace, I thought it through and agreed. My young friends from MPTI came with me, and I invited the winners of school literary contests into the circle. Among these were, as fifth graders, my authors of today: Natalia Danzig, Liza Akhmadulina, Paulina Bahnova; and so we got to work. This is how the Cypress Coffer group began. By the way, the children didn't choose its name straight away, but only after they had some understanding of what creative goals they would set themselves. *The Cypress Coffer* is the title of a famous collection of poems by the Russian symbolist Innokentii Annensky, who published his poetry very late, at the end of a quiet, modest, unnoticed life. All his life he had been storing his poems away in a cypress casket, and they turned out to be one of the greatest achievements of Russian poetry.

With the material support of our sponsor (the Transfiguration, a women's club at the Academy of Sciences), we have just produced our first anthology of poetry on a commercial basis: *The Seventeenth Echo*, containing poems by seventeen of the group's writers, twelve of whom were still at school when the book was compiled. This is an unprecedented event in Russia. Now many of them are studying at various tertiary institutions. Five of my group members have entered the Gorky Institute of Literature. The point here is not that the institute was named

after Gorky, but its professional orientation.

TM: So you're working with young people. What do you actually do?

OT: As I've already mentioned, I now view my work with the group as a natural development in my life. I myself have been writing since childhood—poems, stories, I've even started novels—but no one was ever interested in this, and most of all I felt that the white heat of my creativity was lacking something, something real, some kind of knowledge, understanding—of what and of how. From my earliest glimmerings of consciousness, I have felt terribly alone in a spiritual, intellectual sense—despite my being an adequately, even overly, sociable and collectivistic person. My favorite poet was Lermontov, since there was no one else to like; I read too much foreign literature in translation, and I only heard the words *Pasternak* and *Tsvetaeva* at the age of 22—when I'd already completed my studies at the technical institute I had enrolled in out of despair over my cultural incompetence, which I was well aware of. I read their work when I was already a young specialist in the field of space technology, and they became for me the focus of latent, slumbering creative inclinations—while the world around me celebrated profanity, the morality of the herd, and a party ideology that was deaf to people's spiritual lives.

And so, at the age of about 25, I felt myself to be, if not a spiritual—I now think spiritual life cannot be expressed in words or understood—then a cultural and linguistic cripple, deprived of essential information about the humanities, of intellectual society, of teachers whom I could have loved and so wanted to love. This deep grief and spiritual hunger, which have oppressed and darkened my existence since early childhood, gave me a real sense of the greatest Russian loss of our time: the loss of a cultural milieu. All my life I've missed the teacher I never had. At the same time, I am indebted for the best, richest, and most interesting things in my life to those contemporaries who showed what I now understand to be real intellectual heroism. Scorning ideological stamps and the underlying mercantile disintegration of the system, they occupied themselves with their own spiritual development, gathering cultural knowledge grain by grain, through persistent and unpaid labor—studying philosophers, theologians, publicists; organizing in the most difficult circumstances exhibitions of the forbidden, forgotten work of artists from early in this century, redolent with the aura of things lost; and, finally, themselves trying to write, sing, paint, and make films in the spiritual tradition of the lost past.

In my work with children I try to give them what I had lacked at an early age: intellectual and emotional understanding, and essential information. Supporting their creative efforts, saying a joyful "yes" to everything substantial, beautiful, and formative in them, I simultaneously try to convey to them—during free, noncompulsory, casual conversations—some very basic information that could subsequently be related to studies

in the culture of language, literary history, the history of literary directions and styles, the morphology of the arts, literary theory—in a word, everything that was never even mentioned in Soviet schools and that I am sure every writer is interested in from the moment they pick up a pen.

Overall, I would describe my course as being about the meaning of form—I try to pass on to my students all the thoughts I've had about this throughout my life. And I've done a lot of thinking about it. In part, I think our national tragedy is a kind of general incapacity to grasp the forms of life, to some extent an inability to structure one's own spiritual context—the source of our strength and our weakness, insofar as it is too far beyond the material world, too sophic.

TM: What impact has glasnost had on your activity?

OT: There have, of course, been a few extremely inspiring episodes. For example, our correspondence. As soon as the border was opened—I, together with my husband, that student of mine above mentioned, Igor Bolychev, acquired our best friends: the wonderful American artist Herb Jackson and his wife Laura, and the German Thomas Bremer, who translated Igor's poem *The Tower of Babel*, dedicated to Herb and his family. In October of this year [1990] I crossed my country's border for the first time in my life. And on Moscow soil I have had countless encounters with Americans, Germans, and English people. Such meetings with soul-mates didn't and couldn't happen in the past. I don't know whether or not this is due to glasnost, but in this period—in 1988—*Soviet Writer* publications brought out a large collection of my prose writings, which had formerly been rejected and which unfortunately bore the scars of earlier editorial changes (both from periodicals and from the Literary Institute where I got my degree). Our circle is sponsored by the Transfiguration women's club—as you will understand, both the women's club itself and the fact of its sponsorship, are also a consequence of perestroika.

It's also invaluable that general readers have had the opportunity to learn about Russian literature which had been forbidden by the regime—they have been swamped by great Russian names—though we, of course, have long been reading all of them in photocopies. (By "we" I mean dissidents, internal émigrés.)

However, for me, at least, and for those like me, the situation on the whole looks grim. The impression is that people in the West don't understand this situation very well. In all spheres of activity, the reins remain in the hands of the very same people who have wrecked our lives. They still have the same literary tastes, formed by their system of "education"; the same head on their shoulders, the same instincts, the same subconscious, the same hidden motives. If, for example, they instinctively didn't like my style, and my whole existence as a writer was inimical to their very spirit—how on earth is all this supposed to change simply because they've

become members of the PEN club? I don't understand In any case, my novel, completed in 1987, is still lying around at two publishing houses, though reviews of it have been positive; and my book of poems has been awaiting "its turn" for over ten years now. These days, apparently, there's "no paper" for us. Translation of poetry, on which I used somehow to struggle along, has ceased altogether: it is not a commercially viable activity. The sharks of the publishing mafia are the same, and they continue to think up joint publishing initiatives for themselves — but the small fish, especially the *poetically helpless* ones, went to the bottom several years ago.

TM: There is much talk these days of difficult economic conditions. But is poetry still alive?

OT: In part, I have already begun to answer that question. I will only add that many of my poet-friends and students have pointed out that "the universe is silent." Maybe only true poets will be able to understand what that means. In general, those who draw their creative energy from the psychic depths of their disposition, rather than from the mass mercenary excitement now gripping society, are not writing. I'm only consoled by the fact that my children — those under 20 — are as fervent as ever. Maybe God still has plans for this unhappy land; maybe it's not an accident that it's remained to this day one of the last of the Mohicans — possibly even the very last breeding-ground and irrepressible disseminator of poetry in the world. Practically speaking, in the Russia of my time — whether things were going well or badly — one person in five was scribbling something singable or rhyming at some point in their life. Poetry, the love of poetry, the need for it — this I understand to be the main indicator of a people's spiritual essence. I'm of the opinion that a poet is not just a person who can make rhymes, but a certain psychological type, a person who has what all ages have termed "a poet's soul."

TM: What do you think about the future of perestroika?

OT: That question appears to me to be deeper than it's now commonly understood to be.

By the start of the 1960s, it was already obvious that the blow dealt by Khrushchev had been fatal and that the regime was doomed. But the builders of the Soviet regime had been diverse; its ideology, in contrast to those of other fascist regimes, contained much from the eternal aspirations of the poor — and so it proved to be quite resilient. For some time, despite all the bloody costs of its support, it also ensured the mental development of those from the poorest layers of society. And insofar as everything living strives to develop, to perfect its form of being, the elimination of illiteracy alone gave the regime a strong basis of support.

I tend to view fascism, as such, in broad terms — as a practical phase of that idea of government that is characterized by complete submission, the individual being swallowed up by the state. In one form or another, this

ideology has manifested itself during the twentieth century all around the globe and has proved to be a useless goal—a dead end in the development of government. Up till now, humanity has only been able to counter fascism with the various forms of Western democracy, and nothing more: the Universal Declaration of Human Rights. That in itself is a lot. However, we risk a long trip into arguments and doubts simply by asking the question: human rights before whom? But, reply the liberals, we're only talking about civil rights—and somehow liberals systematically fall flat in a puddle on the sharp bends of history. It happened in Russia and also, alas, in the West.

A second issue, one that is directly related to the one above and is just as metaphysical and no less painful, is the question of property. Personally, to quote Tsvetaeva, "I love the rich." Especially those whom I have directly encountered in my own country: the party bosses who have gathered everything to themselves, and the prosperous Soviet bourgeoisie who have adapted to the system, and who in the late Brezhnev period whined only about having money and not being able to do anything with it. Of course, my many Western friends, who are all members of what we call the Western intelligentsia, tell me that the middle class in the West lives in a world that's well ordered, comfortable, and sufficient for productive mental labor—and it hasn't a clue about any concrete threat to capitalism; although this threat exists, it troubles the middle classes neither in dreams nor in reality. They simply exist in different worlds. And this is the result of long, determined, civilized social struggle by trade unions, social democrats, and other thinking leftist forces.

After all these years of thought, I have come to the conclusion that the world stands either at the threshold of destruction or at the threshold of something completely new: a new religion, a new culture (by now sophic, of course, rather than masculinist—and not selective or elitist, but pan-human), new forms of social community. This will be a new world, our mutual world, and I believe in it.

As for what's happening in the former Soviet Union, the problems and conflicts of interest are too acute for there to be much hope of anything but yet another national tragedy. The whole point is that even if Gorbachev's government did break the desire of the party apparatus and executive functionaries for complete control of national production, they did not have the power to do anything for the deprived working masses. By the will of the fates, whatever he may have initially wanted was forced: legally redefining national property as private, to the united approving murmurs of yesterday's time-servers—who haven't even had time to discard their party membership cards but are already proclaiming themselves to be social democrats, liberals, and the owners of perestroika's actions.

Of course, the dirty, degraded, hideously dressed mass of good-for-

nothing people (for one has to know at least something in life besides drinking), this whole 200-million-strong cursing Soviet germ-cell that has been told for the past seventy years that it is the master of life, cannot fail to resist when it is offered the option of perishing, going to the wall, lying down as a corpse on the pathway to the next bright tomorrow. Even now, it's becoming necessary to publish letters in which invalids, pensioners, and just plain ordinary hundred-ruble workers, who are still in the majority, are asking the government: what are we meant to do, commit suicide? Some obediently do so; but others once more go out into the square with an axe, just like that, without any set political slogans, including the sauce of national strife—with that same little old axe of Raskolnikov, the traditional symbol of our victorious revolutionary-democratic ideology. And I fear that there is nothing to counter that with, except for tanks: as ever, none of us, not even the kindly Gorbachev, have anything else. But it seems to me that it will not fall to him to complete that dark road: his role in history has been determined—it's possible that he will remain a savior, at the price of personal tragedy, if we as a whole world can save ourselves.

Meanwhile, the poor are losing the last of what little they have. That's what is now happening in the former USSR.

TM: Tell us about your background—you have a famous last name.

OT: About my great surname—the family name of the countess with whom General Kutuzov stayed before Borodino. But that's in a book! In the novel *War and Peace*.

When I was about 10 and my first silly piece was published in the *Pionerskaya Pravda*, I was showered with letters from all over the world. There were even letters from Australia and Greenland. Grandmother couldn't cope with the correspondence. And all letters without exception asked whether I was by any chance a sister of Katia Tatarinova from Kaverin's *The Two Captains*—and if so, then they were at my service, all of these children, if I should ever be hard up. Thus did I first experience for myself the power of art. And that's why I will never believe that *poetry* can be wiped out. In extreme conditions, it is capable of changing the forms of its incarnation.

In reality, I know little about my roots. It seems that my relatives had good reason not to initiate us children into our background. I have no idea who my paternal grandfather was, he whose name I bear. My grandmother's maiden name was Logatino. They lived somewhere along the Volga. My other, maternal, grandmother was from St. Petersburg, and her surname was Shishkina. While married to the manager of the Stoliarov trading house, before the Revolution, she gave birth to three children—including my mother. As a child I heard rumors that the Stoliarovs and their whole trading house met a terrible end—all of them, including small children, were put on a raft and set adrift down the Neva River. My

grandmother, Natalia Aleksandrovna Logatino, died of starvation in the Volga district at the start of the 1940s. My parents were paupers, students at a factory high school, who both graduated from the Novocherkassk Polytechnic Institute in 1937 and worked honestly as Soviet electrical engineers, attaining such professional heights as did not require a party membership card.

So I myself would give a great deal to find out something about my roots, about the lives of the families I come from. Alas, all that is gone, never to return.

7

Lada Smirnova

Lada Smirnova is the daughter of Kari Unksova, a feminist writer and poet who worked with Women and Russia.

Tatyana Mamonova: Tell us about your relationship with your mother.

Lada Smirnova: The question "What was your relationship like?" is always a hard one when you're talking about a person who had and has an enormous significance in your life. And as I begin to write about my relationship with my mother, I would like to point out that to my great regret I did not inherit her talent for writing—and I wouldn't want people who don't know of her to judge her solely on the basis of what I say. I can say with pride that I am the daughter of a great person, and I don't believe I need to prove this, since I think that mother herself said all there is to say, through her creative work and her life.

TM: Was your family close?

LS: My parents were an infinite gift from fate. And right from my childhood, mother was my closest friend. From the earliest age I remember long talks with my parents, and I always knew that my opinion would be heard without any reference to my age. Maybe this sounds odd; for what kind of conversation can there be with an unreasoning child? But this was the first lesson my parents taught me: a person can and should have her own opinion, regardless of age. They always paid attention to my words, and mother often said that she learned much from me. In any case, I don't recall a single instance where my mother failed to pay attention to someone. She had a rare talent for seeing in people their potential strengths and possibilities, both human and creative. And I can confidently say that she was one of those rare people whose influence touches by no means only those closest to them. She never tried to keep anything exclusively for herself. A conversation she had with one of her

friends has stayed in my memory. They were talking of poetry:

> "Look, Kari — there's lines in these poems which have obviously been ripped off from your work."
> "So what?" said my mother. "What matters to me is that people know and understand what I'm saying; the form in which it reaches them isn't all that important."

TM: But your family situation wasn't typical, was it?

LS: Various people have often asked me: "Didn't you ever wish you had different parents? Look, you don't see your mother for months at a time, none of you ever have any money, any peace, or any confidence in the future." Would I swap my family, if such a thing were possible, for what's called a "successful" family? My answer: I couldn't bear to imagine anyone else in their place. And this is even without taking into account my love for my mother, as a mother. What would have become of me?! I neither can nor want to imagine such a nightmare. I have never wished for what's known as a "typical mother," who always remembers whether or not you've had breakfast, and whether your clothes are worse than those of your peer group, but doesn't have a clue about who you are and what matters to you. For my mother, my spiritual state was one of the most important things in world. Of course, I was far from being the ideal child who could understand this at every moment of her childhood. But something in me always knew that, overall, it was so.

TM: Can you give any concrete examples?

LS: I don't know why I've remembered this, but I have. I was in a children's sanatorium, and all the kids really wanted to have a badge with this sanatorium's logo, "Duny." So I wrote to my mother. (Parents were only allowed to visit their children on specific days, once every three weeks.) I wrote to her, asking her to send me some money to buy one of these badges, explaining how desperately I needed one. I got the money, of course (20 kopecks); but in the letter there was a small note: "Dadika (my childhood name), here's your 20 kopecks, but I would really like it if you thought about this — of what use will a Duny badge be to your immortal soul?" And this was precisely what I needed to understand. Of course, mother wasn't worried about the 20 kopecks; that would be absurd. But she wanted me to understand that all these trivial things which we so desire, and can't immediately have, poison our whole life. And we forget . . . forget . . . and forget. . . . And sometimes, as I go to bed, I still ask myself: "Have you been occupied with Duny badges today, or did you raise your head even once to see the sky, and be aware of all the beauty and infinity of the world, even for a moment?" And this is a gift from my mother.

TM: What effect did her death have on you?

LS: Even now, when mother is no longer with me, whenever I'm in trouble and feeling like I've run out of inner strength, it's enough for me to remember my mother and say: If a person like that put strength and energy into me, I have no right to forget about that, no right to stop working on myself, no right not to advance further. Surely no mother in the world can say that she's done more for her child.

And I was far from being the most fertile material. I always excelled in blunt stubbornness and spite, and it's only now that I'm beginning to understand what my parents were involved with. I remember how during that wonderful time known as puberty, even my father (who always expended no less strength and energy on me than did my mother) finally said: "I refuse to have anything more to do with her. If she wants to be a fool, let her." Meanwhile, my mother was waging a real war with me for me. And I hope with all my heart that she won it. True, it's taken me years, by now without her, to bring myself to a more or less human state. But only God knows how she helped me and what would have happened without her.

TM: How did you relate to her poetry?

LS: There was another side to our relationship. No longer the relationship between Dadika and her mother, but the relationship between a major creative figure, a poet, and myself, Lada Smirnova. And this was a relationship I chose to have. Mother was a well-known and much-loved poet. I was her daughter. And at a certain point I said to my mother that I didn't want her to introduce me as her daughter. Mother instantly understood why. I don't want to be just somebody's daughter. I don't want this to be the only reason why I'm loved or not loved, or accepted into any given circle. Yes, mother understood and supported me in this. And here I'd like to tell you about an evening which was memorable for me. It was in Moscow; mother was holding a "creative evening." Not anywhere official, of course, but in the apartment of some friends. (At that time, just as there were unofficial "apartment" exhibitions for artists, there were "apartment" readings.)

Although it was dangerous, plenty of people always came. People sat and stood wherever they could. Anyway, the apartment (quite a large one) was packed. I came to this reading. I listened, along with everyone else. I loved to hear my mother recite poetry. Every time, I would feel afterward that something beautiful had taken place in my soul, and that this would remain with me forever. . . . The reading ended, and as always people began socializing. I spoke with someone for a long while. And when my mother entered the room, the person with whom I'd been talking led me over to her (this was a great honor) and said: "Kari, this is Lada; I know you like interesting people, so I want to introduce her to you." Remembering her promise not to mention in public that I was her daughter, mother very pleasantly got acquainted with me. I was so happy

that someone had judged me sufficiently interesting to be introduced to her. I was really (no matter how funny it seems) proud of this. And mother was no less happy for me.

TM: Was her death accidental, or the work of the KGB?

LS: I don't want to write here of mother's death. I would just like to look her killers in the eye. That's all I can say. Who took upon themselves the right to take her life?! (It looks like I'll never know the answer to this question.) And for what reason? I don't know of a single person in this world whom she harmed. And I know many whom she helped to find their path, not sparing her own strength. Her creative work was not political, but it made people think, and this is precisely what the *sovdeps* (soviet nomenclature) fear even more than any openly political protest. She simply lived in the way it's possible for a person to live who has a deep inner honesty, who is incapable of looking and not seeing. And together with her love of life and boundless energy, her mighty talent, this became a forceful weapon, which could only be destroyed along with her life. This is just what they did. . . .

I believe that in every person's soul there are limitless resources, which we spend our whole lives learning how to use. And the path to my soul was shown to me by my parents. In addition to this, mother left her poetry, not only to me, but to the whole world. It is an endless source of energy and self-understanding.

TM: What do you think of feminism and glasnost?

LS: A friend of mine went to a clinic in St. Petersburg to have an abortion. So they ask her the usual question: "Married?" On receiving the answer "No," the doctor replied: "People like you should be shot." And this was fifteen minutes before the procedure, which is far from being one of the most pleasant (taking into account the state of medicine over there).

Yes, we have undoubtedly gained a lot from glasnost. It is now possible to learn from the mass media why people used to be imprisoned, exiled, killed. But how much time will it take for those like that doctor — an average Russian woman — to understand the real meaning not only of feminism, but even of ordinary *humane behavior*. In my opinion, it is this — the understanding of one person by another — which is the basic idea behind feminism. It's precisely this which I could relate to and understand in the orientation of this movement which was adopted by the creators of the first Russian feminist almanac, *Women and Russia*. As I see it, this was not a struggle by women against men. It was the fight of women for humaneness. A fight with a soulless system. A fight, as human beings, not "against," but "for." A call to see and not to accept the position that women were forced to take in the former Soviet Union. However, the majority of women still don't want to see this, even now. And this is where glasnost has the potential to help and is already helping to some degree.

TM: What effect did the era of stagnation have on the Russian intelligentsia?

LS: Let's look at something that amazes the whole West: the number of female doctors and lawyers in the ex-USSR. In the West, these jobs are prestigious and well paid. . . . That's in the West. The state of the Russian medical and legal systems is no secret—for a country that aspires to the title of "developed," it's a disgrace. Hence, the complete absence of prestige in these professions. And the pay is a joke. Any manual laborer gets more.

TM: What could really help Russian women?

LS: Going by my own experience, I can say that while living in the ex-USSR, it's impossible to imagine even a tenth of that which a Western woman uses every day, taking it for granted. And, unfortunately, the generally low standard of living has its primary impact on women. How infinitely hurtful it is to spend hours on something that takes minutes in America. (Searching for groceries, doing laundry without washing machines, or just being incapable of anything for hours because of menstrual pain and the absence of any appropriate medication; and so much more.) Unfortunately, all this affects a woman's spiritual level. Not everyone is given extraordinary strength and character. And in order to work on oneself (read, think, spend time with friends), you need precisely that time and strength which is lost on the trivia of everyday life.

I don't mean to say that it's impossible to be a Russian woman and an interesting person at the same time. But how I long not to see mothers who because of years in the Soviet system have lost the ability to think, want, and aim, now raising their daughters in the same style. Can glasnost be of any help with this? I hope that something will change. But you can't just throw out seventy years and declare that "tomorrow everything will be different." It will take more than a year or two to lead the ordinary Russian woman out of this labyrinth.

But I still hope for the best. If even without any glasnost there were some women capable of seeing this world through their own eyes, not somebody else's, when this was dangerous and difficult. . . . Then now, when this no longer demands such superhuman effort, I hope with all my heart that there will be more of them. And finding out about them will be easier.

8

Anya Kirin

Anya Kirin is the daughter of Ludmila Kuznetsova, an avant-garde writer who worked with Women and Russia.

Tatyana Mamonova: Do you follow in your mother's footsteps?

Anya Kirin: I often find myself talking about my mother, about our life together, about her life and what she believed in. I find myself talking about her when I try to say something about myself. I try to act the way I think she might have wanted me to act. The longer I live alone and the older I get, the more I love and respect what she did with her life, the more I hope to be like her.

TM: Can you describe her?

AK: There is one picture of my mother which I especially treasure. She is standing outside, next to a friend, the wind blowing their hair back. They're looking straight ahead, past the camera. The year is 1976. The event is the opening of the Izmailovo Park exhibition, one of the several unofficial exhibitions that Soviet nonconformist artists organized during the 1970s. My mother is pregnant. This is the only tangible record I have of this pregnancy, which was so tragic for my mother. This pregnancy has also come to mean to me all her pain that I only now begin to understand and never even saw during her lifetime.

TM: How much do you know about her writings?

AK: A few months after my mother's death I sat down to finish translating the book she had been working on for the last two years of her life. She always said that the book was fiction, that she had only taken the necessary background out of her life and certain events that happened to certain people she knew, but that was all. In the letter written to literary agents to solicit their representation, it was pointed out that the main and most dramatic portion of this novel takes place in Soviet hospitals. The heroine, as a result of a physical struggle with a militiaman, goes into pre-

mature labor and finds herself trapped in a maternity house, her newborn baby's life endangered by the incompetence of Soviet doctors and KGB interference. The heroine is unable to save the life of her child, and the authorities do not even allow her to bury the baby girl. It is through this fictional book that I first found out the true story of what my mother went through during her second pregnancy.

TM: Your mother herself was born in Siberia?

AK: Yes, my mother was born in Siberia. Her father was a major in the KGB, and her mother was a member of minor Polish nobility, all of whose relatives died in Soviet concentration camps. By marrying into the KGB, my grandmother believed she could protect herself and her children from any further troubles with the Soviet authorities. Growing up in a sheltered and privileged environment, my mother knew nothing of Stalin's purges, of the starving Ukraine, or even of her own mother's history. She genuinely cried when she heard of Stalin's death. She finished high school with a silver medal of academic excellence and went on to study engineering in one of the top schools in the country, the Bauman Institute in Moscow.

TM: Was it in Moscow that she became a dissident?

AK: Yes, it was during her college years that she met those "undesirable" friends who started telling her about what really went on in the Soviet Union during the 1930s through 1950s. On one of her trips back home, already after her father had been ousted from the KGB along with other Stalinist officers by Khrushchev, she was traveling in the same train compartment with a man who started telling her about his life. He told my mother that he was going to Kurgan to kill the KGB major who had ruined his life and sentenced him to a decade of hard labor. He named her father.

TM: It must have been a hard time for her.

AK: It was not as if my mother at this time made a 180-degree turn and said "OK, I now know about communism in the Soviet Union, my childhood beliefs were a lie, and I am now going to lead a different life." For many more years she tried to rationalize the communist ideals, why they didn't work in the Russian experience, why they couldn't work anywhere else. Until she was exiled from the Soviet Union, she still had a strong belief in her homeland, in the need to fight for human rights from within, from home. At one point, while she was still in college, a friend brought her documentation on the hunger in the Ukraine, how Stalin punished Ukrainians by refusing to send them grain. My mother later told me that while she was reading these materials, all she could think of was her childhood memories of stinking mountains of rotten grain that were never even picked up off the fields. The contrast shocked her so much that she became physically sick, and after a month of fever and delirium she started seeing life around her through slightly different eyes.

TM: I know she wrote about the "Bulldozer" show.

AK: The same friends brought her to the "Bulldozer" exhibition of unofficial artists. This exhibition later became a milestone in the Soviet nonconformists' movement for freedom of creativity. It was the first independent move by these artists towards a battle with the state for freedom of expression. The fight was no longer clandestine. The artists chose an outdoor deserted site, invited their friends and the foreign press, and notified the authorities of the upcoming exhibition. On the appointed date a giant crowd gathered at the site. Everybody expected arrests, but nobody expected it when several bulldozers headed straight for the artists who stood next to their easels with paintings. Many paintings were destroyed, and the artists and many onlookers were gathered up and taken to the nearest militia station. My mother, among many others, saw how one of the artists, Nadezhda Elskaya, a tiny woman, stood in front of several militiamen and simply stated to them that they could not take her, because as a Soviet citizen she had a right to express herself freely by painting and to exhibit her work. What shocked the people who were watching the woman was that the militiamen actually backed off.

At the "Bulldozer" exhibition my mother ended up among those who were taken to the station for questioning. Several of the artists were in the same room with her. Among them was Evgeny Rukhin, a man who was generally recognized by the artists as one of their leaders, a tall, handsome, hairy giant. He was asking his friends not to be afraid, not to sign any statements of hooliganism, not to admit to anything except what they had actually done—which was to exercise the rights which the USSR constitution granted them. The authorities were threatening everyone present with grave consequences unless they signed statements of hooliganism. They said that if they agreed to sign a statement saying that they were acting like hooligans, nothing more would happen to them than a customary fifteen-day sentence. But if they didn't, then they would regret it for the rest of their lives. Some people signed the statements, but the artists and my mother along with them did not. As it turned out, everyone who had signed the statements were released. Rukhin introduced himself to my mother, told her she had done the right thing, and from that time the artists accepted her as one of their own.

TM: How did she decide to have a "home gallery"?

AK: Since we lived in the center of Moscow and had two spacious rooms, my mother offered the space to the artists to exhibit their paintings there. It was a convenient location for those who wanted to see them, and it provided an opportunity for the artists to let their work be seen. The shortage of living space in the former Soviet Union is well known, and the offer was gladly accepted. The risks of providing such a space at the time are also well known. Threats, harassment, constant arrests, and searches were the consequence of such an action. But my mother believed she had learned a lesson at the "Bulldozer" exhibition—her strongest defense was

that she was a citizen of the country with a constitution that grants certain rights, and it was those rights which she exercised. This stance protected her from militia and KGB for a long time; but what she wasn't prepared for was what it meant in her personal life.

TM: And it was at this time that she became pregnant?

AK: During this time my mother fell in love with, and became pregnant by, a professor from Moscow University. He was a successful man, a man on the upper rungs of the Soviet hierarchy. He was so successful, in fact, that he permitted himself to quietly associate with the nonconformists. He felt that by his presence he contributed to a worthy cause, as long as no one knew about it. When my mother found out she was pregnant with his child, he even contemplated publicly acknowledging their union if she would agree to discontinue all her activities. At this time the artists were planning another big outdoors exhibition at the Izmailovo Park. They were excited by the official promise that this time it would be undisturbed. Many of them looked up to my mother as one of the people who would not be afraid to try holding the authorities to their promise. She couldn't become silent at that moment.

TM: What happened then?

AK: A few months after the Izmailovo exhibition, Rukhin died during a fire in his studio. The circumstances of the fire were not clear, and my mother decided to investigate what had happened, since the state authorities were not doing anything. Some of the evidence that she uncovered irrefutably pointed to arson. It was then that a couple of militiamen came to our apartment, trying once again to force my mother to sign a statement: something to the effect that she attacked them and deserved arrest. During this visit, one of the mlitiamen twisted my mother's arm to the point that she was bent to the floor. Scared that they might have gone too far in hurting a pregnant woman, they hurried out. My mother went into premature labor. The ambulance rushed her to an abortion clinic. The girl who was born there was left alone in a room with broken windows in the middle of November. All my mother's efforts to get the baby out of the hospital so that some adequate help for her could be organized at home failed, and the girl died. The beloved professor, horrified by what had happened, broke off all relations with my mom.

TM: Did she continue her nonconformist activity?

AK: After this pregnancy, my mother threw herself into organizing home exhibitions for the artists, publicizing their efforts, and the work of anyone else who created against the Soviet norms. During the last half of the 1970s the group of unofficial artists, writers, and musicians finally made enough noise to be heard in the West and began receiving support from the foreign press. Western diplomats expressed their sympathy for the movement by organizing events like musical evenings and poetry readings in their homes. Outside of the Soviet Union exhibitions of paint-

ings smuggled out of Russia gained great attention. And even though inside the Soviet Union the persecution did not ease, the movement gathered a strong momentum.

TM: Is your mother's role now recognized in the nonconformist movement?

AK: My pride today is that I am the daughter of one of the women who was considered a leader by the group of people who were striving for those victories.

My mother was arrested, our apartment was burned down, but it all ended with her exile. On the other hand, one of my mother's closest friends, the poet Kari Unksova, was murdered four years after we left the Soviet Union. We were very lucky.

TM: What have the recent changes in the former USSR given you?

AK: Lada Smirnova, Kari Unksova's daughter, has been my friend since about 1973 or 1974, since the time our mothers became close. Until 1979 we had spent a lot of time with each other, despite the fact that we lived in different cities. When Lada came to the United States at the end of last year, we decided to stay together again.

TM: I know your mother worked right until the end.

AK: During the last years of her life, after she had already been diagnosed in New York as having leukemia, my mother dedicated her time to writing a book about the life of an ordinary Russian woman who oversteps the boundaries outlined by the Soviet authorities.

She also organized the Kari Unksova Fund, the goal of which was to publish Kari's poems and help her family. Now, when she is no longer with me, and as I feel I am getting closer and closer to adulthood, I am at a point in my life where the decisions I make will affect the kind of person I become. Is there a lesson in all of this for me? I don't know. I just want to live as the person I am, with all the rights given to me by this country, by my heritage. What I want most is not to betray myself.

9

Galina Kolobkova

Galina Kolobkova is a judge from St. Petersburg.

Tatyana Mamonova: What is your background?
Galina Kolobkova: I was born on August 13, 1946, in the village of Ivanovskaya, which is in the Yaroslav district of the Ilyin region. I was delivered by the same midwife who had brought my mother into the world. And they say I was born lucky. Although I was born at a time when my mother, a Leningrad resident (now St. Petersburg), was vacationing in a village of her native region, the rest of my life has been linked to Leningrad; after eleven years of secondary school, I attended evening classes at the Law Faculty of Leningrad University, combining study with court-related work.

I have worked within the legal system for more than twenty years, since 1968. During this time, I have passed through every stage of legal work, having been a courtroom secretary, a judicial functionary, a legal advisor, a people's judge at the Krasnoselsk Court from 1979, a people's judge at the Vyborg Court in Leningrad from 1982, and a board member of the Leningrad Regional Court from 1984 to 1987.

Wherever I worked, the collectives have always elected me to union committees or entrusted me with some sort of public work. From 1974 to 1979, when my daughter was little, I worked as an advisor on codification and legislature at the Judicial Office of the Leningrad Regional Executive Committee; there I was elected as people's assessor in the Dzerzhinsky Regional Court. At the Krasnoselsk Court, I was elected chairperson of the union committee for the Court and Prosecution. At the Vyborg Court, I was elected as a member of the production sector of the union committee. At the Leningrad Regional Court, I was elected as a member of the production sector of the union committee twice in two years.

The Krasnoselsk Court was the furthest from the city, so I had to write

up my verdicts on the train. Then, after getting an apartment in the Vyborg region, I transferred to the Vyborg Regional Court, which handled the heaviest load of civic cases. I dealt with 100 to 120 cases a month, over a thousand cases a year, specializing in a very complex category of case—privately owned residences. My territory covered all the suburbs of Leningrad. My work was of high quality: for two years out of five, I achieved 100 percent stability, with no verdicts being overturned. In civic cases, that's not easy. In the other years, I had only a handful of overturned verdicts and citizens' complaints.

TM: What other interests do you have?

GK: As far back as I can remember, I've been drawn to everything complex, extreme situations, risks. In my youth, I went rock-climbing with the Gvandra Club and went hiking on mountain trails of first, second, and fourth degrees of difficulty. The fact that I was born lucky is demonstrated by the following cases: once, on a fourth-degree hike in the Caucasus, I fell into a crevice and hung by my rucksack—my friends pulled me out. While climbing a glacier in climbing-irons, I slipped and fell; luckily, I was saved by landing on a small ledge and got away with almost breaking my nose. Eight years ago, I taught myself to ski. On weekends I would ski at Toksovo and Kavgolovo. I went downhill-skiing twice, at Chembulak in the Murmansk region and in the Medeo hills. I'd arrange my vacation so as to have two weeks in the mountains in winter and two weeks at the seaside in summer.

I've also been involved in clubs ever since I can remember. I sang in the Pioneer Palace choir from the first grade, joined dance collectives, and really got into recitiation and theater. I also studied speech and movement, which helped me a great deal in later years when I had to give lectures on legal topics. For two years, I studies at a drama school.

And I can drive a car; I have my license—that was another interest of my youth.

TM: Tell us something of your family life.

GK: I got married in my final year at university, graduating with my daughter in my arms; she was born in 1971.

In 1979 I divorced my husband and was granted alimony. My husband, B. A. Kolobkov, was a gymnastics expert. Under pressure of his work, he broke, as tends to happen with professional sportsmen, and started drinking. He quit work and fell behind on his alimony payments. My salary at that time was only 97 rubles and 50 kopecks a month, but I took the court order and wrote off his debts. He hasn't been drinking at all for six years now and has another family. His wife has a son from her first marriage, who visits us, and my Vika goes to see them. Relations between us are friendly and very good. He loves his daughter, buys her things along with her grandmother, and can't wait for grandchildren.

My daughter and I are quite different. I'm a Leo—I'm interested in

politics, social movements, meetings. Vika is a Virgo — very feminine and domestic; I think she'll make a very good wife and mother. I'm practically never home; she always is.

Vika is 19 now. She graduated from high school, after spending the final two years at a practical training center, learning sewing. After graduation she mastered the craft of machine-knitting; she works at a knitwear house, knitting sweaters, dresses, and children's wear on a Japanese machine. She has an excellent fashion sense. All her designs have some kind of ornament or embroidery, and they're all original, beautiful, and modern. She intends to really master knitwear embroidery.

Vika loves children and animals. Just like in my own childhood, our home has had cats, dogs, parrots, white rats, and fish. For five years now we've had a dog called Alyi. Someone gave Vika 35 rubles for her fourteenth birthday, so she bought herself a present at the market — a puppy which she thought was a German Shepherd. He grew up with a German Shepherd's markings but a laika's curved tail.

When Vika was little, I took her along on hikes and rock-climbing trips. We even slept in the forest, and once greeted the New Year in a tent. But now she's grown up, leaving tents and hikes behind her. . . . Well, as they say, there's a time for everything. These days she has to deal with much more serious issues.

TM: Why did you choose to be a judge? Is this a typical profession for a Soviet woman?

GK: Why did I choose to be a judge? I'm deeply convinced that not every lawyer can be a judge, even if they're highly qualified. A person who's indifferent to human grief and suffering, an unkind person who's left unmoved by the fate of others — such a person can't be a judge. Those very human qualities should be the main criteria in recruiting all workers involved in preserving law and order, especially judges; for a judge embodies fairness and humanity. Doing concrete work with people; righting wrongs; giving real help to those who need it; assessing and resolving conflicts; reconciling opposing sides — all of these things let you feel how vital your work is to others, and then you forget about everything and don't even notice how time flies. Anyone who's worked in a court for a long period of time is incapable of leaving it for other work, because nowhere else can a person derive such true satisfaction from their work as they can here.

There are many women in the judicial system, even more than there are men. It's very complex work, very stressful. No one comes to court gladly, so there's a constant flow of negative emotions; yet throughout it all you have to keep a warm heart, and not become callous or disillusioned with life. Men are a weak lot, and many can't deal with it. Women are more steadfast, and have more stamina. And besides, the pay was low (260 rubles a month); only now has it been raised to 3,000 rubles.

TM: What do you think of perestroika?

GK: In 1985, along with many others, I believed Gorbachev and all the agitation and propaganda about change which flooded party publications and the press. But in real life everything turned out to be more complicated. Those who started exposing the administration's various wrongs and abuses in the media and at meetings were repressed: various excuses were found to fire them, expel them from the party, send them to psychiatric hospitals, bring criminal cases against them. There are more than enough examples.

Today there's an entire layer of society made up of such people who have basically been cast out of life by the system. Some of these people haven't worked for five years or more and have nothing to live on. Many of them are scientists who have suffered for their ideas because of talentless nobodies who held the reins of power. Y. Emelianov invented the best ozonizer in the world, patented in Japan, France, and the United States, but for twenty years he couldn't get it accepted in his own country. In the end he was dismissed from Moscow University and lived on the brink of starvation; only now has he been reinstated and elected as a deputy in the Moscow Soviet. Then there's S. M. Dobroumov, a Leningrad physicist who had two inventions previously unknown to science; one of them was taken over by his institute's administration, who then forced Dobroumov to leave under threat of dismissal without a reference. So the institute continues its research, having full use of Dobroumov's work and laboratory facilities, and the scientist carries on with his beloved work in a home-made laboratory, without any funds or equipment.

TM: I know you've had personal problems with the system. What were these conflicts about?

GK: I myself have approached everything from the party's Regional Committee to the Party Commission of the CPSU Central Committee—and at every point I've been refused reinstatement into the party, despite the blatant breach of regulations.

I've now completely lost faith in the party, which does nothing to protect its members from obvious illegality and injustice; I haven't the slightest desire to belong to it. The institutions that are there to protect our rights shouldn't be linked to any party; they should obey their inner convictions, principles of social justice and the law. Unfortunately, these institutions (the courts, the procurator's office, the militia, the ministries and departments) are still turning away from the common people and still avoid entering into conflicts with the system in defense of citizens' legal rights and interests. And so people only get token replies to their complaints; the facts set out in those complaints aren't investigated very deeply, and no action is taken. People's rights are being restored only with great diffieulty. People's complaints are an indicator of popular opinion, but the old mechanism for handling them no longer functions and the

new one doesn't work yet, for it's only just being implemented.

My own conflict with colleagues began with a speech I gave at a party meeting in November 1986. Naming specific cases and facts, I spoke of illegal, unfounded, and unfair verdicts that should have been overturned, but passed through the Court of Appeals and the Procurator's Office without amendment. After this speech I produced three reports, six special opinions, and two presentations. The administration, prompted by the authorities, retaliated with disciplinary punishments, refusing to put me forward as a candidate in the elections, forcibly striking me off the register (which is against the legal code), making me leave the party (that is, expelling me), supposedly because of unpaid dues, and breaking contact between me and the party organization.

Our vertical structure for protecting human rights isn't working—I'm convinced of this from personal experience. I filed fifteen complaints with the RSFSR (Russian) Ministry of Justice and in reply received only two formal notes. There was no investigation at all into the facts of my case, although I'd listed the verdicts I was questioning. However, they did offer me jobs in the civic legal service and in the regional people's court—anything to stop me from washing their dirty linen in public.

In fact, I still haven't seen justice done. But some RSFSR people's deputies have informed me that new legislation is being prepared on the election of judges. I think if there's some competitive basis for selecting members of the judiciary, I may be able to continue the fight.

At present, I've been elected people's assessor of the Leningrad City Court by the people's deputies of St. Petersburg; I am also a member of the Council of People's Assessors and the leading specialist at the Leningrad Commission on Human Rights. I see citizens who come in with complaints, and I work together with people's deputies and independent unions to investigate them, going out to the location involved; after which we present our findings. We're creating a new structure for investigating complaints, made up of lawyers, psychologists, sociologists, economists, and the public. This commission has been operating for four months now, with very positive results.

We're planning to establish an International Coordinating Center for Human Rights in St. Petersburg. As soon as the documents are ready, I'll send you copies. If you're interested, you can join us.

TM: Has glasnost enabled you to express your opinions?

GK: Glasnost has been a very positive part of perestroika. It's provided the opportunity to express one's opinions in public, in the mass media. Before perestroika this was impossible. But people are already starting to get used to it. For instance, I used to devour newspapers and magazines! But now I'm so tired of information overload that I confine myself to the "Vremya" news, "600 Seconds" current affairs, the late news, and the Deputy TV and radio stations. I think people are sick of information.

Nothing surprises them. Nobody believes in anything, because changes have been few. The level of tension in society is very high.

But I'm an optimist by nature. There's a battle going on between the new and the old, and the old doesn't want to give in. That's why things are changing so slowly. But I'm sure there can be no return to the past. Glasnost has enabled radical leaders to emerge.

In general, I think as soon as there's a competitive system in place for the selection of all leaders—in enterprises, institutions, and the organs of law enforcement—suitable cadres will be found. But after a year they should all be reviewed and dismissed if they haven't coped. And the voters and deputies should decide this.

TM: What do you think of the position of women in Russia today?

GK: In my opinion, the average Russian woman has seen no improvement in social conditions and material goods. On the contrary, they have deteriorated. You probably know that we're getting food parcels from America, Germany, and other countries; things are very bad in the services sector, equipment is old, enterprises are on the verge of bankruptcy, and it's the same for general and maternity hospitals. For many decades, all of our country's wealth flowed into somebody's pockets, with the nation growing poorer while some grew rich. The democrats' immediate task is to take back what was stolen and give it to the people.

As for women's participation in government affairs, all leading positions are still occupied by men. Women still haven't spoken out, but I think they will speak. I think that woman, by nature, has a more flexible mind, is more perceptive and diplomatic, more capable of resolving conflicts painlessly than a man; kindness and humanity in resolving critical problems come naturally to her. I'm deeply convinced that women would resolve many of our country's problems better and faster.

TM: What kind of changes have there been in Soviet law?

GK: In my opinion, Soviet laws lagged behind real life. However, the problem doesn't lie only in adopting new laws. The more complex problem lies in interpreting and applying the law. Putting a law into practice is a job for officials, and another major problem involves the recruitment and deployment of cadres. I think all leaders and workers in the judicial system should be put through high-level professional and technical tests, involving psychologists and sociologists, before being admitted as candidates for election. Only then could we entrust them to implement the law and wield power that should be used to protect human rights.

TM: What do you think of the future development of Russia?

GK: The main brake on our nation's development lies in the center: the ministries, the departments, the system of planning and finance. We can't enter a new economy with an old vertical structure. Democratic centralism has outlived its purpose. The future lies in horizontal links between regions and republics, and the faster these can be established, the faster

we'll escape destitution. But this will require radical measures for dismantling the vertical structures. So far, only the signs on the buildings have been changed. The ministries' power is moving to associations and consortiums. Economic power is more dangerous than any other. The administration is adapting to new conditions, trying to gather as much as possible to itself, leaving nothing for ordinary workers. The law is still helping them in this effort.

TM: What are your personal plans?

GK: What can I say? The most immediate task will be to create a new structure, part of which will be a service for investigating complaints and taking urgent action. Another will be to create the International Coordinating Center for Human Rights in St. Petersburg.

I would really like to know more about the American judicial system and American judges. I am currently learning English.

TM: Is there anything you would like to add?

GK: Our legal system is in need of radical reorganization—starting with the method by which judges are selected, where more attention must be paid to a judge's personal qualities; and going through to the composition and structure of the Court of Appeals and Procurator's Office, which are not ensuring that human rights are protected. The vertical reporting structure of the courts is also incapable of ensuring judicial independence. Therefore, the legal system must be restored by regional forces of law and order; and it should be confirmed or dismissed on demand by deputies and the electorate.

It should be
　　it could be
it would be...
I am trying to find
　　words,
It should be
it could be
it would be...
They're flying,
like birds,
about me
over me
at me

I didn't believe
　　in angels
before meeting you,
I didn't believe
in heaven
before being with you,
I didn't believe
in miracles
before loving you,
I didn't believe
in anything
before believing you.

10

Ulyana Bostwick

Ulyana Bostwick is a lesbian activist of Ukrainian background.

Tatyana Mamonova: Tell me about your ethnic background.

Ulyana Bostwick: My mother was born in Kiev, Ukraine, and was a refugee during World War II. She endured extreme hardships and witnessed terrible atrocities at a young age, rescuing her family at age 8 from forced deportation back to the USSR. My maternal grandmother, whom I affectionately refer to as Baba, lived not only through the war, but also through the Great Famine of 1932-33. This famine was deliberate genocide by Stalin against the Ukrainian people, especially the land-owning peasants (kulaks), to break the people of their will for independence and their hatred of collectivization. Consequently, my grandmother saw hundreds literally dying in the streets and being carted away to mass graves. She herself subsisted for a while on grass, horsemeat, or anything else remotely edible, at risk of being shot by police for eating what was "state property." My maternal grandfather was a Ukrainian nationalist who fought in the Petlura army and was sent to Siberia twice for his involvement with counterrevolutionary activities.

My mother's family began their escape to America in 1942 by being taken by the retreating German army to Berlin for the remainder of the war. They came to Hartford, Connecticut, in 1943, through the sponsorship of a church.

My father's story is quite different. He had a quiet, happy childhood in upstate New York. The son of a physician, he had a privileged upbringing, attending private schools, country clubs, and Yale University. He met my mother in graduate school, married, and began a career in Washington, D.C. Baba also lived with our family after her husband died.

TM: How does it feel being bicultural?

UB: I have many mixed feelings about being half Ukrainian and half

American, or, more accurately, half Anglo-Saxon, and so I feel ambivalent toward both cultures. No less complicating is that I am also a lesbian, which is hardly esteemed by either culture.

Like many other children, my parents' cultural background influenced my outlook on the world. The dichotomy between my mother's and grandmother's refugee background and my father's upper middle-class world affected me in subtle ways. As a young child, I didn't notice any differences from my peers, except that I spoke another language, ate different food, and missed Saturday morning cartoons to attend Ukrainian school. But as I got older, I noticed more cultural differences between myself and both my American and Ukrainian peers, differences that were not conducive to "fitting in" with either group.

My American friends ridiculed my grandmother and referred to her as a "maid" because of the shawls she wore on her head and because she did all of our household cooking and cleaning. I often felt foolish because I was usually overdressed for cool weather, and because both my mother and grandmother were overprotective of me. I also began to feel guilty about my privileged childhood when my mother compared me to herself during the war, reminding me how tough her childhood was and how much harder she had to study.

My sense of not fitting in the Ukrainian world came mostly from adults. My Ukrainian was not as good, some felt, because I had an American father, and I sensed their pity. In religion class, I fit neither the Catholic nor the Orthodox mold, as I normally attended my father's Episcopalian church. When placed in an Orthodox class (because my mother's family was Orthodox), I was humiliated when the priest pretended he could not pronounce my American name.

As I grew older, I began to feel ashamed of my grandmother. I developed low self-esteem and began to hate myself. I remember looking in my mirror and telling myself how ugly my face was, how ugly my eyes were. I was a complete and utter "nothing" who didn't look like anyone, at least like any of my American peers. I began to think of myself as a misplaced "half-breed" long before I was aware that it was a term reserved for mixed-blood Native Americans.

Was this source of confusion and self-hatred a result of the way I was raised or a result of the realities of growing up different in America (however slight the difference may be)? How much of my childhood was influenced by my mother's experiences in the war? My mother and Baba were sometimes critical of me and had high expectations of me. They also tended to be pessimists. Were these traits derived from Ukrainian culture, or were they expressions of trauma received during the famine and the war, or both? Because I was confused about the source of such behavior, I distanced myself from Ukrainian culture. I saw Ukrainians as being overprotective, domineering, and emotionally overbearing, and I clung

to the cool etiquette and polite objectivity of my father's world.

At this point, I've been cautiously trying to get in touch with my Ukrainian side again, to analyze what parts of that culture I like and what parts perhaps have been destructive. Gloria Anzaldua's *Borderland* has helped me understand that I'm not a traitor for having negative feelings about my culture, and her analysis of mestiza/mestizo culture has also helped me understand how many of my own negative feelings have stemmed from growing up bicultural in America. I've been able to see how some of my hatred about the Mongolian fold of my eyes stems from an all-American learned racism turned inward.

TM: What do you think about nationalism (anti-U.S., pro-Ukraine)?

UB: I also have mixed feelings about nationalism. I was raised to have a strong sense of nationalism toward the Ukraine. With the exception of a brief period during 1918, one must understand that the Ukraine has not been an independent state since the days of Kievan Rus. Since those times, one conqueror after another has swept its plains, including Tatars, Mongols, Turks, Poles, Austrians, and the Russian/communist empire. It's no wonder that the name "Ukraine" means "borderland" or land without borders. Simply learning these facts in school promoted a sense of nationalism.

I also leaned toward nationalism in self-defense. Throughout my school years, peers and adults would inquire about my ethnic background, and I would always laboriously explain where the Ukraine was, who Ukrainians were, and reinforce the important distinction between Ukrainians, Russians, and communism. While such explanations grew tiresome, they also reinforced my protective feelings towards a country that most considered only a region ("the" Ukraine), a language that was often banned from Ukrainian society, and a people that weren't legitimately considered Ukrainians but were known as "Little Russians."

Likewise, I was raised to be a patriotic American, as America saved my mother's family from Stalin's purges and gave them a second chance. My father also has always believed wholeheartedly in the American constitution and democratic process.

Yet I haven't ended up being particularly patriotic towards America and am ambivalent about Ukrainian "patriotism" as well. To me, patriotism holds the potential for nationalism and jingoism, and I find nationalism dangerous. Extreme nationalism has allowed people to feel superior to others, to feel justified in committing acts of terror against neighboring countries or within their own country. I find that nationalistic feelings can border on irrationality because it is precisely these kinds of feelings that dictators such as Hitler and Stalin catered to when enjoining the support of the masses. It just doesn't feel right, and in America's case, is downright hypocritical by not taking the diversity of American culture into account. Especially within the last few years, the trend in America

has been that there are only certain ways to be patriotic.

Thus, I can't be a patriotic American if I'm for Native American rights. I can't be a patriotic American if I'm a lesbian and in the military. And supporting arms control implies support for communism, which is yet another betrayal of the Ukraine as well as America. So you see how confusing the issue of nationalism has become for me.

Yet I'd be lying if I didn't admit to the sparks of nationalism and pride that sweep my thoughts when hearing about a newly independent Ukraine. There's nothing wrong with my pride and joy at finally being able to refer to the country of my heritage. The danger of nationalism is that if I become so proud that I believe the Ukraine can do no wrong, then its past history is inconsequential to its actions in the present. It's about perspective and how one paints the picture.

TM: So you are not a "good Ukrainian girl"?

UB: That depends, of course, on one's definition. In my opinion, the concepts of patriotism, sexuality, religion, and culture all intersect with the idea of what it means to be a good Ukrainian girl. But the effects of generational and historical influences may also alter the definition of what others might consider to be a good Ukrainian girl. Of course, when I speak about a good Ukrainian girl I speak from my experience as a Ukrainian-American lesbian. I cannot speak as a Ukrainian native and from the values in the Ukraine today, as they have undoubtedly changed in the last seventy years.

When I think of a good Ukrainian girl, I think of someone who is fairly devout (either Uniate Catholic or Orthdox), a virgin until she is married, and devoted to her parents and to the Ukrainian community. I feel that I have failed to meet hese criteria. I'm not religious, nor was I ever raised solely within a Ukrainian denomination. I am a lesbian, and therefore, I cannot get legally married; I also live thousands of miles away from my family in a town with few (if any) Ukrainians in it.

But my definition of what makes the perfect Ukrainian girl is molded by my biases and will certainly differ from one generation to another, from diaspora to Ukraine, and from men to women. I think that today, most Ukrainians, whether in the Ukraine or the diaspora, are so delighted to meet someone who speaks their language, who has more than a passing interest in their culture, that the other "criteria" don't really matter. I think of a friend of mine who was born Ukrainian but does not speak the language any more or practice any Ukrainian customs. Her daughter, also born of Ukrainian and American parents, is enthralled by the culture, takes Ukrainian lessons, and is constantly traveling to centers of Ukrainian culture in Canada. So who's the "real" Ukrainian girl?

So I look at my life again and can't say I've failed entirely! Within the last few years I've developed an interest in learning more about my Ukrainian roots, partly bceause I think it's important to understand where I've

come from in order to understand others and my reactions to others. And I've been trying to understand the negative feelings I had as a child and to learn not to be afraid of the "difference" within myself — whether that difference is my Ukrainian side, my lesbian side, or my American side. I miss the everyday Ukrainian customs and foods that I had as a child, and I miss Baba dearly, despite her chronic lectures! I've enjoyed reading Ukrainian books to her on tape both to entertain her and to keep up my accent. I enjoy corresponding with my relatives and hearing about their lives in the Ukraine.

I've also begun to reach out as a Ukrainian lesbian and am trying to develop a new kind of community through corresponding with other "Ukie dykes" and learning about their feelings and experiences. Through a little effort (and a letter in *Lesbian Connection*) I've discovered new friends in Santa Barbara, Australia, and Canada. I even met a gay Ukrainian Catholic priest!

I think that my family is beginning to see that there are many ways to be Ukrainian outside of the heterosexual mold, and I am proud that they compare me less often with my heterosexual peers.

TM: What are your parents' reactions to your lesbianism? How have your relatives in the Ukraine reacted?

UB: My parents' reactions were definitely more dramatic than those of my Ukrainian relatives. I'm not sure if this is because modern-day Ukrainians have more tolerance than immigrants who remember the old world, or if I'm just lucky to have accepting relatives. I think it's probably the latter as I have yet to meet a Ukrainian lesbian still living in the Ukraine!

I came out to my folks during my first year of college, when I was 18. The first thing my parents did was send me to a counselor that I'd seen in high school. She felt I was well adjusted and that my parents were the ones with a problem to solve. Indeed, the news was difficult for them to bear because I'm an only child and so all chances of grandchildren rest with me. Relations between my mother and myself became quite strained as she went through stages of self-blame, denial, and grief. At times she felt that attending PFLAG meetings were helpful, particularly as the leader of the group was also a former refugee. At other times she chose to avoid the subject as much as possible.

My father remained fairly aloof. My mother seemed to understand *how* I could have such feelings, having had strong platonic friendships with women herself, but my father has had trouble understanding my preference for women and has felt squeamish about the issue. They kept my lesbianism secret from Baba for awhile, so I was lucky to be able to approach her first. Baba was always accepting of my lesbianism, if not always in my choices of lovers! Her only concern has been that I wouldn't have a man to "take care" of me, and she feared for my loneliness as I grew older. She couldn't quite understand why I wanted to throw an opportunity for

marriage away.

Fortunately, this situation in my family has not lasted long. My parents are far more accepting now and recently invited me and my lover to spend a week with them. The only down side is that my mother strongly prefers that I not come out to the Ukrainian community because this would embarrass her and the other Ukrainians would either gossip or see my lesbianism as a sign of her failure as a mother. For this reason I have changed my name for this interview.

But hiding my lesbianism makes it extremely difficult for me to approach Ukrainian communities and feel genuine. I start to feel guilty for not allowing people to know all of me, and I find attachments difficult as I'm always wondering if the Ukrainian community would accept me if they knew who I really was.

I came out to my cousins in the summer of 1989 when they were visiting us. My lesbianism was a complete turn-on for my cousin's husband, who thought of it as some kinky perversion that he wanted to know more about. My cousin and I talked about if for some length, but I was unable to get my true meaning across to her as I don't have the vocabulary to express abstract thoughts. I didn't even know the Ukrainian word for lesbian! She does accept that I'm queer, but she has a hard time understanding the concept. She is firmly convinced that I'm gay because she thinks I've had rotten experiences with men, although I explained to her that I didn't have much personally against men. I simply identify sexually with women.

I came out anonymously to the Ukrainian community in 1991 when responding to a particularly antifeminist, anti-Semitic, and homophobic column written by Dr. Myron Kuropas in the *Ukrainian Weekly*. To my surprise my letter was not only printed, but was also accompanied by an anonymous letter written by another lesbian. Only one antilesbian letter was printed, and at least three positive letters appeared in the following weeks. So I think that the Ukrainian community's views are changing. As I mentioned above, I think that most Ukrainians care only that you care about the Ukrainian culture, and they care more about who and not what you are.

TM: Tell me more about your cousin in Kiev and your pen pal in Latvia.

UB: I first met my cousin on my trip to Kiev in the summer of 1984. Before that summer I had not known of her existence because I was unaware that my mother had two older half-brothers who were lost during the war. My family discovered my cousin and her family when we stopped at an information kiosk and looked up my half-uncle's address. Since that time I've been corresponding with her on a regular basis.

Unlike most Ukrainian women, my cousin does not work outside the home, although she used to work in a turbine factory. Part of this reason

is because she suffers from severe asthma that is exacerbated during the winter. My cousin is also fortunate that her mother lives with her and helps with the daily struggle to find food. She also helps my cousin raise her two boys.

I asked my cousin to write a few words about her situation as a modern-day Ukrainian woman. Her tone is one of extreme hopelessness. She writes:

> I am a simple person, and simple people are looked upon as trash. All the time this demeaning treatment gets a person down. We completely lose our sense of self-confidence. One loses hope in one's abilities. You feel like you are nothing, that you can't even help your own children; you can't even protect them from humiliation, because one is in the same humiliating situation. No matter how hard you try to become someone you can't, it's just not possible.
>
> In our society there are women who have achieved a certain status in life. But these women are rare. All positions of leadership are held by men. This is my opinion. In our society behind every woman stands a man. This is the father, or the husband, or lover, or mentor. What this means is you cannot make it in any other way. At first they will push you in your work, then perhaps make you a little more visible. Then, if you are a talented woman you can continue out on your own. This has been and shall be. The only equality of women is that women do the heaviest labor, the kind that's not in her physical capability. In general we have to sustain incredible injustices. I don't know if these can be fixed.

Medea is a 23-year-old Latvian lesbian who became my pen pal after I contacted her through an advertisement of the U.S.-Soviet Gay and Lesbian Pen Pal Project in March 1991. She currently lives in Riga, although she spent a few months in England in an attempt to get British citizenship so that she could continue her career as a pop singer and a model. Her artistic idol is Madonna. She has performed lip sync as a Madonna impersonator across the USSR and has been reviewed in many foreign and Soviet newspapers. Madonna is her idol because she likes "extravagant sexuality and bright individuality in a woman." One of Medea's big dreams is to live in America, specifically California, which she calls her "most favorite country." This is because she has found lesbian life in the Soviet Union a "very unhappy and lonely one." Although she has many gay male friends, she has found very few lesbians, and she prefers to meet women from other countries.

Since she was very young, she knew she was "different." She never felt completely at home or safe until her mother began to have gay males as friends. As Medea says:

> Their life is my life. I adore every one of them. I can feel good only in gay people's society. In "normal," "natural" people society I feel very bad, sad, and gloomy, because I feel that nobody understands me . . . I've been homo-

> sexual since childhood, and I'm very happy that I so long ago found my gay society. Otherwise I probably would have killed myself. "Natural" men have always wanted to sleep with me or rape me; with gay men I have always felt safe.
>
> But I hate being a woman because I've never felt like a woman. And it is a hard role for me in this life—being a woman. What I especially hate about being a woman is that every "natural" man I meet wants to sleep with me. It is very humiliating for me. But I do it because people in Riga thought I wasn't normal and wanted to put me in clinic. Therefore I *must do* it for "normal" society.

Even her appearance as a Madonna impersonator causes problems, for she doesn't dress like the "normal" Soviet woman:

> No woman looks like me in Riga. My appearance has caused big problems for me. Soviet people don't understand my style, and I can't go on the street alone. I wear clothes like Boy George and Cyndi Lauper. My hair is pink, red, yellow, blue, green, etc. Soviet people are very shocked and think I'm crazy!

Since I've begun corresponding with Medea, I've been trying to send her as much information (newspapers, magazines, books, etc.) as I can about gay and lesbian life in the United States. At the moment, however, mail delivery anywhere in the former republics is not trustworthy, so we have simply been trying to stay in contact.

TM: What do you know about Ukrainian men?

UB: Some of what I know about Ukrainian men I learned from my mother. As a child, I wondered why my mother had married an American, when all of my Ukrainian friends had Ukrainian fathers. She did not explain fully, as I was pretty young, but she made it clear to me that she did not want to be under her husband's control, and when she told me more about my grandfather, I began to understand why. My grandfather was extremely strict with his daughters. He forbade my mother to go to dances before she was 18, and he generally dictated all the rules and regulations of the household. In contrast, the women of the household did most of the work. (My grandfather had various jobs outside the home as a janitor, painter, or factory worker.) My mother also implied that my grandfather, a university-educated man, married my illiterate grandmother precisely because he knew she could never stand up to his education. My grandmother also corroborates this perception, but adds that he was always a good provider and took "good care" of her as regarded reproductive responsibilities. He didn't really try to please her sexually, however, and Baba told me that she pretty much couldn't wait for him to get off of her.

My own experiences with Ukrainian men first occurred in my childhood with immigrant men who I met through my mother's community.

As I got older, I noticed rampant sexism pervaded this community. For example, when I was about 10, I asked a friend's father if he would teach me to play chess. He kindly refused because I was a girl. I told him he must be kidding (I was attending an all-girls school at the time and wasn't familiar with such blatant sexism), but he insisted it was not a game for women. Another time the altar boys at my mother's church panicked and began yelling at me when I came too close to their sacred quarters behind the church altar.

I also had to endure numerous passes and sexist comments from young Ukrainian men who toured with us on our trip to the Ukraine in 1984. One young man kept insisting that he could "spot a queer a mile away" while simultaneously making passes at me!

Native Ukrainian men do not seem much different. Although my cousin's husband is kind and helps around the flat, he also sees no conflict of interest in having a few affairs and behaving like a real "ladies man" the moment his wife is out of his presence. He made several advances not only to me but also to my mother.

Sexism is certainly not limited to the social and familial realms. A friend of mine who attended the Harvard Ukrainian Summer Institute told me that a male professor had discouraged her from applying to a particular program, while all of the men inquiring about the program were eagerly encouraged to apply.

TM: Did you realize any Ukrainian class issue—give me an example . . . your parents?

UB: I gradually became aware of Ukrainian class issues by observing the way my middle-class friends treated my grandmother with disrespect and by the way I often felt superior to my Ukrainian friends who had a lower economic status. I went to private schools; they did not. I lived in a wealthier neighborhood. I felt less bound to the culture than they did, and thus far more cosmopolitan.

I also learned about Ukrainian class differences from my mother. For many years, I had believed that she came from a working-class background, only to find out that she vehemently denied it. Because she was poor as a child and because her family was poor in America, I had assumed that she was definitely from the working class. My mother explained, however, that her family was not working class because my grandfather had had a higher education and had come from a family of cattle ranchers who had owned their own property prior to collectivization. I didn't understand that for my mother education meant the difference in class status.

The issue is complicated because what is working class in Ukraine today by our standards is not necessarily so to Ukrainians, just as their standards of living and luxury differ from ours. I consider my cousins to be working class: my cousin's husband drives a bus, and my cousin used to work in a

factory. Yet they are economically better off than most by having their own car and a dacha.

Finally, there's always the hypocrisy of what "working class" really means in both communist and postcommunist Ukraine. Certainly, all of the country's communist leaders must have been working class in order to attain their positions of power. But "working class" is a meaningless phrase when describing leaders whose lives are luxurious compared to those of the average person. The economic gap between the two classes is not any smaller now in postcommunist Ukraine, because the people in power now are mostly former communists who still retain their former connections and privileges.

TM: What are your thoughts about the future of the former USSR, including the Ukraine as a nation, and so on?

UB: I think that the future of the Ukraine and the other former republics is shaky. I think that the Baltics may have the best chance because they were not oppressed by communism for as long, and the people there may still remember what it takes to get a market economy going. From my mother's experiences in a free Ukraine, she does not see any immediate change for the better occurring. Certainly, there is more freedom of the press, but even this freedom is not guaranteed in all circumstances, and the government controls the media more than the West would like to believe. Although he won his office last December in a generally free and fair election, President Leonid Kravchuk, the former president of the Communist party in Ukraine, is an authoritarian at heart. His government has recently hauled reporters from two newspapers into court for published criticisms of his government. Moreover, Kravchuck, through the official news agency, threatened to expel Ukrainians from the diaspora for uttering criticisms of his government during and after the World Forum of Ukrainians.

As my cousin wrote in her last letter:

> The Ukraine now exists [as a nation]. But the government is the same as before. It is not to the advantage of the people in the government to make reforms in society. These people have all been left in leadership positions. Earlier they were called "democrats" of the Communist party, and they were located in all the regions and counties of the Ukraine. Now all these people are called representatives. There are very few new people hwo are breaking through as true democrats. And it is difficult for them to make progress because they are being halted by threats.
>
> Now there is such chaos in Ukraine. Laws are not obeyed, the government is falling apart. Nobody is responsible for anything, and nobody takes care of anything. Many people are losing hope that there will ever be better times. People are just trying to exist from day to day, each person for themselves. Family members try to support one another. Survival here is very hard.

Prices for consumer goods and food are increasing exponentially, so much so that butter has gone from 6 kopeks to 400 rubles in less than a year. At this time, the exchange rate for Ukrainian coupons (the temporary currency that has been used until the new hryvnia is introduced) is 1,000 to the dollar. Inflation is increasing approximately 60 percent each month.

However, the groundwork for progress is being laid. The first wave of two groups of Peace Corps volunteers will arrive soon. One group will be teaching English in the schools and the other will be helping small businesses get started. Over seventy U.S. businesses are now investing in the Ukraine. And Ukrainians in the diaspora are mobilizing each day to bring their talents and skills back to the country they left so long ago.

TM: How have perestroika and glasnost affected the ex-Soviet society?

UB: I think that both perestroika and glasnost started the process of free thought and free speech that eventually went "out of control." I don't think that Gorbachev had any idea that his reforms would set into motion one of the largest bloodless revolutions in history, and although a part of me will always admire him for beginning the process that led to the Ukraine's freedom, I think Gorbachev would have thought twice about what he was doing had he anticipated its effects on his own power. The effects on Ukrainian society are tremendous. For example, when I visited the Ukraine in 1984, no Ukrainian native would be seen speaking to me within any vicinity of a government building or an Intourist Hotel. I remember communicating to relatives via pads of paper or following them outside the building to "have a chat." Phone conversations were always marked by the clicking sound of wiretaps.

Now hundreds of publications abound, and everyone is interested in politics. A plethora of political parties exists, although Ukrainians are still trying to understand how the process of gaining support for a party works.

Still, the effects of perestroika and glasnost are not fully realized. Economic reform is slow, and there are many former communist leaders still in positions of power that slow change by complicating bureaucracy. Most of the land is still owned by the state, and privately owned cooperatives and shops are still in the minority. Furthermore, the sense of openness that initially swept the country is diminishing as the Ukraine struggles to develop itself as a nation. For example, sometimes my taped letters to my cousin contain erasures about undesirable topics (in my case, a discussion of the recent San Francisco Gay Freedom Day). Letters have arrived torn up and obviously read. And another byproduct of corruption makes it impossible to send parcels of any worth overseas (even old clothing) as the contents are immediately ransacked and often stolen by mail personnel. I have already discussed how the government is warning citizens against the diaspora's negative influence.

TM: Now we're having a backlash against women there. The slogan "Women go home!" is being heard, and there are some new "improved" stereotypes such as beauty pageants. Do you have hope for women?

UB: I think that a *conscious* sense of feminism is not going to form quickly among Ukrainian women. First, glasnost caused the freeing up of speech and thought. Now the Ukrainian people are trying to change the basic structure of their lives: how to find work, how to buy property, and how to learn a new language (for those who live in the largely Russified eastern Ukraine). In a very real sense, Ukrainian women are busy with the process of surviving the transition from a communist to a capitalist economy. My relatives are too busy hunting for potatoes and sugar to think about organizing consciousness-raising groups—or even to protest against lack of women representatives in the Congress. Many women do not see their problems in relation to Western feminism at all. My cousin's mother read some articles from *Woman and Earth* that I had mailed to her, and she kept muttering that she didn't understand any of it.

Glasnost has also encouraged religious freedom as well as the freedom to propagate stereotypes. I know that the Ukrainian Orthodox faith is taking a stronger hold each day. It is successful not only because of cultural pride, but also because of the population's need for solace during these incredibly tumultuous times. Stereotypes are propagated through traditional Western forms as well. In *Perestroika and the Soviet Woman*, Solomea Pavlychko notes that

> This misogny appears in different forms—women's beauty and loving heart are idealized in poetry, written by men. In fiction, women are usually depicted as emotional creatures with a longing towards "true love." The walls of the subways in big cities are plastered with pornographic posters. Numerous beauty contests have become a major television entertainment . . . This list goes on. . . . [The] roots [of this phenomenon], however, lie not only in the legacy of seventy-two years of communist regimes, but also in a strong peasant ethos, in Christian traditions and in certain aspects of Ukrainian history and culture specific to a non-sovereign country (p. 84).

Another increasingly popular concept is the "ancient cult of Berehynia" which promotes the cult of the mother, the child, and the home and hearth as the Ukrainian woman's most desirable ambition. Much of the characteristics of this cult are nostalgic and remind one of Ukrainian peasant life in the small villages centuries ago. In reality, then, this concept of the "salvation of rural culture" is equated with the entire national culture, which also means that old peasant patriarchal structures are once again being encouraged and revered (p. 91).

Finally, Ukrainian women have rarely considered themselves as acting feminists in their own behalf. I think of the title of Martha Bohachevsky-Chomiak's ground-breaking work *Feminists Despite Themselves* and how

those words apply to the Ukrainian women in my life. My stoic grandmother considers herself to be devoutly religious within the patriarchal framework of Orthodoxy; she supports the idea that women should be priests. Baba also unequivocally supports a woman's right to choose, especially since her own mother died in an abortion attempt. My mother refuses to think of herself as a feminist, yet she equally refuses to remain in a traditional female role — either at work or within the Ukrainian community — and she often thinks of herself as "one of the boys." It's simply a question of perspective for both Western feminists and post–Soviet women, a perspective on issues all too familiar to all women.

11

Kira Reoutt

Kira Reoutt is a Russian American from Berkeley, California.

Tatyana Mamonova: Please tell us something about your background.

Kira Reoutt: I am a Russian American: that is to say, I was born in San Francisco, but my family is Russian. To briefly give you a sense of my family's history: My mother's mother was born in Samara, in the southern Volga region. She was roughly 7 when the Revolution occurred, and her family was essentially forced to flee from their home, as they were landowners. They headed east, through Siberia and to China. Her husband (my mother's father) was born in Harbin, China. There were many Russians in Manchuria at that time (the end of the nineteenth century and beginning of the twentieth). My mother's parents met in China, and my mother was born in Tien-Zien. Subsequently, both families came to the United States, my mother's family arriving at the beginning of World War II and my father's in 1950.

I spoke Russian before I spoke English, but once I started attending school at the age of 3, I began to speak only English. The shock of discovering that no one around me spoke Russian affected me so greatly that I decided not to speak Russian any more. All my life I've understood a modicum of Russian and could say only a few standard phrases, such as "Zdrastvuite" (hello) and "Do svidanya" (goodbye). Once I started studying at Berkeley, I decided to take up Russian. As part of my language study, I went to the Soviet Union (Leningrad) for a semester in the spring of 1987, and since I enjoyed myself so much there, I returned to Leningrad for an academic year, in 1989-90. As a result of these trips and my studies at Berkeley, I speak Russian with a fair degree of fluency. My Russian background has aided my pronunciation and my speaking ability. For instance, I speak much better than most Americans of my language level, but they may comprehend Russian better than I. Most natives can

tell fairly quickly that there is something not quite right in my speech. I emphasize all of the above because I want to make the point that I am not wholly a Russian; rather, I am a composite of an American and a Russian.

TM: How did you come to be a feminist?

KR: I don't recall a point in time when I became "interested" in feminism. I take feminism to mean that men and women are equal under law and that women should not be discriminated against in the job market, in universities, in school, in sports, or anything else. Feminism is (for lack of a better word) an "ideology," which combats sexist attitudes in all spheres of life.

I am also unable to recall when I began labeling myself a feminist; it was probably in high school and most certainly in college. I never considered myself as being inferior to men or boys in any realm, including sports or intellectual pursuits. That's not to say that there were not any boys and men who were not smarter or better at basketball, for example, nor were there no girls and women who were not smarter or more athletic then I. I just never felt that my sex put me in any sort of disadvantaged position compared to men. Of course, in the light of the existence of sexism, I am in a disadvantaged position and have faced problems owing to sexism (both in my country and abroad).

TM: What kind of experiences have you had in the former USSR?

KR: I gather that by "experiences in the USSR" you mean "experiences with sexism in the USSR"; otherwise, the question would be much too broad, and the answer would fill a novel. I have decided to list some of the remarks I heard Soviets make at various times, and for each of them I will comment briefly. Sadly, it does read like a novel—a very bad one.

"Don't sit on the grass! You'll catch cold and not be able to get pregnant." (This statement assumes we *want* to get pregnant, that to be unable to get pregnant would be tragedy for a woman. I'm not saying that it would not be awful to be unable to have children, but people there have the attitude that you will not be complete as a woman if you do not have children, yet they don't believe that the same holds true for a man. My friends and I, who were the objects of this comment, never knew that sitting on the grass could be a form of birth control.)

"Women shouldn't smoke." (This is an example of the many statements that impose different standards on men and women, with the strictest standards, of course, being placed on the women.)

"It was better before, when men could beat their wives." (This comment was made to me by an engineer/black marketeer in his early twenties. He is very polite, helps women off buses, and enjoys breakdancing.)

"She asks to be beaten: she whines and whines, he smacks her soundly, and then she shuts up and everything is fine." (This comment was made to me by a 30-year-old artist, who was talking about his neighbors in a communal apartment. I consider it a fine example of "muzhskoy um," the

masculine mind.)

"Some Azerbaijanis who used to live here threw a girl out this window. They couldn't decide who would have her, so they threw her out. She died." (I don't know how true this story is, but the striking thing was how my friend, a young man, told the story: he was actually sort of laughing as though he were amused at actions of these "wild Azerbaijanis." He stopped laughing when he saw the expression on my face—possibly because he began to have an inkling of the horror and despicableness of the situation he described.)

"Women should stay home with the children: it's more natural for them." (I repeated this comment to a friend of mine who was born in the Soviet Union, and he said he never heard anything so ludicrous, for his father took very good care of both him and his sister. He was very attentive to their needs, cooked, cleaned, and so on. But this example is an extreme rarity for men in the Soviet Union.)

"That's women's work." (This comment refers to cooking, cleaning, taking care of the children, etc., etc., etc. It is an idiotic concept, with which we are all too familiar and which is all too common in the Soviet Union. When I said that comment was insulting and condescending, my male friend replied, "It is absolutely normal here." I couldn't have put it better myself.)

"Do you knit?" (Women asked me that question sometimes and gave me the feeling that they thought that my upbringing was somehow defective in that my mother did not pass on—and indeed was incapable of teaching me—these time-honored, traditional, *feminine* arts.)

"Are you married?" (Many different people asked me this question, with various motives. But whether it was asked simply in order to get to know more about me or about America, and I said no, numerous people again gave me the feeling that I was defective. How could it be that I was 23 and unmarried?)

"I am the only woman who works in our office (the Geography Department). Who else is going to make dessert to go with the tea?" (This is what my roommate, a Bashkirka in her mid-twenties who was working on her *kandidatskaya* (Ph.D. thesis), said to me when I asked her why she was always doing such things above and beyond the call of duty for various events at work, when it was clearly making it difficult for her to complete her own work. She did not feel put upon in any way, and in fact she defended what she was doing by saying that she was grateful to her boss (a man) for letting her work there, etc.)

"We are tired of our emancipation." (Unfortunately, this is a very common statement among women. Having been convinced all their lives that their exploitation is "emancipation," they are unable to understand what true emancipation is, and it's rare that they will listen to you when you try to explain otherwise.)

"She's just a man in a skirt." (This comment was made by an artist in his late twenties about a former teacher of his, who decided at some point not to get married or have children. Instead, she devoted her life to painting. Another friend of mine—also a former student of this woman's—said that she is a "super-*khudozhnik*" (super-artist). But the fact remains that these men feel that if a woman does not do "feminine" things (at least, what they consider feminine), she is not a real woman, no matter what she looks like on the outside.)

"Women cannot create. They are of the earth and not spiritual enough creatures to create." (This statement was made by a male artist in his early thirties. When I said that he was himself quite effeminate, and asked him how that quality affected him, he said that it helps him to create. Our discussion essentially ended there.)

"I don't believe in feminism. You (in America) simply tried to turn women into men." (This is one of the common misconceptions of feminism that people, both men and women, have there (and in the United States, actually). Some others include: "feminists hate men" and "feminists are all lesbians.")

I told a friend of mine that I read an article by a woman who wants to start up a bilingual (Russian-English) feminist journal, and she said, "We really need it."

TM: What do you think of glasnost?

KR: To put it crudely, glasnost is helpful to feminists, fascists, freaks, and freemasons. (Please don't think me sarcastic; I mean the above most sincerely.) Glasnost has allowed all sorts of groups to have their say, to make a statement, to voice their opinion—no matter how serious, banal, insipid, or insane they may be.

As for feminists specifically, I can honestly say that only one woman that I knew in the ex-Soviet Union could be described as a feminist. A few other people (both women and men) could be categorized as "quasi-feminists," but the vast majority of people whom I met were sexist and antifeminist. And this vast majority was composed of people from all walks of life, of all generations, and of various ethnic backgrounds. This group includes students, graduate students, engineers, musicians, artists, black marketeers, the average Vasya and Sveta on the streets, babushki (grandmothers), and dissidents.

According to a sociologist acquaintance of mine (a woman from St. Petersburg), there are only a few small feminist groups today. Although this is hardly enough to be considered a movement, at least they are not being actively persecuted as in the recent past, and this is thanks to glasnost. Yet, also thanks to glasnost, there is a corresponding rise in antifeminist attitudes, which should be taken into consideration and which should be addressed by feminists. Among other harmful repercussions, antifeminist attitudes threaten to keep Soviet women, even more than today, from

entering into various professional fields.

In addition, there are people with different world outlooks, who label themselves "feminists"; yet some of them may not be helping women's position in society at all. For example, there was a woman mentioned in Francine du Plessix Gray's atrocious book on Soviet women. This woman said there is biological evidence that men are more "logical" than women. She kept emphasizing the differences she believed were inherent to men and women, and she essentially supported the idea that women were subservient to men in her attempts to make the argument that men and women were "equal but different." The example of segregation in America gives a stark example of the ludicrousness of this sort of theory (most especially when legislatively applied).

A clear example of an antifeminist development due to glasnost is the rise in pornography. As a male American friend of mine said about the ever-present pornography, "Glasnost has caught the Soviet Union in mid-adolescence." And this is a male-driven adolescence more than a female one, as the sharp rise in public display of female nudity and porno-films indicates.

TM: Do you see men changing there?

KR: I do not see ex-Soviet men's roles changing greatly, though I suppose I'm not qualified to answer this question since I haven't known *homoSovieticus* for very long.

The majority of men, including young men (in their mid- to late twenties), believe that women should stay at home, cook, clean, shop, and take care of the children. Because of the realities of everyday life in the Soviet Union, men who do these things do so only out of necessity. Such activities are still considered "women's work," and this prevalent term is not in the least bit derogatory. For men a certain amount of *styd* (shame) is associated with doing such work. Men say, "See what perestroika has done for us? We have to do women's work!"

Men rarely, if ever, stay home with small children—usually doing so only in special circumstances. If a man is perceived as staying home with the children (or child, as is more often the case) *more* than the woman (whether or not this is true), both women and men consider him an emasculated henpecked shadow of a man and see her as a tyrannical, selfish, career-minded *baba* (broad). A woman perceived as putting her career before her family is looked down upon. She is seen as striving for something unattainable for her, and such stepping out of bounds is viewed with great disapproval.

TM: Did you notice any feminist or women's movement there?

KR: To answer this question, I must clarify the terms *women's movement* and *feminist movement*. While there is some overlap, the two are not necessarily the same. In the United States, these two terms can in most cases be used interchangeably, but in the CIS they cannot; and this is

because the words *feministicheskaya* and *zhenskaya* have very different connotations. These differences are, in part, due to a lack of feminist critique and vocabulary in Russian, which I will elaborate on later.

Those women, some of whom may call themselves "feminists," who support women by encouraging them to stay home and conform to their so-called natures, could be considered part of a women's movement, but they are most definitely *not* feminists and not part of a feminist movement. A feminist movement is one that supports women's desires and attempts to enter into realms that they have been traditionally barred from entering due to sexism. A feminist movement tries to combat sexism in all spheres of life and prevent discrimination against women on the basis of their sex. To give further example as to how a women's movement and a feminist movement differ: a women's movement may back the idea that women should not work night-shifts or work with hazardous chemicals, and such a movement might seek legislation to bar women from such labor. A feminist movement should support neither the enforcement of women into such labor nor the barring of women from it. A feminist movement would seek to inform women of the risks and hazards they will face (as women) in such jobs, but allow the individual women to make their own decisions as to whether or not they want to work at such a position. (Of course, this is assuming some choice is available.)

People do not believe that a *feminist* can exist — that is, a male feminist. "Sexism" doesn't really exist as a concept in people's consciousness, and most people have never heard the word. The definition and understanding of the word "emancipation" has been completely warped as it is more often used to mean its antonym or "exploitation." The idea of consciousness-raising is completely alien in the CIS. The perceived dichotomy between women and men is reflected in the words people use, such as *muzhskoy um* (masculine mind), *zhenskaya intuitsiya* (female intuition), and *zhenskaya/muzhskaya rabota* (women's/men's work). Soviet feminists must begin developing a vocabulary, and make others accept and understand it, in order to begin changing people's sexist perceptions.

TM: What do you think about the future of Russia?

KR: The communist government is no longer considered legitimate by a vast number of ex-Soviets, and this attitude further undermines the workings of the state. This, in turn, makes the lot of the people worse since so much in that country is either state-owned or regulated by the state. As their lot worsens, people support the state even less than before, and so on. This is a vicious circle due to the fact that the communists do not command full authority. People do not have faith in the government, and rightly so. I don't believe the communists will regain the authority they once had. And I don't see the Communist party becoming "revolutionary," which may be what Gorbachev was attempting at the beginning of perestroika, but as recent events show, he has failed to achieve this.

Ideally, the communist government should be replaced with a government that is able to command authority by being perceived as legitimate by a majority of the people. Will this happen? When will it happen? How will it happen? And what form will this government take? We can only speculate on the answers to these questions.

The rise of nationalism can conceivably be a great detriment to the women's movement because it will further split them apart from one another. In a way, I think the rise in nationalism can actually help Russia, if Russia is able to develop lateral ties with the other republics (which would require at least partial, if not total, dismantling of the central government), and is able to stop supporting others and start supporting its own populace.

The increase in religiosity is also a problem, for most all religions traditionally espouse a subservient role for women. I don't want to say that people should not be Orthodox, Catholic, Muslim, Jewish, or Buddhist, but that with the absence of a feminist critique of these religions and without exposing their patriarchal elements, women who take up these religions are doomed to continue playing subservient roles in the family and in society.

The economic situation is, of course, not helping anyone, least of all women. I don't think I need to expound on this further.

Last but not least, I would like to add that women's movements which seek the support of the state, that is, of a strong central government, are making a mistake. For one, the central government commands very little authority today, and if the political and economic situation worsens, the government's authority will continue to decrease. Thus, it will not be able to effect real change for women. Even more importantly, there are few women within that power structure, and to depend on the "benevolence" of patriarchal structures is a mistake. Women will have to seek ways to improve their lot themselves.

12

Olga Filippova

Olga Filippova is a student from Kohtla-Yarve, Estonia.

Tatyana Mamonova: Olga, you're 20 years old. Could you describe what life is like for people your age?

Olga Filippova: Before describing the life they lead in the former USSR under the present circumstances, I must point out and briefly sketch what these circumstances are and the basis on which today's youth was raised. A completely unnatural situation had developed—ideology, not culture, had become the main determinant in the education of younger generations.

Ideology permeated the school system, which was essentially ordered in such a way that not a single subject could be taught without a heavy ideological burden. All textbooks were written along these lines, all methodologies were worked out along them, and the administrative system's work corresponded to them. At times, the possibility of any free expression of human spirit was completely precluded. And culture is impossible without freedom; under such conditions it withers and, of course, dies. People were told over and over again, for years, how vital it was to satisfy the human being's ever-increasing needs—the needs of that same Soviet person, who in reality wasn't allowed anywhere near the world of satisfaction. And all that was achieved by this was the creation of a whole generation of young people (22 to 25 years old) who aren't interested in anything, least of all in the problems of production. These are highly educated people, but what are they doing now? Having qualified in medicine, energetics, and teaching, they're now working as taxi drivers, porters, waiters, and fire fighters. Why? Because when they began their studies, they thought there was nothing more honorable than the calling of a doctor, a miner, a teacher! And if it paid peanuts, and you had nothing to live on—so what? We were all building the bright communist future.

And then, when this so-called perestroika opened their eyes to everything, it turned out that the main difference between here and the West is that there they work in order to live, and here we live in order to work. The concept of making money easily has led to the degradation of a whole generation of young people. What can you say of a society where a teacher washes dishes and a doctor minds the door? And yet these young people often say that they don't feel at all humiliated. What concerns them is money and how to make it, but this is cheap and dirty money — racketeering, prostitution, speculating, and so on. One can try to explain this. In my opinion, pre-perestroika society, which was oriented only toward the rational level of consciousness, reached the point where it encouraged a warped worldview from earliest childhood; growing up, people couldn't attain success, harmony, or even a state where they could be at peace with reality, no matter how much they desired it.

And if I've started dividing our young people into cultural/age categories, then the second one must contain those aged 16 or 17, senior school students. With a few exceptions, they are also a lost generation, people without a present. They don't want to study, because our government has started thinking of bringing in foes for education, and they're generally incapable of worrying about money. They are spiritually impoverished, preferring simplistic detective novels to the works of Dostoevsky, silly comedies to the masterpieces of Tarkovsky, three-chord ditties to Mozart and Prokofiev. I called them people without a present, but they're also people without a future; rejecting many of yesterday's dogmas, they've unfortunately turned to new errors. Delighted that they no longer have to zealously rote-learn history and social studies, they've decided for themselves to reject all other social sciences. It's completely absurd — they have no educational foundations. The old saying may be forgotten, but it's still true: people's strength is in their knowledge! Ask them what they want, what concerns them, and in monosyllables, they'll reply: music and sex. That's all!

There's a third category of ex-Soviet youth — the students. Although all of us were raised in the era of militant socialism, there was a timely transition to reality and awakening, when everyone still needed everything, although for set reasons. These are educated people, who with few exceptions are studying at universities and institutes; besides sex and music, they're interested in sport, politics, history, languages, literature, and art. Having evaluated the situation, as the whole country was doing, the ordinary student was no different from the teacher — everyone was on the same level, and it was this absorption and sorting of new ideas that led to the development of new personalities. It's this segment of youth which has above-average educational and cultural qualifications. It's they who play tennis in their spare time, spend hours in libraries, and would never confuse Gogol with Hegel. In conclusion, I would like to say — and this is

only my opinion—that the desire to think and dream has been absolutely suppressed in young people. They're afraid of teaching us to compare, contrast, and analyze events. Someone must want us to grow up into stupid bourgeois consumers, apolitical and uninterested in anything besides possessions and entertainment, because as long as people are stupid, they can be fooled.

TM: What do you think of perestroika and glasnost?

OF: What have they actually done for me? First of all, I realized that I'd had enough of living according to slogans, constantly creating one mythical blessing after another. After all, a person wants to be happy now, today, not in the next life or in another world; a person wants to finally feel emancipated and free. All of this led me to change faculties.

On leaving school, we are all on about the same level. I say "about the same" because some of us have cherished career hopes for years, while others don't care what they go on to study. I'd always wanted to be a mathematician. But we all learn by trial and error; I realized that I would never make a very good mathematician and wouldn't make any money being a bad one, so I decided to try another field.

Glasnost has given us much. A wealth of wonderful, previously forbidden writing has been opened to us, both literature and journalism. I've realized that this is a world of amazing variety—in color, in form, in sound, in texture, in all other aspects—and, of course, one's perception of it is equally varied. I learned that I couldn't permit them to foist on me the idea that there exists a single correct Marxist philosophy that holds the answers to all problems of existence. And finally, I understood that one can't shut oneself off from the greater system of humanist values and ideals.

TM: Do you feel that your life, as a woman, is better than your mother's was in her youth?

OF: That's a complicated question, insofar as everything is relative. However, if I look back from my present viewpoint, then it's clear that my life is better. I'm completely financially secure, and I can choose one or more fields of higher education, even if they bring in fees for it. I spend more time on myself: on my health, my appearance, sport, art, languages, and so on.

TM: What do you think of fees for education?

OF: Unfortunately, I don't have a very clear idea of what changes will take place if fee-based education is introduced, as this doesn't seem possible in the former USSR. But what are the colleges doing now? Battling for equipment and facilities, fighting the bureaucracy and regulations. And the students? Searching for all possible and impossible sources of income. Quite often, education takes second place.

TM: Do you believe in profit-based institutions?

OF: Only under those conditions can the shameful oversupply of specialists be halted. They're the ones who can't find jobs in their own field

and end up working as taxi drivers, waiters, yard-keepers. Long before graduation, students will be confident of employment in their chosen line of work once they have their diploma. And the enterprise, having paid for the education, will have an interest in creating for graduates all necessary conditions for productive work. A tertiary institution's development will be determined by the real demand for specialists in various fields, rather than by directives from above. There are some other forms of fee-based education which may be appropriate for the former USSR.

TM: Tell us about your own education.

OF: Will I get the full benefit from my education? Of course, I will; although Tartuss University may lag behind some European universities, by comparison with the rest of our country it's high on prestige and perspectives. As for the learning I acquire at the university, much depends on me; in part, it's vital for me to know English, in order to read literature which I otherwise wouldn't have access to.

My whole future depends on the qualifications I will get in law and economics, which will form the base for graduate study, and hence of my future career.

TM: Is it possible for sexism to have an impact on your plans?

OF: Not really. For example, I want to enter the Law Faculty this year, and I believe my plans are quite feasible. So I will be studying in two faculties, law and economics, as well as doing some external legal studies. Afterward, I will attend graduate school and eventually get into international commercial law. If I have such an excellent education, and I'm a good specialist, as well as being a charming woman, how can the fact that I'm a woman possibly harm my career?

TM: Have you encountered any stereotypes?

OF: The force of stereotypes is rather like the force of gravity: for many years it has enabled us to know without seeing, to judge without thinking, to decide without analyzing. But these are new times, with a new way of thinking—we're starting to glimpse the faces behind the masks.

TM: How much do you know about Americans?

OF: We have much in common with Americans, but we are also quite different. For example, smiles and friendliness are as plentiful as goods in America. Every American is born with the firm resolve to become a millionaire. Business is democratic, so if a person helps the corporation to flourish, they try to keep him, whether he is a Jew, a Turk, or a black. Whereas here . . . some people blame Jews for everything from bad weather to meat shortages; others hate Armenians; still others prefer to have nothing to do with Muslims; in some republics they see Russians as occupiers; and so on.

I think the greatest characteristic of Americans is charity. In America it's become the norm to give to the poor, to education, to the arts, to

medicine.

As for what we have in common, it's youth problems: drugs and so on. Our young people are little different from those in America, apart from being greater layabouts and poor organizers of their leisure time.

TM: What would you like your future to hold, professionally and personally?

OF: In the future I'd like to work in the field of international commercial law, to build a career in this field. Personally, I'd like to be happily married to a very clever man, own a home with a greenhouse, and bake pies for my grandchildren.

TM: What would you like to say to Americans?

OF: Excuse the paraphrasing, but he who has eyes will see, he who has ears will hear, and he who has a mind. . . .

There's one subject common to all religions, but best known to us from Greek mythology. Chronos deposed his father Uranus from the heavenly throne, castrated him, took his life, and lay with his mother, the Earth. And Chronos was mortally afraid of the younger generations who were to replace him; together with his league of Atlanteans, he preserved the order he had created with the help of just two "harmless" methods: forbidding thought, and devouring his own children. And it seemed like this would go on until eternity. However, we know that Zeus, with Gaia's help, would rise against his father and defeat him.

But let's not forget that it was this very same Zeus who would punish Prometheus for giving people the gift of fire.

13

Galya Lanskaya

Galya Lanskaya is a psychotherapist and singer from St. Petersburg.

Tatyana Mamonova: You give the impression of being a very busy person, always giving lectures and concerts.

Galya Lanskaya: You too probably lead a fascinating and interesting life. I'm almost never at home, there's a portable stove in my kitchen just in case, but I have no time for cooking. Last year in Germany, I organized a delegation for the first international congress on parapsychology to be held in Russian Ecoenergetics—Bioenergetics. Although I initiated the project, the editor of a German newspaper, having made his profit, placed my eminent surname at the very end of the list of coordinators. The Academy of Sciences had appealed to me directly as a parapsychologist to get the whole ball rolling, and he alone reaped the fruits of my labor.

TM: Have you tried working with women?

GL: I am a feminist, have contacts here with German feminists, and should you have any questions for them I'll arrange things.

TM: Thank you. Now, what changes have occurred in Russia?

GL: Tatyana, speaking as a friend—people have changed incredibly! That is, all of the negative traits seem to have drifted to the surface. Nowadays, even between girlfriends there is a price fixed on information concerning the whereabouts of sausage and cheese for sale. People's characters are changing unbelievably. Clearly, all this chaos destablizes the psyche. On the other hand, freedom in the area of mysticism is unusually great, which gladdens me very much. This year I attended the opening of the first theosophic forum in Russia. I dropped everything in Germany, flew off to celebrate this new spiritual freedom, then did an article about the forum for a German magazine. Attending the theosophical forum were businessmen, doctors, engineers, politicians, and Krishnas from

Australia. I truly hope the new consciousness or 21st century belief in a "superior intelligence" in the Cosmos will eventually prevail in all of our minds, since all other religions, while in essence preaching one and the same thing, nonetheless nurture dissension among people. In the outlying areas of Russia people are brimming over with aggression, especially in Georgia, Osetia, and Armenia. People want to fight. The terrible situation in Yugoslavia should have been example enough. By the way, the new consciousness assigns a major role to women, as the harbingers of Enlightenment and Harmony, of Creation, rather than Destruction. The woman is expected to assume a leading role in politics and economics, for she possesses a keener intuition and the talent for constructive problem solving.

TM: What do you think about the relationship between men and women in the family? Tell me about your own background.

GL: After thirteen years in a marriage where all the decisions were made by my husband, I decided to divorce and take charge of my own fate, at my own discretion. I look like I am 35; what is on my passport isn't important for now, I've no plans to marry. My lover, possibly my future husband is from the Ukraine. I have known him for two years. He is 18 years younger than I am. He is a talented hard-rock bass player. I am in the process right now of negotiating a film on this theme. I want to speak with Alla Surikova; she has played in several successful comedies. I'd also like to do a rock-comedy with a Russian-German theme. I've already made arrangements with a certain well-known film producer about a possible cooperative venture, however I suspect it won't prove profitable for Alla Surikova. In Moscow, I have plans to discuss my ideas and will request some scenes along these ideas. In Russia a significant age difference between marriage partners is viewed as unusual — something in which only very well-to-do women can indulge themselves. In the West, it is my impression this is becoming more widely accepted. In Petersburg I have been attempting to reconstruct the genealogical roots of my father, who was arrested three months before my birth. The surname, as you well know, originates in the nobility class and I hope I'll manage to uncover all the data.

TM: I wish you luck. How do you see women's position in today's Russia?

GL: In my opinion, it is horrible. First of all, women are aging terribly fast as a result of the stressful life. At forty years of age they have already gotten fat and let themselves go. This applies primarily to the working class contingent. The intelligentsia, despite the horrors of everyday life, are still hanging in there. In one family with four children, a forty-year-old wife, mother, and graduate of law school, looks wonderful. She is a tall, lovely figure, free of excess fat rolls. The kids jump around and play like rabbits, and she keeps apologizing for the torn wallpaper in the

bathroom, and the closeness of her two bedroom apartment. Her husband is a docent at a university department of law, and I'm looking at her as though she were a saint. How she manages to appear so radiant, look so beautiful, is unfathomable. Moreover, this young wife, younger than her husband by ten years, is clearly the one calling the shots at home. In general, I see this regularly. The woman is the one who sets the tone in the Russian family. Outside of the home, however, there are few women involved in politics. I've been watching for their appearance in the so-called parliament, but there simply are no powerful and strong-willed women there! I'm all for the power given American women! I have thought about returning to Russia and getting into politics. After all, I possess an absolutely phenomenal capability for stress endurance. They speak of me there as having an iron constitution, but it's all quite simple. I, getting low on energy, recharge myself automatically by means of the Cosmos using the *chakras*, those mysterious energy centers in the human being. As soon as the intellect, more exactly, rational thought, this being somewhat or maybe even very cynical, takes control, the link to the Cosmos is severed and you are left alone to struggle, with only your personal resources for strength available. It is precisely on this theme of the regulation and channeling of bioenergy between the *chakras* that I do lectures, conduct seminars. It is especially important for the person under extraordinary stress to be aware of the positions within the body of the *chakras*, and the means for self-regulation of energy through them.

TM: How might it be possible to change the situation of women in Russia? Solely by cosmic means?

GL: The situation could be improved upon by raising the standard of living. In the West a forty-year-old woman enjoys her second youth. The children are all grown, she's wonderfully preserved, there are places for her to go, any number of possibilities for entertainment for a single woman. In Russia these factors are absent. True, the role of acquaintanceships, which until very recently were also impossible, has escalated in importance by leaps and bounds. I also wrote mec'e Golitsyn in Moscow, I hope it gets there. In general now, after my divorce, I had hoped to find myself a Russian seeing as how before my last husband — the German — I had been married to a Finn and a Pole (obviously some sort of subconscious interest in cultural anthropology is being expressed here). In Finland, I completed a degree in ethnography at the University, but nonetheless it is nearly impossible to find gentlemen in Russia. They were all done in during my youth, and now even more so. A man who will be considerate enough to phone home while away on a business trip, who can cook, who knows how to hold out a coat for his woman, kiss her hand, give her a compliment — all this went out with Russia's past. On the faces of these descendants of the aristocracy is a Soviet expression — this is not the refined aristocratic spirit our ancestors wore, but rather some sort of

plebeian contempt for people.

TM: How do you view the future Russia?

GL: I don't think there will be a civil war, however, I do expect the lumpen-proletariat to wage an attack upon the more privileged class. Rioting and slaughter will provide the military with an excuse for taking the power into its own hands. It could happen that a military dictatorship with a bourgeois-democratic slant would then be established.

TM: Do you plan to return there?

GL: I think that I must return to Russia. While there are people there like my friends, it is still possible to fight for things. However, I can't do that right now. I have a thirteen-year-old son, a highly intelligent boy. I have already experimented with leaving him alone at a boarding school, where he received no word from me for a long time. Upon our reunion the effects of this were quite evident in him. No matter what kind of boarding school it might be, emotional and spiritual energy are vital to the child, especially since his father is also continuously on the road. He has his own "Industry-consulting" company.

TM: Did perestroika and glasnost' serve the desired results?

GL: First of all, Russians already loathe that word "perestroika." They don't wish to hear it anymore. Everything is already rebuilt, that is, *reordered*, but there is no order in any of it. I see that Russians are terribly lazy, they themselves create the chaos that surrounds them, then wait for assistance from others. Whenever I start saying to them that discipline, a surrounding sense of orderliness, and collaboration play a tremendous role in the success rate, people start answering me: "We're poor, we're fighting for base survival, when the stores are stocked again, then we'll start creating a deserving order about ourselves both outside the home and within". . . . A spiritual vacuum emits destructive radiation. With respect to glasnost, all kinds of sad changes are now taking place. Intelligent and powerful people, respectable folk, are now becoming disturbed. Opportunism continues to enjoy success among those in power. For example, when I asked the deputies why, to this day, they have never questioned the disappearance of all that money collected during the international marathon, he had no answer. Foreigners, in grand demonstrations of generosity, wrote checks, sometimes up to one million marks, as did one particular guest from Hamburg, for the restoration of architectural monuments in Petersburg. They collected the bucks, but no one knows where or to whom they all went.

TM: How is democracy understood there?

GL: Just recently when I was returning to Germany from Russia a few of my Russian friends traveled with me. Like an idiot, I had them riding with me in my Mercedes with the German plates, and it was precisely this fact that so infuriated the customs agents that they robbed my Russian friends as if they had been prisoners. Again, this is democracy. . . . Now

they are raising the cost of train tickets in accordance with western prices, meaning the little guy, who thought he might be smart enough to travel abroad for some trading to help out the family budget, can discard that notion, or at very least, must travel significantly less often to the West. Everything is done so that the poor find it harder to live. The only thing, and I always notice this with great joy, is that people have stopped being afraid to state an opinion. However, under certain circumstances connected with government-funded trips abroad, people remain afraid to speak openly.

TM: Please tell me a little about your healing practice.

GL: I have always wanted to help people, therefore at one point I completed a physician's assistant degree at the Oncological Institute. Once I had glimpsed all the horrors of cancer however, I decided to complete my studies in the department of history and philology and to start working as a journalist. This took place after I'd completed an M.A. in Finland. Having done a year at the radio station, I left to teach the Russian language in schools. While studying in Finland, I had to supplement my income with singing. My wealthy Finnish husband didn't feel like helping out his independent Russian wife. I also appeared in concert in Germany. My German husband was a wonderful pianist who well understood the Russian romance. He recorded some new arrangements for the organ, thus originated the record "Russian City Songs"; it has been sold out. Now "Melodia" is producing a second record "Moya Nostalgia."

14

Svetlana Tabolkina

Svetlana Tabolkina is a technician from Donietsk, the Ukraine.

Tatyana Mamonova: So you're 23 years old, and you've recently graduated from technical college. Could you tell us what life is like for young people today?

Svetlana Tabolkina: Young people's lives vary just as much as anyone else's. And life is different for people in different layers of society. Everything depends on your environment. I can only speak of the other young people I know; for my acquaintances, the main thing in life is having a good family. And after getting married, it's as if they get locked into their family. Their main concerns become those relating to their family and home. Everything else takes second place.

More and more people have been getting interested in politics lately, both internal and external politics. New parties have been appearing, so now everyone who wants to be active can choose a party that corresponds to their views. Life has become freer. And the concept of free love predominates among most young people today: that is, having no obligations to each other.

Life is generally diverse; some people have it easy, others don't. If a person has money, life is obviously easier for them; these days money can do almost anything. But basically, we get by.

TM: How have people's lives changed over the past few years?

ST: I think life has changed for every person in our country.

What's changed for me? Well, I never used to read the papers, especially the political pages. Now I'm interested in the news, especially with regard to our country, and I've become interested in its history. I used to know history from 1917 onward; anything earlier, I knew very superficially, and nowhere could I find out more. But now lots of books and other materials about history have appeared.

Besides that, I've dropped out of the Komsomol (Communist Youth League). I never would have done that before perestroika, because it would have led to a lot of unpleasantness and difficulties for me. But now it's normal. Apart from this, personally speaking, nothing much has changed.

TM: How is your youth different from your mother's?

ST: I can't say for sure that life for me is better than it was for my mother. Of course, it's better materially. And it's better in that we can say what we think, without fear that punishment will follow.

But I know from my parents' stories that life used to be happier and that people were kinder to each other. Many holidays have lost their attraction for us today. In the past, people used to get together and have fun on a holiday; these days, everyone tries to sit at home watching television. And it's not only on holidays — every day, people just try to get home as fast as they can — the men, in order to lie on the couch and read the paper; the women, in order to buy groceries.

There's almost nowhere for young people of my age to go, except for the cinema and restaurants. But you need a lot of money to go to a restaurant, and not everyone has enough. So that leaves the cinema. Sometimes I wish I were living in the 1950s or 1960s.

TM: So what do you do in your spare time?

ST: I read various books; I try to be more aware of current events. I'd really like to learn English, but I haven't been very successful. Of course, we have courses where one can learn, but they're too expensive for me. That's why I'm trying to learn it on my own, as best I can.

TM: What do you think of Soviet education?

ST: I think it's good that there's freedom of education in our country. Everyone can study where they like; and in life you need either knowledge or money. If you have knowledge, you can do without money; if you have money, you can get by without knowledge. Education is free for us, though now in some colleges they're bringing in fees; that never used to happen. It's too bad that we still don't have any private schools; I think we need them. There should be different kinds of schools — lyceums (secondary schools), girls' schools; they're only just beginning to appear. Of course, there should be freedom of choice in education; I think that's important for everyone.

TM: Do you intend to study any further?

ST: I've completed my studies at the technical college, and for me that's enough. I have a good job and I like it. At this stage, I don't intend to change it; if I need to change jobs in the future, and my skills are insufficient, I'll go back to study. It's never too late to learn. At the moment, everything suits me fine.

TM: Do you like your profession?

ST: I consider it a woman's profession. It's not hard; it's mostly paperwork. I think the main thing for a woman is that her work should

not be too hard, and that she should feel first and foremost like a woman, not like some kind of machine.

TM: What do you think of young Americans?

ST: It seems to me that we're not at all like Americans. We have a different way of life, and this fixes its stamp on people's character and behavior. Last year an American exhibition was held in our city; most of all, I liked the girls and guys who were telling us about America— especially their faces. They all smiled at us. Our people's faces are all sort of grim and preoccupied with something or other. It seems to me that Americans are more uninhibited and independent than we are. Their outward appearance is also different. But I don't really know enough Americans to answer the question. Americans always used to be criticized here; now they're usually praised. It's hard to tell what's true and what's not.

TM: Do you have any message for young people in America?

ST: I'd like to correspond with one or two American girls. And I'd like to learn more about the people of America: how they live, what their interests are, what's important to them.

TM: Could you tell us about your homeland?

ST: Do you mean, about Russia? I live in the Ukraine and feel closer to it, but I am Russian.

I think that now is not the best of times for Russia; much of what used to be a source of pride has now disappeared forever. But each of us still hopes that a lucky star will one day shine on us.

Проект Храма Богини Земли
май 1991 — 93

Четыре портрета
Женщина Юга, Севера, Востока и Запада

15

Galina Vinogradova

Galina Vinogradova is a translator from St. Petersburg.

Tatyana Mamonova: What is your background?
Galina Vinogradova: I was born in 1944 during the evacuation when my mother was forced to leave the blockaded city of Leningrad by way of a road across the ice. The first, most horrible winter of the blockade, 1941-42, she spent in Leningrad. She got sick and with great difficulty got herself into a car that was leaving the city across the ice of frozen Lake Ladoga. She miraculously survived and returned to Leningrad in May 1944, about a month after I was born. My father was fighting at the front and made it to Berlin, where he worked in a mobile hospital as a doctor and surgeon. In 1948 he and my mother got divorced.

TM: What kind of education did you receive?
GV: Beginning in May 1944 I lived in Leningrad. I went to school, then to the Leningrad Pedagogical Institute named after Herzen. As for my career, I am an English teacher. I have worked as a tutor in a kindergarten, done written translations, and was a leader of the Workers' Union at the Intourist Hotel, where about 1,300 people worked, primarily women.

TM: What is your current family situation?
GV: I'm married now. My husband, Aleksandr Sergeevich Babkin, was born in Yugoslavia in a Russian family, which left Russia in 1920. He studied in Canada and has been living in America for thirty years. I have a daughter, Katya, who is 19 years old. She studies at an American university. She would like to return to Russia after she graduates.

TM: You're interested in parapsychology; what do you enjoy about it?
GV: Until 1985 in the Soviet Union, the notion of parapsychology did not even have the right to exist. Only psychiatry existed, and psychiatry as a subject that was studied in the institutes only from the Marxist point of

view. I've always liked forbidden things. That's evident in the fact that at home we always listened to the BBC and other radio stations, as my mother listened everyday, although one time it was thought that there was no longer a need to listen to broadcasts. After glasnost, all of the newspapers and magazines quickly began to fill up with articles on "paranormal substance." My friend lives in England in the town of Glastonbury, which is a well known center for various kinds of paranormal phenomena. She became interested in what is happening in Russia and asked me to gather material for a book entitled *Paranormal Phenomena in Russia*. The collection of materials brought me to an understanding of various phenomena, which occur in our country. To me it seems necessary to know how to differentiate between things that exist independently of social change, or between something that has always been popular tradition and something that arises as a tribute to fashion or as a means to earn money and the like. This is, of course, a very difficult problem, and I can't say that I'm able to do it.

TM: What did you sense at the time of the coup in August 1991? You were in the Soviet Union then.

GV: I felt horror and despair, in that I understood that the miracle didn't occur. Nobody from the old regime had abandoned their position, and they would fight to the end. The Soviet bureaucracy had enough time to entangle the entire society like a cocoon; yet even worse, the fruits of its work turned out to be very effective, unlike the economy, agriculture, and other sectors. The ability to survive, to find yourself a place, is a demonstration of a very strong desire and strong connections between oneself and ordinary people, who are used in such goals. Now in place of the old Bolsheviks come the new, energetic, young communist leaders, who were brought up in the period when the only opportunity to survive was to please those in higher positions. This is exactly how Gorbachev came to power, and Yeltsin as well, as he believed in Gorbachev and wanted to please him and to free Moscow from corruption. In the end, however, it wasn't necessary, because the people who supported Gorbachev were those whom we saw on television during the time of the coup on August 21. Furthermore, I'm afraid that control of nuclear capabilities could fall into unreliable hands or be sold to Arabic nations for hard currency, which is completely unnecessary; that is what is most frightening.

TM: What is your view on the future of the former Soviet Union? It seems that here we should discuss the Commonwealth.

GV: In my opinion, the Soviet Union never really existed. There was just a huge Soviet empire that provided opportunity for a certain sphere of society, but it allowed limited power and welfare and would never give all that was asked of it, that is, a regime quick to punish and reward. Everyone knows that. I remember Gorbachev's horror, his scream and his distorted face, when he found out that Estonia, Latvia, and Lithuania no

longer wanted to live in his paradise of perestroika.

What we have now is a continuation of the process initiated by Gorbachev. Some people accuse Gorbachev of destroying the country. I think that he could not prevent this destruction. It was an inevitable process. As soon as we were told that something was possible, we ran even faster to secure ourselves a "place under the sun." So the former chairmen of the People's Soviets (councils) immediately organized elections and appointed themselves as presidents. As far as the people are concerned, no one seems to care. I'm absolutely positive that people don't even understand what is going on. They got used to constant structural changes, even though some of them don't object to the closing borders between republics, because they earn a profit from it. But the more simple people believe that this is a way to secure a supply of food and goods for themselves.

TM: Will the free market play the same role in Russia as it does in the West?

GV: I believe that the free market has always existed under Soviet power. There has always been street vending, and people have always illegally traded all kinds of goods. Furthermore, there has consistently been a problem with deficits, and customers know that in order to get something you've got to pay more. So this kind of buying and dealing is an established practice. The free market of the West will only emerge in Russia with privatization, when large numbers of people lose their property and subsequently realize that they must work harder and earn more money in order to support themselves well. I am afraid that the above-mentioned bureaucracy will continue to slow the development of free enterprise for a long time. Eventually, it will no longer be needed, and those bureaucrats will have to find work. Moreover, a notion of capitalism emerged at the turn of the century in Russia and has been largely created and supported in films and literature.

TM: What do you think of the Russian Orthodox church?

GV: I think that people who actually go to church could better answer this question. I believe that the church's growing role in society can be explained by the fact that our bureaucracy cannot maintain all the power, and its ideology does not interest anyone any more. I mean that the people are so fed up with the notion of communist and socialist ideology that the idea of religion is something different for them. I know that the people around me who were openly religious have embraced religion in order to "find their place under the sun." I don't like it when new leaders purposely go to church on holy days, and then they are shown worshiping on television. I believe that religion and faith are private matters and should not be announced to the whole world. These same leaders used to go to Lenin's mausoleum, and now they attend church services. When you get close to them, you see that their bodyguards are the same.

I know an instance of children returning home from school and that their entire class was baptized that day and that they were told to go to church on Sunday. This reminds me of the Communist Pioneer groups. The communist leaders who are shown in the church on holy days in fact do nothing for the church. They do not even encourage the people to help the church or to give anything at all for the sake of the church. That is, they use these new symbols in their own self-interest. One can only hope that this charade will soon end and that the church will be able to get rid of its new "friends." It will do what it must, and people will then truly have freedom of choice to go or not to go to the church, synagogue, or Catholic masses.

TM: What are your personal plans?

GV: I was not planning to stay in America. I came here to help my daughter get into the university, but something didn't work out, because someone promised and then didn't help us. My plans then changed, and I wound up staying here longer than I'd expected. Then I got married, and now I'm waiting to get a green card so that I may visit Russia.

16

Remo Kandibrat

Remo Kandibrat is a Jewish lawyer from Minsk, Byelorussia.

Tatyana Mamonova: What's it like for older people in the ex-USSR?

Remo Kandibrat: Well, first of all, the pension benefit is very low. Let me give you an example from my own family's experience: for many years, my mother received a monthly pension of 52 rubles. Without my help, she couldn't have paid the rent or bought groceries and food. But 52 rubles isn't the lowest pension level; I know some used to get 26 rubles or less. Second, the government is not really concerned about senior citizens who live alone, or are ill—though there's a lot of talk about them. "Vzgliad," a TV program (which has now, alas, been banned), repeatedly covered the disgraceful conditions in old people's homes and poverty among lone pensioners.

I can give a personal example. In June 1988 I noticed a swelling around my thyroid, and I also rapidly developed polyarthritis (due to the effects of Chernobyl). Over the next eighteen months I was hospitalized for treatment in Minsk four times, for a month each time. The doctors tried to put me on my feet again, to relieve my suffering, but without success. When I came home from the hospital I couldn't manage on my own, because of joint pain in my arms and legs. I was forced to turn to SoBes, the welfare authorities, requesting them to assign someone to at least do the shopping for me once a week. They refused, on the grounds that I had a daughter living in the same city. I explained that my daughter was working and had two young children, one of whom was very ill; but I still received no help, free or otherwise.

On February 7, 1990, I arrived in the United States on a direct flight from Moscow to New York. I could neither stand nor sit on the plane, I had to lie down for the whole flight. At JFK Airport I was taken to a car by wheelchair and carried from the car into my sister's Fairfield home.

Here, in the USA, the hospital waived the fee so I received free, qualified medical treatment, which literally put me on my feet. My thyroid gland was also healed without surgery. Now, I had worked honestly in the ex-USSR for forty years — but when I needed moral and physical support, I received it from neither the government nor society. And out of all the money I earned over those years, I was only permitted to exchange $145, which I brought to the United States.

The customs inspection at Sheremetievo Airport (Moscow) is bad by any standards. A person's dignity is crushed by the shameless attitude of the inspectors. Americans find it hard to understand how people can be forbidden to take out items that have been in their families for generations, personal things made of silver or gold, antiques, or even just a string of pearls or turquoise.

TM: What do you think of perestroika and glasnost?

RK: They have helped me to read works by formerly forbidden writers such as Solzhenitsyn, Pasternak, Grossman, Voinovich, and others. I was able to leave this uncivilized country, which, paradoxically, has so many talented people making their way with difficulty through the general grey mass.

TM: Have you encountered anti-Semitism?

RK: Unfortunately, it's been on the rise in recent times. Rumors of impending pogroms on Jews made it impossible to live in peace. In the apartment block where I lived there were no other Jewish families. Most people had come from Byelorussian villages. I often heard fights and bad language. I was especially afraid of my upstairs neighbor; he would often get drunk and beat up his wife and children, and make unflattering comments in my direction. I was asked more than once when I would be leaving for my Israel. Quite often I was afraid to go outdoors. The press in Byelorussia did nothing to refute anti-Semitic declarations. People would demonstrate in the streets, with placards reading "Byelorussia without Jews and Communists!" and suchlike. Periodicals produced by the Byelorussian Republic and the central organs were full of accusations against Jews as the cause of all outrages, and called for the elimination or expulsion of all Jews.

A great number of Jews in the former Soviet Union are forced to uproot themselves and leave the country where they were born and raised, had a job they enjoyed, a home, and so on.

TM: You're living in Bridgeport now. Do you get a chance to travel?

RK: I can go to any country, without permission (as long as I have the money).

TM: You have a daughter who is studying. What do you think of free education?

RK: Free education is a great social achievement. The same can be said of free medical treatment, maternity leave, paid leave to care for sick

children—none of which exists in this wealthy nation, the USA. But if we're talking of free higher education, then, like everything else, it has a good side and a bad side. People don't always undertake tertiary study because of a real professional vocation. Quite often, people who are incapable of mastering the syllabus still enroll in college. And colleges often award degrees to undereducated students, who later get into leadership positions with the help of their influential relatives, party members, or otherwise; they then block progressive ideas and interfere with the development of science and culture. Many tertiary institutions have long been off limits to Jews. Even those Jews who were at the top of their class in high school, with a gold medal of excellence, were not admitted to the Moscow State University, the Moscow Physico-Technical Institute, aviation training institutes, faculties of law and journalism at the universities, not to mention institutes of international relations or external trade. Even getting into medical institutes was next to impossible.

TM: What do you think of the position of women in the former USSR?

RK: In recent years, people have begun to say openly that women suffer a certain amount of discrimination. There aren't many women at the top levels of power. There are very few female managers in industry, directors of schools, and other educational institutions. Men earn more than women, even when working conditions are the same. Men get preference whenever there's a job vacancy. It's also easier for men to get into graduate school. Although women have proved their worth and responsibility in the workforce, stereotyped attitudes toward women remain unchanged.

TM: How do you relate to Americans here in the USA?

RK: Do I come into close contact with Americans? To tell the truth, most new émigrés don't. A Jewish organization and some volunteers helped me for the first four months, but now they only occasionally ask me if there's anything I need, or invite me to their synagogue on festive occasions. You get routine smiles and the routine question: "How are you?" I often catch myself thinking that we are considered second-class citizens, and therefore people don't make close friendships with us. Mixing with Americans is also made harder by the language barrier. You don't get that unconditional Russian emotional openness here.

TM: What are you planning to do now?

RK: I will try to improve my knowledge of English, in order to gain a better understanding of what I hear and read, of English and American literature, and some poetry. I was raised on Russian cultural traditions, and I miss them here. But I would also like to learn the language and at least the basics of the history and culture of the ancient Hebrews. The Soviet government deprived three generations of Jews of their own language and culture. I know Minsk used to have a splendid Jewish theatre, but that was closed down. These days it's permitted to organize evenings

of Jewish entertainment, but still it's very hard to re-create what has been lost.

TM: What's your advice to Americans?

RK: Speaking as a short-time U.S. resident, there are a few things I would like to see changed or improved.

First, lower the cost of secondary and higher education. The exorbitant cost puts higher education out of reach for most people, and the government only loses out in the end by this false economy.

Second, the cost of medical treatment is insanely high. For a three- to five-minute consultation you find yourself writing a check for hundreds of dollars.

Endless TV films featuring violence, murder, and other horrors deform the souls of the younger generation, fostering cruel attitudes and contributing to the rising crime rate.

To my mind, the high school curriculum is not very complex. However, children grow accustomed at a very young age to independent thinking and democracy. They are free, and there's none of those inhibitions you see in Russia, from which we older people are unlikely to ever free ourselves.

TM: Would you like to add anything about Russia?

RK: There's a lot that one could say about Russia. In short, it's a large country with good opportunities to develop its natural resources, but there's a lot of pollution—rivers and lakes have been contaminated, fish are dying. The rural economy has been taken to the brink of destruction. In the factory where I worked for the last twenty years, resources were wasted on totally unnecessary objectives; I saw how much useless work was done there. I'm no economist or politician, but I do understand that if a country doesn't value human individuality, thought, and initiative, then nothing good will ever come of all the promises.

17

Chanie Rosenberg

Chanie Rosenberg is a British socialist and author of Women and Perestroika.

Tatyana Mamonova: What is your background?

Chanie Rosenberg: I was born in South Africa and as a child felt the sting of anti-Semitism, which was very prevalent in the white population. This I naturally transformed to antagonism against apartheid, so I became a socialist, and as a Zionist socialist I went to live in a kibbutz in Palestine, a couple of years before it became Israel in 1948. Living there I rapidly — within weeks — became an anti-Zionist and left the country for England, where I've lived since, and have been involved in revolutionary socialist politics from the beginning of my stay here. I earn my living as a schoolteacher and have been very active in union work in this connection.

TM: What led you to write about women and perestroika?

CR: One factor in my coming to do the work is that the oppression of women is a major aspect of our work, and I have had occasion to speak on the topic quite a few times. I also participated on the sidelines of my husband's production of a book on a related theme.

Another factor is the central position which a consideration of the nature of the Russian state has played and currently plays in our politics. We always considered the former Soviet Union to be state capitalist, and not in any way a workers' state, deformed, degenerated, or anything else. So I have always had a keen interest in developments in Russia.

A third factor is the location of the mass struggle for women's liberation in the working class's struggle for its emancipation. The feminist movement has risen and fallen with the rise and fall of the class struggle. Britain provides a clear example of this pattern in the huge rise of the working class and feminist movements in the 1960s til the mid-1970s, and the subsequent decline of the feminist movement, in the wake of the

workers' movement, into individualistic expressions of dissent, accompanied by the death of all its organs of propaganda and agitation.

The members of my family were already writing on Russian topics, my husband first on Lenin and then Trotsky, my son on Bukharin. I became a third, intending to write about women in Russia under Tsarism, but at the time some amazing revelations appeared under glasnost that inspired me to bring the issue up to date.

TM: What do you think about the changes in the ex-USSR?

CR: It's difficult to answer this question briefly. Clearly, my assessment of the changes are conditioned by my consideration that Russia has a state capitalist regime. Since the command economy was irrational and uncompetitive in world capitalist terms, it had to do a perestroika by elimination or rationalizing the firms that were inefficient. This probably covers 70 percent of the industrial economy. It took Britain under Margaret Thatcher eleven years to privatize and rationalize 5 percent of industry, and during this time unemployment rocketed and poverty grew. The task in Russia is so vast that it cannot be done under present conditions except by the absolute devastation of people's living standards. This attempt, whether by Gorbachev, Yeltsin, or whoever, is what will shape workers' lives in the ex-USSR in the coming period.

TM: Do you think glasnost helps Russian women?

CR: However reform comes about, the facts of the case must be known in order to give some basis on which to build reform. Suppression and censorship are the enemies of the oppressed. Knowledge can help, even sometimes inspire, a fight against oppression. Without glasnost I could not have written my book.

TM: What do you think about the future of the ex-USSR?

CR: The crisis cannot be solved under the present system except by totally smashing the working class, so it will go on and on with different possible permutations. The solution is the same as the solution in every other capitalist country—a socialist revolution (in a number of advanced countries to avoid the isolation Russia suffered after 1917), and complete democratic reordering of the economy and society by the working class in the collective interests of the majority, not the Nomenklatura.

TM: What are your plans for the future?

CR: I have just finished a booklet on education and capitalism. Before that I had started work on the National Question in the Soviet Union, but that's a long job.

Who said
the sadness
is the most
attractive?
It was true
in Rome:
la Tristezza
è bellissima –
but in New York
we prefer
the Joy.

Part II

Mamonova on Women and Glasnost

AMERIKANKA

I don't know why
I feel nostalgia
sometimes
not only for Russia —
its cities and meadows
but also
for Paris —
mal du pays
or Berlin —
Heimweh
or another place
I lived
and for Warszawa
I never lived
I feel nostalgia
sometimes
even for your soul —
the most misterious
country
I ever knew.

O Gentle Creature
 you seem to be like us,
but I know your secret,
 my dear:
you do not have any fear.
Our Queen of Care
and Goddess of Justice
from where
do you take
every week
your mercy
and strength
for each of us,
miserable and weak?

18

Revisioning Our Women's History

The main goal of my work "Sexism in Soviet Culture" (in *Russian Women's Studies*, 1989) was to take a fresh look at Soviet literature, history, and art. Of course, that was only a small part of my research objective. Most of all, I wanted to continue my efforts to resurrect the memory of a number of distinguished Russian women who made an extremely important contribution to human culture. Many of these women were heroines in their time, known not only in Russia but also far beyond its borders. Today in the former Soviet Union not only their accomplishments but even their names have been forgotten. In this chapter I hope to reintroduce them to a new audience. My role is modest: only a popularization of their work.

AN INSPIRED GENERATION

In 1856, in St. Petersburg, three activists of the women's liberation movement, Marya Trubnikova, Nadezhda Stasova, and Anna Filosotova, pooled their talents and created Russia's first women's university. The leader of the Triumvirate, as they came to be known, was Marya Trubnikova, who not long before had come to the northern capital from Siberia to study sociology. Her grandmother was a Decembrist[1] and Marya from childhood was fascinated with the democratic ideas of Herzen. In those years, the emancipation of women was on the tongues of all progressive people, and for Trubnikova it became the paramount issue.

In addition to the famous Bestuzhevsky courses for women, the Triumvirate organized the Society for Cheap Apartments and other benefits for the needy. This society, which lasted in St. Petersburg for more than fifty years, largely helped women from the proletariat. Trubnikova and her allies had some philosophical differences with the other philanthropists of the day. For example, whereas Baroness Shtakel'berg, a woman of Ger-

man origin, and her fellow philanthropists argued for strict controls on the residents, the Triumvirate thought that support of the poor should not injure their feelings of self-worth. The Triumvirate maintained that the residents of the cheap apartments must remain free and that the business of the new society was to help them live, not to control their lives.

Applications for the apartments were numerous, and the means insufficient. As a result, the Triumvirate arranged amateur performances, concerts, and lotteries to raise money. In 1861 with the 90,000 rubles it had made on a lottery, the society purchased the big house on Izmailovsky Field and a majority of the poor families moved in. They built a school for children there and provided handicraft training for women. It was a three-year course, and all the help served without pay. Later, they added a kindergarten and a community kitchen. A dinner of two dishes cost 20 kopecks. They served 20,000 dinners a year. The Anninskoye Division for Needy Women Students was opened in the society's building, the means provided by a Baron Gintsburg.

There Marya Trubnikova led a circle that was in touch with students who belonged to the radical group, the *Society of Land and Liberty*, a group influenced by the revolutionary writer-democrat Nikolai Chernyshevsky. Trubnikova was personally acquainted with Chernyshevsky, whose views conicided with her own antimonarchical perspectives. To express public sympathy with Nikolai Cherynshevsky or Aleksandr Herzen in those years was extremely risky. For example, the aides-de-camp, Counts Nikolai and Mikhail Rostovtsev, were discharged from the service only because they visited Herzen while in London.

The feminists felt that opening a school for girls was especialy urgent, since in 1862, one after the other, the Sunday Schools and the craft schools for girls in St. Petersburg were closed: namely, at Tavrichesky Garden, on Vasil'evski Island, on the Vyborg Side, and on the corner of Sadovaya and Engineer's Street. The feminists frequently had to fight for the students' right to attend the Sunday Schools. Employers, who were generally unwilling to release female workers, frequently stood at the door threatening them.

In the manifesto of the Society of Women's Labor was compiled with the assistance of the progressive Colonel P. Lavrov who sympathized with the Triumvirate's goals. The society's regulations addressed the necessity of effecting urgent changes in the position of women, a position that pushed them into prostitution (including the prostitution of forced marriage) or into the aimlessness of ecclesiastical life. The government did not, of course, give its consent to this society, but its ban did not immobilize the Triumvirate. They fell back on Trubnikova's idea of founding the Woman's Artel, which would bring together translators and publishers. The aim of the Artel was to provide independent earnings for its members and at the same time useful and progressive reading matter

for the rising generation.

Finding translators presented no difficulty since in that epoch most women of the intelligentsia knew several foreign languages and were only too happy to find a way to use their knowledge. The printed galleys of the Artel were given to another woman's Artel, founded by Barbara Inostrantseva, to sew and bind. Women also did the illustrations and engravings.

The first book published by the Triumvirate was a translation of the tales of Hans Christian Andersen, which, had only recently appeared in Germany and had captured the attention of all educated Europe. The huge success of the book rewarded the publishers for their labors and worries. The first edition quickly sold out, and a second edition was released. But the government, as it had done in the case of the Society of Women's Labor, refused to confirm the regulations of the Woman's Artel. The Triumvirate countered with the suggestion that the government must take all responsibility "if women are not trustworthy." They had begun work on the translation of the American writer Louisa May Alcott's *Little Women* and *An Old Fashioned Girl*. Only then, thanks to their persistence, was the Firm of the Triumvirate officially recognized.

Meanwhile, the Society for Cheap Apartments did not have enough teachers. In that period the only way to obtain a secondary education was to attend the private schools founded by Catherine the Great and Catherine Dashkova, the first woman president of two Academies (Science and Art) in Russia during Catherine the Great's rule, although their program of study had not changed for many years and was now obsolete. The Mariinskye Gymnasia, with a seven-year course founded in 1858, also supplied a small number of teachers. Although they were of a lower class than those from the older institutions, they all fully met the demands of

The many progressives who supported higher education for women confronted a still larger number of fierce opponents. In order to destroy the education movement, these opponents began to circulate gossip on the unseemly nature of the teaching. Retrogressive elements maintained that too much learning was harmful and unnecessary, and would divert a woman from her rightful obligations at the domestic hearth. They "proved" that in every way the study of natural science was incompatible with the necessity to safeguard woman's "innate shyness." Alas, the reactionaries often sought the forced disruption of resolute steps they found displeasing.

In 1859 women began to attend the Medical Academy and St. Petersburg University as auditors. In 1861, at a time of strong student unrest, among those arrested was a woman attending the university lectures. This incident was reported to the authorities and resulted in the Stroganov Committee canceling the student regulation that permitted women auditors. The public lectures were now prohibited, and the liberal journals *The Contemporary* and *The Russian Word* were suspended. Women con-

tinued to attend the Medical Academy, but there too, in 1864, by order of the war minister, the doors to women were closed. An exception was made for one woman, Kashevarova, who had been assigned to complete the full medical course so that she could go to the Orenburg region to treat Kirgiz women. According to Kirgiz law, women were forbidden to consult male doctors. Kashevarova would in due course justify the confidence shown in her, winning renown as the first woman doctor to receive a diploma at the Medical Academy.

In 1867 the first Congress of Naturalists was held in St. Petersburg. At the meeting a petition that had been read by Evgenia Konradi, one of the most energetic representatives of the epoch. Her petition demanded permission for women, as mothers and educators of the younger generation, to attend the university, and it was met with thunderous applause. The congress expressed full agreement with Konradi's idea and readiness to aid in its realization, but in the end it refused to take any initiative in the matter.

The Triumvirate gathered 400 signatures in support of the petition and secured the agreement of professors and the rector of the university. Next, the women set off to see the minister of public enlightenment, D. Tolstoy who promptly informed them that the ministry would not give any kind of subsidies. The maximum that the sovereign had permitted, Tolstoy stated, was the public lectures to be attended jointly by men and women.

Unfortunately, precisely at this time Trubnikova and Filosotova's husbands denounced the activities of the Triumvirate and, even worse, joined the opposition movement. As a result of the ensuing tension, Trubnikova's health was undermined, and she went abroad. Nonetheless, she continued her work, making contacts with feminists in England, France, and Switzerland. Still earlier the women's liberation movement in Russia had received support from the West. John Stuart Mill addressed them: "Thank you, dear citizens of Russia. You truly will soon leave Europe far behind."[2] The sympathies of the famous philosopher and political economist in no slight measure encouraged those who were fighting for the rights of Russian women. They also received a letter from Jenny de'Hericourt, the author of a rebuke to Proudhon:

> Try to instill in all the women around you consciousness of their responsibility. Become concerned about coming closer to people and to the common people. Come to oppose the fact that we women drag behind us the towboat of the male spirit, so full of cruelty and hatred. Women of the East, women of the West, begin to love each other, to help each other, stretch out your hands to each other from all corners of the world. We shall remember that before the face of justice there is only work and the common people, free and independent, and all existence outside of that lives in evil."[3]

The French writer André Leo also addressed the Triumvirate: "Against

poverty, against defects, against suffering—physical and moral, against prejudice, against barbarism there is only one means—enlightenment. Lift up the woman, enlighten the mother. After you the praise stops. What you carried out in Russia is our dream."[4]

In 1869 in Geneva, Trubnikova became acquainted with the active English feminist Josephine Butler and members of the International Women's Society and discussed the question of creating an international feminist journal with them. Everyone agreed that such a journal was a practical necessity for removing obstacles that had been erected between women of different lands with their patriarchal traditions, varying historical development, and many languages. Such obstacles were completely irrelevant when they began to discuss the interests of the future of the earth.

The Triumvirate spread the idea of women's education with enthusiasm in Russia, but difficulties arose over realizing a woman's university and so the project was relegated to the background. Public lectures by professors were again permitted, but there were no places to hold them and no money. The Ministry of Public Enlightenment prohibited the Triumvirate from publishing advertisements in the newspapers soliciting contributions. Count D. Tolstoy explained that they would have to wait for an institution that would consolidate and delineate its direction—thus creating a vicious circle. Nevertheless, literary-musical evenings and the payment of individual dues soon provided the desired results. M. Turgeneva used donations of a thousand rubles to build a chemical laboratory whose success surpassed expectations. Through the selfless, dedicated work of the Triumvirate, the means were collected for the professors' public lectures, and they were given rent-free quarters in the building of the Ministry of Internal Affairs.

This victory did not, however, mean that the Triumvirate's trials were over. More than once the Women's Higher Courses wandered from place to place. While in the end they did not obtain any subsidies from the Ministry of Public Enlightenment, only when they finally settled down on Vasil'evsky Island.

As the cause of women's higher education progressed, a significant part of society was becoming increasingly agitated and hostile. The secret service jealously trailed the growing woman's movement and put it under surveillance, questioning its political trustworthiness.

Aleksandr II (1855-81), who in general was unsympathetic to women's studies, now demanded information about the Triumvirate from the chief of the Gendarmerie Drentelen. Drentelen revealed to the Tsar the name of every woman student whom he regarded as a revolutionary, and wrote a report about a Woman's Committee, which ostensibly existed without permission. Also in police files was a letter Filosofova wrote to Trubnikova which identified the society's and Bestuzhevsky's one and only aim:

their human rights. The auditors of the Higher Women's Courses did not have to look upon the members of the society as "benefactors"; students in these courses could enjoy the maternal and moral support of the society as their right, and not as a form of charity.

Despite many setbacks, the Triumvirate's efforts continued and Bestushevsky became even bigger. In twenty-five years the Higher Women's Courses became the Women's University, with a stable faculty and more than 6,000 students. The infinitesimal capital with which the Triumvirate began—202 rubles—had grown to millions in property. Young women now received the opportunity to avail themselves of laboratories, study rooms, and libraries—all in a place of their own.

Thus, a small circle of stoic and intelligent women, infused with a high democratic spirit, achieved their aims not only without government help, but in spite of its active opposition. The Triumvirate's path was thorny, but the firm belief in the vitality of their aspirations liberated these women from spiritual slavery, and civic and material dependence, and helped them win the battle for education. The dedicated service of the Shestidesiatnitsy, as the 1860s liberals were called, opened the path for a new generation of women.

NIHILISM

The chief police officer submitted a report to the minister of internal affairs about the development of a "corporate spirit" among young women in the Higher Courses. He made a special point of their appearance describing their "black dresses, spectacles, short hair"; undoubtedly among them were members of the Society of Nihilists.

In this epoch Peter Kropotkin lived in St. Petersburg and was closely associated with the circles where the most intense feminist movement developed; he pronounced the movement great and wonderful in its results. As the characteristic feature of the movement, he noted that its older founders never broke their ties with their younger sisters, even when these younger members began to preach extreme views. They never forgot that the strength of the movement was in the mass of young women, the largest part of whom later joined revolutionary circles.

Marya Trubnikova was a typical example. All four of her daughters entered into revolutionary activity; she often said that with daughters you cannot stand in the way. Although she herself was sympathetic to the revolutionaries, she never became reconciled to their means of struggle, and she resolutely refused to consider terror as a strategy. "The leaders of the woman's movement," wrote Kropotkin, "seemed to turn to the most radical youth and say: We will wear our velvet gowns and our chignons because we have to appear in our business before stupid people to whom being well dressed is a sign of political reliability. But you girls, be free in

your tastes and inclinations."[5]

When the Russian government ordered the women students studying in Zurich to return home, the elegant "ladies of feminism" did not turn away from them. They declared to the government: "You don't like it [young women studying abroad]? Then open women's universities in Russia." When they were reproached and told they were educating revolutionaries, and when the Bestuzhevsky courses and the faculty for women at the Medical Academy were threatened with closing, they answered, "Yes, many students have become revolutionaries, but does it not follow from this that it is necessary to open all of Russia's universities to women?" "How rare," remarked Kropotkin, "political leaders having the courage not to turn away from the most extreme wing of their own party. The secret of this sensible and successful tactic is explained by the older women standing at the head of the movement not simply as feminists wishing to occupy a privileged position in society and the state. They were thinking about the transformation of the whole society."[6]

Kropotkin's positive remark about feminism was not made without reason. The representatives of alternative movements began to experience a crisis in the 1870s. In the massive retreat of the liberal intelligentsia after the upsurge of the 1860s, one of the leaders, the writer Nadezhda Khvoshchinskaya, stood firm. From generation to generation, people who were close to the luminaries of progressive thought did not let it die out. Khvoshchinskaya, who was one of the conspicuous figures among them, described the 1860s as "that dear, short, near, yet far away time."[7] Her recollections published in "The Famous Commune" rings out with a deep nostalgia for lost confidence. In this commune six young writers, men and women, came together and arranged to rent an apartment together in the name of its most secure member. They helped each other in word and deed. "People believed in people and were ashamed to betray a trust."[8] In the period of crisis, the press began to slander such communes. Many did not hold out. The moral death of a whole generation evoked anxiety in Khvoshchinskaya and her associates.

Writers within the democratic camp searched for support in feminism. For example, Khvoshchinskaya's women characters underwent a significant evolution. Earlier they restricted themselves to honest, moderate effort of little benefit to the people, trying to keep their souls, dreams, and sacred discontent alive. In the 1870s Khvoshchinskaya created women who broke away from the slavish paths of the bourgeois family, going out into the arena of real social activity. Even so, she restrained herself when it came to all-conquering heroines and heroes. Specifically, with regard to women's emancipation, she stated that "A woman can never get on the right path alone, by herself. She must have help in this for the whole structuring of her life. . . . The martyrdom of her position is only the consequence of her surroundings. I point out the sacrifice in order for the

guilty to see what they do, so they can change their minds and begin to live more constructive lives."[9]

In her novel, *Big She Bear* (or *Bolshaya Medveditsa*), Khvoshchinskaya created charming girls, struggling for spiritual freedom and the right to act on behalf of the people. This novel was written in 1871 and received wide renown. Its heroine, Katya, stands up against the entire fashionable society of the city. Infatuated with a married man, Verkhovenski, Katya does not become a slave of her emotions. She demands that her beloved be her comrade in battle. At first Verkhovenski truly suffers in his fight for human dignity and honor, but then, giving up, he becomes the typical representative of his depraved environment. Katya tries to convince him that as individuals we are but drops of water, but that united we become waves. Achievement called not only for strong units, but also for all working together. However, Verkhovenski did not have a strong sense of the people's honor, and, power hungry, he leaves to make a career for himself.

For some, nihilism found expression in the repudiation of society's firmly established legal injustice, and for others in the repudiation of all morals. In the novel *The First Struggle*, Khvoshchinskaya starkly and pointedly confronted the question of the relations between two generations. The father of Serezha — a rank-and-file citizen in his sixties — works for the future, but all his life he has followed the principle of selfless dedication for the sake of humanity. The son — full of opposition — is practically his father's class enemy, a betrayer of his ideals. Not by chance was Serezha in the midst of the leading intellectuals of those years, ironically called "the heroes of our times." Ostensibly, Serezha is "of a special kind, chosen by fate; finely mature people to whom by right all pleasure belongs, as if this treasure is unexpectedly received, as if without effort (or work). Effort, this is the lot of another kind of people, the incapable, those unable to follow, to appreciate the fragrance of pleasure."[10] Nietzsche and Schopenhauer, as we know, extended this thought into a philosophy, and the Nazis put the philosophy into practice.

Marya Tsebrikova presented a full analysis of Khvoshchinskaya's achievements at the end of the nineteenth century. M. Goriachkina continued Tsebrikova's analysis during the liberalization period in the Soviet Union, but all of this writer's works remain inaccessible to the reading public.

Khvoshchinskaya's forty-year creative development was not easy, nor was her fate. She was very close to her sister, Sofya, also a writer, and they tenderly loved each other. Sofya's early death deeply affected Nadezhda, her grief caused her to become seriously ill. To relieve her loneliness and anguish, she married a young exiled doctor, Zaionchkovski. When they married, she was 41, and he only 27. Her nickname "Blue Stocking" dates back to this period and marked her separation from the

world of femininity.[12] Now that she had taken a spouse of different age, she began to receive unfavorable accusations. The critics, among them Tsebrikova, noted a feeling of melancholy and discontent in Khvoshchinskaya's writings that they believed created an affinity between her and George Sand: "This sensation of being cooped up, as in a fortified enclosure, where there is insufficient air for breathing, the feeling of being alone in the midst of many people because in them there is no responsiveness to questions of mind and feeling."[13] But when Khvoshchinskaya laughed, it was gay and infectious. Dostoevsky said that our souls most of all desire to experience laughter. Nadezhda Khvoshchinskaya's laughter was the bright laughter of pure, good souls. People danced to it. The representatives of Russian democracy considered her their ally: among them were the actress Ermolova, the artists Repin and Kramskoy, and the scholars Mendeleev and Sechenov. They called her "our own George Eliot."

Khvoshchinskaya's marriage was not happy. He was a real nihilist, holding extreme political views, and he was closer to Bazarov[14] negativism than to the "idealism of the 60s activists." During his exile, his health had been weakened, and a trip abroad did not help. Galloping tuberculosis took his life in 1872.

The loss of those closest to her, forced Nadezhda Khovshchinskaya to withdraw still more into herself. She could not even bring herself to meet with friends in St. Petersburg. Indeed, she had reached that stage of grief when she began to question the point of meeting, since it would only reopen the wounds of loss. In this period she created a large gallery of portraits of "backsliders" and "bystanders" who deeply suffered in the atmosphere of reaction that followed the first crushing defeat of populism. In her 1878 novel *Between Friends*, one of the bystanders, after long wandering, returns to his friends at the university who have abandoned their faith in the social idealism of the 1860s. With pain and grief he sees before him not his former comrades but reactionary philistine-proprietors. They consider him an ordinary romantic crank who needed someone to bring him to himself. His idealist fever had raged long enough. So, soon freed of his illusion, he became a powerful bureaucrat–bribetaker, a sober guardian of the new order (which was actually a restoration of the old order).

In the novel *The Past*, written the same year, its heroine Tanya, reared in the security of a gentry family, leaves home, journeying to St. Petersburg for study. The spirit of love and selflessness reigns in the circle she enters, even though her student friends are living in poverty, go hungry, and run all over the city seeking work. Their attempt to stand up for their rights makes them feel all the more humiliated and weak. Censorship held up publication of *The Past*; the authorities demanded that Khvoshchinskaya recognize the "new order," but she refused to write for the amuse-

ment of the "triumphant ones." She could not quietly look on as the lonely, repudiated dreamers of the 1860s disappeared. Nor could she resign herself to the fact that many of yesterday's heroes, unable to gather enough courage to sacrifice themselves in the name of the people, chose to plunder and suppress the people.

Khvoshchinskaya's displeasure with the "triumphant ones" was clearly expressed in the novel *The Healthy*. In a circle stood all the healthy and broad-shouldered—a solid wall. They are admired and they live, these "healthy ones," in making every person participate in their vile and evil machinations. They are mean-spiritedly out for revenge when someone repudiates their pretensions. The author, as before, sides with the persecuted, and in several books her tone appears hopeless. A destitute actress dies in the story "Ridneva." In another story "The Schoolmistress," as in *The Healthy* written in 1880, Zinochka, wandering around seeking work, is insulted by insolent and powerful, superficial people, although she, a young teacher, was thinking only of earning enough to pay for a warm corner for her mother.

In 1884 the journal *Otechestvennye Zapiski*, in which Nadezhda Khvoshchinskaya and Marya Tsebrikova had published most of their work, was closed down. Attacks on the Higher Women's Courses also continued. In 1885 administration of the Higher Courses was transferred to an appointed (from above) director and inspectors. The optimism of the 1860s changed to pessimism in the 1880s. Keeping the ideas of her time alive, Khvoshchinskaya, like her heroines, became the surviving personification or embodiment of the tragedy of the epoch. The young Russian intelligentsia knew and loved her work. In 1880 gymnasium and seminary students in Riazan organized a manifestation (demonstratation) for her: "We thank you for your sympathy for the younger generation and your challenging us to life. Hurrah!" The Tsebrikova fund, which for many years helped support the Bestuzhevsky courses, collected money for Khvoshchinskaya, for in these years censorship practically stopped her from doing her literary work as she had done earlier.

Marya Tsebrikova was not only a feminist critic, but also a translator, publicist, and social activist. No young woman who read her book *American Women of the Eighteenth Century* (1871) was unaffected. In this study of a splendid succession of Americans, Tsebrikova showed that, under certain circumstances, perfectly ordinary women can emerge as remarkable individuals. Strengths were concealed in these women, and to realize these strengths only the right conditions were necessary. From the mass of evidence in her source—the three-volume *The Women of the American Revolution* by the American writer Elizabeth Ellet—Tsebrikova analyzed the positive characteristics of these women: their strength of character and intellect, resourcefulness, talent, political tact, and ability to organize and to manage. In the troubled times of the American

Revolution, they did not shirk their civic duties or fail to stand up for their rights even under fire. In the dreadful hour of the people's grief, they showed heroism. They treated the wounded, they crossed enemy lines to deliver messages, and they were ready to counsel the revolutionary leaders when called upon for advice. Tsebrikova pointed out that in full measure they proved false the age-old slander about the worthlessness of women. And she proudly noted that the anthem of peace that was sung in all victorious establishments of the new Republic was written by a woman, Sara Morton.[15]

The nature of Marya Tsebrikova's relationship to rebellion is reflected in her works. Like Marya Trubnikova, she came from a family of Decembrists. Troubled by Russia's disturbed state at the end of the 1880s, Tsebrikova decided to write a letter to Tsar Aleksandr III (1881-94) about the murderous role of the bureaucracy. "The law of my country forbids free speech. All honorable people in Russia are condemned to look at the exultant despotism of the bureaucracy persecuting truth, indulging in the moral and physical massacre of our youth and the lawless spoilation and flogging to death of our people."[16] The limitless power the bureaucracy enjoyed in the history of the Russian government was, undoubtedly, exceptional. Through its hands passed everything that touched the intellectual life of society and the legal position of the people. Tsebrikova's letter to the emperor was sent in March 1890. Soon after, without benefit of a trial, she was dispatched to a remote village near the border of the northern Vologodskaya Province, hundreds of miles from St. Petersburg. Tsebrikova's contacts with foreigners made it possible for her letter to be published in Europe and the United States, and for smuggled copies to circulate wildly in Russia. But it did not appear legally in a Russian publication for seventeen years. After two years in the isolated village of her exile, she was given permission to live in the western province of Smolensk in what the government called self-imposed exile. (She was banned from St. Petersburg for the rest of her life.)

Tsebrikova's letter to Aleksandr III got a powerful response in the West and was influential into the twentieth century. "Masses of the bureaucracy and official careerists, by order, plant today what will come up tomorrow, and the other way round. And it is always reported that the sowing and the reaping is for the benefit of Russia because it is the highest will. The officials know very well what they do, but their motto is: hold on during this century and the children are ours — even if by then grass has ceased to grow."[17] Tsebrikova wrote about the corruption that penetrated the whole government system, about bureaucratic anarchy held together by an artificial order. That order was an iron-clad mechanism in which levers and wheels served legions of bureaucrats, hundreds of spies, and millions in the army. Semi-official organs of control found employees only among the mediocre. When the flower of thought and creativity did not

support the government, it proved there was no vitality in its ideas and that it held on only by force. Tsebrikova affirmed that it takes lively ideas to inspire the talented.

At the end of the nineteenth century, under the pressure of the youth, the strength of reaction gradually receded. Feminist publications appeared, including *Drug Zhenshchin* (The Friend of Women), *Zhenskii Vestnik* (The Women's Herald), *Pervyi Zhenskii Kalendar* (The First Women's Calendar), and *Zhenskoe Obrazovanie* (Women's Education). But for a long time the name "nihilist" was applied to women who were striving to defy convention; those who, like George Sand, refused to wear women's clothing. This form of protest among educated young women who favored the more comfortable men's clothing evoked extremely unfavorable criticism in bourgeois families. In order to escape the fettering bondage, dozens of girls of that time sought a compromise in the form of a fictitious (on paper only) marriage.

PRIESTESSES OF LOVE

In 1899, under the chairmanship of A. Shabanova, the women of St. Petersburg set up the Committee of the League of Peace, which collected the signatures of 50,000 sympathizers for the resolution they had worked out. The committee exchanged greetings with the representatives of all the foreign leagues of peace. The Peace Committee sent the Russian women's resolution to the Hague for the First International Peace Conference. On the day the Hague conference opened, the women held a huge demonstration in behalf of peace in the hall of the St. Petersburg City Duma.

This was the first association of Russian women with the women of all countries and the first attempt to bring together women of all classes in Russia under one general slogan: "Down with violence, Down with weapons!" Among the signatures on the resolution were many of those belonging to the peasantry. Women displayed unanimous sympathy to the idea of disarmament and the establishment of international peace. When women obtained a voice in legislative bodies, presumably one of the urgent issues they would argue for would be ending the terrible wars and violence.[18]

Women, having achieved the right to education, naturally began to demand the right to vote. Appealing to their government, Russian women cited their American sisters in the states of Utah, Colorado, Idaho, and Wyoming. They published the resolution of the peoples' representatives of Wyoming, which said that the right to vote, given to women, promoted peaceful and honest elections and the establishment of justice in government, and appreciably raised cultural and educational standards. This document was sent to all parliaments in the world. Then in detail it said,

"Pointing to our experience, we insist that every enlightened government on earth at once give women the right to vote."[19] In Colorado, added the Russian petition to power, women entered the legislature and contributed significantly to the reduction of crime in the state.

During this period women in many lands joined the woman's movement, among them, Cubans, Czechs, and Poles. The Ukrainian woman writer Marko Vovchok often debated with critics together with Nadezhda Khvoshchinskaya. Both belonged to the broad wing of democratic thought at the end of the century. Eliza Ozheshko, who became a leading voice in Polish literature of that time, could also be classified in the group. In her book *On the Equality of Women Before the Face of Knowledge, Work and Human Dignity*, written in 1899, Ozheshko noted: "I do not think that I erred, believing that the [woman's] question is the first of all questions of common sense and justice, and that is why it must have every chance for resolution."[20] She advocated a union of virtue, which would actively oppose in word and deed whatever represented moral and physical violence which, by itself or collectively, resulted in pressure on other persons and groups. Ozheshko called dangerous everything that opposed the realization of the ideal good. Why in our human society, she asked, must this ideal be shamefully covered up before egoism and untrustworthiness? Why are those people who listen and try to proclaim it in our society persecuted, ridiculed, victimized? "It is not for nothing that over many centuries a woman was considered exclusively a priestess of good. . . . she had a continuous tradition of goodness and purity. On the other hand she had a tradition of spilling fraternal blood, a tradition of desiring to occupy a bigger place at the feast of life and to push others into the mud . . . but she did not create on this earth war and torture" (p. 35). Restore to woman her immemorial right to be herself, take patriarchy off her back, and all society will benefit. In other historical epochs, in periods favorable to women's development, there arose the highest types of women, remarkable in mind and spirit: Aspazia, Hipatia, Sappho, Cornelia, and Apia.

Undoubtedly, however, Ozheshko affirms, a deeply inner social life constantly and uninterruptedly watered down the current of unacknowledged women's feelings and unspoken thoughts. Then and there developed a whole sea of unmeasurable women's suffering, producing, as a consequence of suppression, waves of repressive laws and customs against women's power and abilities. The patriarchy crippled women, distorting their nature, and they accustomed themselves to that. This is the last type of woman, imitating men, guided not by the wish to bring benefit to society, but by the ambitious aspiration to take out of the social system, or to extract for themselves, more material profit. Their huge imagination and crass demand for pleasure have been put on a pedestal of fashion instead of ideas.

Echoing Ozheshko is Olga Shapir: "Love teaches the simple justice of mutual responsibility which supports peace; let the life of each in turn take wing, so he [or she] can fly to wherever love is."[21] In her book, we detect a premonition that the end of the century will see a damaging weakening of love; people, arming themselves against the instincts of life, forget that after this is death.

In the works of women writers at the turn of the century, the growth of self-awareness advances the image of woman to a consideration of wise reformers, apostles, and everlasting goddesses. "Over the yawning gap of the abyss, in whose depths millions of people crawl about, bitterly suffering morally and physically, as a consequence of countless mistakes and negligence, they are to me majestic figures embodying intelligence, goodness, gentleness, love and ability," wrote Eliza Ozheshko about women in the twentieth century.[22]

Women suddenly realized that the source of freedom was in themselves. They recognized that one-sex legislation and the existing social system led to the deformation not just of women, but of humankind. With daring arguments, women were answering the attacks of conservatives, accusing them of isolating themselves. It was not difficult to prove that men were keeping aloof. Independent women organizing in a patriarchal society had as their ultimate aim, not isolation but, on the contrary, the joining of both sexes as a foundation for work and for rights.

On the question of general humanity, still nothing was said. Humanity must be reached by resolving the so-called woman question. Yet self-aware women were producing radical changes in all areas of social life. "It was a revolution no one had dreamed of," remarked the expert S. Ispolatova, "because the radical change touched the very roots of life, and, most important, it produced neither enemies nor victors."[23]

At the beginning of the twentieth century, the women's movement entered a new phase. From the sheltered sphere of the academy it moved out into everyday life, taking on vitality and becoming closely tied to the economic conditions of woman's labor. After the fourth year of its existence the International Union of Women joined the sixteen-nation Women's Union, among them: the United States, Canada, Russia, Germany, Denmark, Norway, Sweden, Finland, Holland, Hungary, Bulgaria, Italy, Switzerland, and Australia.

OVERSEAS SISTERS

Evgenia Konradi's book, *Women's Student Life in Cambridge*, was published in 1900. She wrote, "Perhaps only in our transatlantic friends can we recognize people standing on a level with us in their success in the area of the woman question."[24] At that time trips to America were in great vogue, and every Russian, having been on a visit overseas, on her or his

return home became a kind of marvel. One of those travelers persuaded Konradi to go to America and give lectures on the position of women in Russia. "They guarantee you for that work, $15,000 a year!"

Not many Russian women were able to go across the ocean, and, in turn, not many American women could make the trip to Russia. For example, the first Russian Women's Congress opened in St. Petersburg in 1908, under peculiar and unusual conditions even for the Russian empire. The minister of internal affairs cut out of the program the fourth paragraph: "The struggle for political and civic rights of women for us and for those in foreign lands. The necessity of equal rights and the right of women to enter all professions and state service."[25] This deletion was made to avoid mention of the political struggle and political movement of women in the West.

The setting in which the sessions of the Congress took place was also unusual. Everywhere, and constantly, even at the closed sittings of a section, a police officer or two was present, following every word and not infrequently stopping a peaker in the pretext of using "too free" expression. Even stranger were the arrangements for the well-attended meetings of the joint sessions. If, without giving advance notice, a visitor stepped into the Agricultural Museum to have a look around before a meeting began, she would be stopped, completely bewildered at the entrance to the hall. There in formation stood a long row of policemen, with the inspector at the head, blocking the visitor and leading her to assume she had lost her way and gotten into a company of people who had been arrested, when actually she had simply come to attend a meeting of women who were there to discuss their interests and needs.

The debates between the delegates were quite intense. The extreme wing came out against union with bourgeois women. Z. Mirovich disagreed with Aleksandra Kollontai, saying that if the governing classes had forgotten the ties that linked them to the people, then the proletariat also risked falling into error when it forgot all that the land-owning class did for civilization. From Mirovich's point of view, the whole history of the woman's movement in the West clearly showed that it was essential to reject party claims and dissension in the battle for woman's emancipation. The only path for accelerating the rudiments of reform must be the full solidarity of women of all nationalities, parties, or other categories in the name of all before the law.

NOTES

1. Revolutionary aristocrats who were condemned by the Tsar and sent to Siberia in December 1825.

2. O. Bulanova-Trubnikova, *Tri Pokoleniya* (Moscow-Leningrad, 1928), pp. 98-99.

3. Ibid.
4. Ibid.
5. Peter Kropotkin, *Zapiski revoliutsionera* (St. Petersburg, 1906), pp. 234-236.
6. Ibid.
7. From the memoirs of Khvoshchinskaya, *Zhenskoe Delo* (St. Petersburg, 1899), pp. 63, 69.
8. Ibid.
9. *Russkaia Mysl* (St. Petersburg, 1890), p. 83.
10. N. Khvoshchinskaya, *Gosizdat. Khud. lit.* (Moscow, 1969).
11. Ibid.
12. M. Tsebrikova, Ocherk zhizni N. D. Khvoshchinskoy, *Mir Bozhii* (St. Petersburg, 1889), No. 12, p. 67.
13. Ibid.
14. Bazarov, one of the I. Turgenev characters.
15. Biografiia M. K. Tsebrikovoi, *Pervyi Zhenskii Kalendar* (St. Petersburg, 1904), p. 376.
16. Pismo M. K. *Tsebrikovoy k Imperatory* (1907), p. 2.
17. Pismo M. K. Tsebrikovoy k Imperatoru, *Vestnik Evropy* (1907), p. 13.
18. Ocherk Zenskogo Dvizheniia v Rossii, A. N. Khabanova, *Zhenshchina* (St. Peterburg, 1910), p. 735.
19. L. Gurevich, Pochemu nuzhno dat' zhenshchinam vce prava i svobody, *Vernyi Put* (1906), p. 25.
20. Eliza Ozheshko, O Ravnopravii Zhenshchin Pered Litsom Znanniya, Truda i Chelovecheskogo, *Dostoinstva* (Moscow, 1899), p. 11.
21. Olga Shapir, *Liubov' Kontsa Veka* (St. Petersburg, 1895), p. 179.
22. Eliza Ozheshko, *O. Ravnopravii Zhenshchin* (Moscow, 1899), p. 33.
23. C. Ispolatova, M. Tipg. O. Somovoi, *Samosoznanie Zhenshchiny* (1912), p. 23.
24. Ibid., p. 519.
25. Z. Mirovich, Pervyi Vserossiiskii S'ezd, *Vestnik Evropy* (1909), p. 412.

19

A Feminist Hope in Russia

THE DRESS FROM CARDIN

Pierre Cardin appeared on Red Square wearing a loose-fitting suit with padded shoulders, his tie fluttering in the wind. Cardin was encircled by his models—young women, captivating in corsets and corsages. Most of them wore hoops in their skirts, forcing one to wonder how these women could sit in an armchair or ride on a bus. Photographs of Cardin's show were in many Russian newspapers. One correspondent, N. Krasnoyartsev, assured us that most of these dresses are quite practical; but Cardin's goal is to turn a woman into a queen and in general, into an out-of-this-world creation. Cardin himself said about his models: "Every revolution breaks down all the canons" and, with a bewitching smile, shrugged the wide shoulders of his jacket. Krasnoyartsev was satisfied with Cardin's words. He added admiringly: "The first thing that meets the eye, the real change, is in men's clothing. It has become more masculine, even coarse, having conspicuously departed from the effeminate. Thank you, maestro, for reminding men of their worth and their true character" (*Pravda*, July 23, 1989). And more: Russian TV announced that in 1991 the series "Pierre Cardin—40 Years in Fashion" would be shown periodically. Their advertisement tried hard to attract women with a hat shaped like a big umbrella (which I think will be very useful in Red Square).

As other articles inform us, the Russian people happily buy horror and Mickey Mouse films for a few rubles. Clothing from Cardin costs much more, but not long ago the Ministry of Light Industry of Russia negotiated a contract according to which every year up to fifty new Paris designs "from Cardin" would be delivered directly to the Moscow Center of Fashion. These designs are to be copied and sold to the "deluxe" stories of Russia.

At about this time the miners of Kuzbass and Donbass struck, complain-

America —
 a miracle
 or a nightmare?
 trash
 or treasure?
 What can I say
 Thanks to you
 I found a miracle
 behind my long
 and tragic nightmare.
 I found a treasure
 in the middle of the
 tremendous trash
 of New York city —
 your soul

I heard
 a song
 in my heart
 I opened
 the window
 and a fragile
 melody
 of my song
 went out
 I didn't notice
 the wind
 which was
 cruel and hostile
 I closed late
 the window —
 my song
 died
 in the beginning

ing about the shortage of food products and soap. Soap, which not long before cost 30 kopecks in government stores, had become unobtainable; it was available in the cooperatives (as private enterprises are called in Russia), costing not 30 kopecks but 3 rubles. The Russian government talked about the need for emergency measures for normalizing the consumer market, and the Supreme Court debated a series of draft laws about agrarian reform, cooperatives, private ownership, and social enterprise. The number of cooperatives and their revenues was growing, but the economic situation for the majority of people had not changed for the better.

The increasing complexity of problems centering on the family, maternal, and childhood cares demands prompt economic, social, and moral decisions. Contemporary society requires women to have a double professionalism — one at work, the other at home. Constant physical and psychological overexertion undermines women's health. Fifty percent of all children have become "latchkey kids" while their parents are at work.

One proposal for a new form of democratic centralization has come from Nina Kungurova, an instructor at the Byelorussian Institute of Teachers. She believes that women should be transferred to special self-supporting enterprises within the framework of such operations in the national economy. A special item in the government's budget would set up a Women's Fund. Suppliers would provide the means to be used for ventures — both cooperative and government — in which women work. The most important source of funds would be deductions from profits, and part of the profit society as a whole receives would be transferred to the fund. Kungurova also suggests that the independence and technical equipment of the Women's Councils would make them the proper administrators of funds from self-supporting women's enterprises.

Payment for labor resources was introduced in 1988; so an enterprise would pay 200 to 300 rubles a year for each worker. Maneuvering with this lever might at least bring order to women's labor conditions. First, the pay rates should be raised appreciably for each "unit" of women's labor resources worked overtime, breaking protective norms (3.5 million women are occupied with such work). There are also 4 million women who work the night-shift, even though it was originally permitted only in case of special need — in the "short term." But short term soon became permanent, because women were accustomed to sacrificing themselves. Kungurova affirms that these measures will force enterprises to give immediate priority to the mechanization of sectors with heavy and dangerous work conditions. Returning women to the traditional hearth is not the way out, she maintains. "There is no back tie in the existing mechanism of social protection for women. They know they cannot change their situation by themselves, they shrink away from influencing it" (*Rabotnitsa*, No. 2, 1989).

State privileges and favors represent an especially important lever in relations with cooperatives. Developing her line of thought, Kungurova advises reducing taxes on the profit from the manufacture of commodities aimed at women and children (for example, cooking utensils), as well as on organizations engaged in childhood education. This would stimulate interest in cooperatives. The Center for Study of Public Opinion in Moscow reports that people under 25, especially women, are three times more likely to favor cooperatives than those over 55. These fresh forces of support await realization. And until then we will witness the aggressive methods of some cooperatives in combatting increasingly frequent thefts and the hostility of people against too much success of the cooperatives, which, the experts calculate, will regulate them in due course.

With regard to the Women's Fund, money paid into it will be spent on loans and awards, on technical equipment needed in women's labor, and on professional courses offered to women after pregnancy leaves. The fund will also provide money for the development of an everyday infrastructure. In this way the Women's Councils (the distributors of the fund) will act as guardians of women's and children's interests. Creation of the fund would not interfere with the self-supporting operation of the enterprises. Rather, it would facilitate the main goal of this social experiment: the genuine support of women. Of course, it would also influence the women's position and improve it with their own labor.

STEREOTYPES OF POWER

Women have not been limited to the Women's Councils. Olga Bessolova organized a club on the initiative of women in the Zhukovski Agro-Hydrodynamics Institute. The women's movement reminds Bessolova of Brownian motion in physics, where it is impossible to keep track of the movements of all the individual molecules. Since 1985, in the wake of perestroika, twenty-four thousand women's organizations have sprung up in the former USSR.

To be fair, events are happening so rapidly in Russia these days that many books are outdated by the time they are published. For example, a widely publicized book by Francine du Plessix Gray, *Soviet Women* (New York: Doubleday, 1990) is flawed by a major omission and by a wrong conclusion.

For a serious researcher to fail to recognize the feminist movement that developed in the USSR during the 1980s, is a glaring error. The secular majority of the Leningrad feminist movement contended that, as second-class citizens within a patriarchy, women had become accustomed to bad treatment. Men, on the other hand, were accustomed to treatment as privileged members of the patriarchy. These Russian feminists called for a psychological revolution. This pre-glasnost voice developed later in

numerous samizdats like *Tema, Zhenskoye Chteniye* (Women's Reading), *Day After Day, Russian Woman,* etc.

Olga Bessolova declares, "We are tired of slogans like 'The best for the children!' because the best buildings belong to nomenklatura, the best sanatoria belong to the Ministry of Defense, or the KGB."

The bureaucratic structure of the Committee of Soviet Women was designed as a kind of upward-pointing pyramid, programmed to proceed according to a strict vertical plan, thus depriving thinking women at lower levels or outside the committee of any possibility of exchanging ideas among themselves or with foreign women. The same structure characterizes the other centers of power. Elvira Novikova, one of the 198 women candidates for people's deputy, is disturbed by the small number of women politicians. Until recently, the total number of women deputies was fixed in the so-called rotation. All permanent positions (for multiple terms) were reserved for men, who more often than not occupied the high offices.

According to Novikova, the root of this problem, as well as of many others, is Stalinism. Until the beginning of the 1930s, the Zhenotdel (Women's Division), like the NEP (New Economic Policy of the 1920s), was engaged in confronting such issues. But in Stalin's "barracks socialism" women were assigned subsidiary, subservient roles. The few women's names that appeared on the horizon of Stalinism — women weavers, peasants, fliers — only underscored its superficiality. In the postwar years, women, having experienced equality with men during the war, began to occupy what they thought were stable positions that made use of their talents. Still, until the end of the 1950s, women were completely cheated out of any public life. Novikova attributes this problem to a typical feature of the administrative command system — "maleocracy." She urges scholars who are analyzing the ex-Soviet system to turn their attention to this phenomenon.

For years Soviet society has been run almost exclusively by elderly and middle-aged men. In an interview with Elvira Novikova, Editor Natal'ya Kraminova agreed that "the maleocracy is not, and cannot be, democratic since it does not take into consideration women and the youth who make up the vast majority of the population. What is more, maleocracy cultivates and spreads aggression across the horizon, along with provocation and cruelty. Hence, the short supply of humanity, tolerance and kindness comes as no surprise" (*Moskovskie Novosti*, No. 5, 1989). The Communist party of the Soviet Union always called on women's broad participation in public life, but in fact women made up no more than a quarter of the party membership, and women selected to work in party organs numbered less than 6 percent. The even smaller number of women attaining reasonably high positions was nothing more than tokenism.

Novikova regards the awkward campaign theme "Women go home" as

simply an attempt to camouflage the mistakes that have been made in questions of everyday life, the blunders in social politics. This is not a new phenomenon. There was a similar big surge of women in social production in the 1960s (even bigger than during the war). It began with Nikita Khrushchev's reforms, which soon petered out. This influx of women's work-power helped stabilize the labor force in a broad range of industries during this period. Women ended up in all the heavy and low-paying jobs. Now we see the result. Women are indignant, and they are demanding adequate pay for their work. To drive them back into the home would show the society's flagrant ingratitude. In any case, having tasted freedom and a modicum of independence, they would not stay exclusively in the home for long even if they could be sent there.

Another people's deputy, Valentina Kiseleva, supports Elvira Novikova on the question of choice for women. She believes that the needs of mothers and children must receive top priority and that they must be given material and moral support. Society must take their interests into account in all its plans. In this way an actual civilized society can be constructed. Women must also have a choice as to where and how much to work. There's been enough talk about happiness "for all": the aim should be happiness for every human being. Kiseleva, unlike Novikova, came to Moscow from Poles'ye, a country town; she is a self-made woman who received her higher education in the school of life. She maintains that the division of society into workers, peasants, and intellectuals has become obsolete and that new times need new concepts.

Inna Vasil'kova, a journalist with the Agency of Printers of *Novosti* (APN), has invited women to form the International Club of Women Journalists, appealing not only to Russian women but also to their foreign sisters. Women journalists in Russia up to now have not been allowed to practice their profession beyond the borders of Russia. In the meantime, foreign women journalists stationed in Moscow represent many important publications and news organizations, including the *New York Times, Newsweek, Time, Reuters*, and the Associated Press.

The writer Maya Ganina decries woman's inferior position even more pointedly: "Liberation has become a synonym for decline. A big nothing." As she observes, a woman's freedom to put a cigarette between her teeth and a glass of vodka in her hand is considered liberating. On the contrary, she says, liberation should mean the right to choose one's own fate, but the psychological atmosphere of Russian society deprived women of choice from childhood. Child-rearing practices have had a heavy masculine bias. Is it not then understandable why women must pay for the social and economic mistakes made by men in power? Russian women were excluded from the government, but the current affairs program "Vremya" has quite often shown Western women who make decisions without glancing back over their shoulders in fear of a male official.

The talented woman is suppressed, and her education is not acknowledged. She might be a Solomon in a skirt, and still she will be pushed aside. The maleocracy is noticeably fearful of brilliance, talent, and independence in women, which irritates the "lords of creation" so much that they seem to surround such women with a field of ill-will. They prefer to give recognition to a mediocre woman who knows how to please them and how to push independent women off the path of advancement. Then this mediocrity becomes a mere "functionary," jealously guarding powerful men and all privileges that she and her kind can derive from power.

I participated in the Soviet-American Women's Summit (1989-1992), which evinced a great desire for consciousness-raising among women in Russia—not only regarding economic issues but also some more controversial issues like rape or homosexuality, which were always taboo in the Soviet press. Valeria Basharina, Galina Vokhmentseva, Valentina Matvienko, and Elena Kamenetskaya, all acknowledged the *samizdat Women and Russia* as the first self-consciously feminist material produced in the Soviet system since the early 1920s.

Maya Ganina summed up the current situation in an article for the weekly *Literaturnaya Gazeta* (February 1988), and cited the historical reasons for it. She described how high-flown phrases about equal rights have been used to hide the reality of women's oppression, and how Russian women have gradually lost their own rich history. Ganina also commented on prostitution, a subject that has become fashionable recently in Russia, making the pages of papers such as *Moskovskii Komsomolets, Nedelya, Komsomol'skaya Pravda*, and *Vechernii Leningrad*. Just there are invisible women functionaries in the bureaucracy, there are adolescent cohorts of invisible *bisnesmenkas*, as prostitutes are called, working in sections. As a rule, prostitutes have friends in high places. Many of them give the KGB bribes for the use of hotels, and some of them receive bribes from the KGB if they agree to supply needed information about their clients. In Russian discussions of this issue, a man is sometimes portrayed as a seduced lamb and the "seductress" as a criminal. Maya Ganina's crisp comment is: "Such a transaction takes place with the agreement of both parties. Even schoolchildren know that. If there is no customer, there is no supplier."

Olga Voronina, a sociologist and one of the founders of LOTOS (League of Liberation from Stereotypes), talks about woman's false position in Russian society, in which she is compelled to agree to rules of the game that are fundamentally alien to her. Without drastic changes in the stereotypes of power, the currently entrenched form of what is called "women's emancipation" will remain unchanged. This concept, though excellent at first, is today a caricature of what it was meant to be. Voronina repudiates the old myth of women as "angels of the domestic

hearth." Those who were angels in the old days, she says, had money and domestic servants; the remaining overwhelming majority of women simply suffered, hemmed in by limitations. Now the picture is different, but there is no more consoling with regard to the conflict between production and reproduction in Russian society. On paper, it's "everything for the family," but in reality it is "everything for industry."

The proclamation of the principles of social freedom after the 1917 Revolution was put into practice rather erratically. New concepts about society and individual consciousness, as well as actual political positions, were formed by an intermingling of patriarchal and egalitarian views that enabled traditional stereotypes from the old culture to survive. The results soon became apparent in the sphere of labor activities.

Today 92 percent of the women in the Soviet Union have jobs outside the home or were engaged in study or special training. They make up more than 50.9 percent of laborers and white-collar employees and 44 percent of the Kolkhosniks (collective farmers) (*Zhenshchiny v SSSR*, Tsifry i Fakty, Moscow: APN, 1985; Finansy i Statistika, 1987). However, certain occupations have come to be labeled women's professions, and it is apparent that they have much in common with the traditional female role within the family. The overwhelming majority of women work in retail sales and in the food services (accounting for 83 percent of employees in that service), health and social services (82 percent), cultural services (74 percent) and teaching (75 percent) (*Zhenshchiny v SSSR*, Finansy i Statistika, Moscow, 1986). The situation in industry is analogous. Women predominate in branches of light industry—foodstuffs, pharmacology, spinning, and sewing—where conditions are often dangerous to health neither the prestige nor the pay of these professions is great. As a result, the average salary for women is only two-thirds of that for men (see E. Gruzdeva and E. Chertikhina, *Professional'naya Zanyatost*; 1986, No. 3). The stereotype of "woman's profession" also has negative consequences for men, since these occupations are psychologically closed to them. It was even reinforced in 1990-1993.

The established stereotype clearly manifests itself in the official promotion system as well. On absolutely all levels of professional activity (even "women's") men occupy the positions of authority. For example, although most teachers are women, 38 percent of middle-school principals are men. In the administrative hierarchy, the proportion of women falls as the ranks rise from the lowest to the highest. Among the leaders of production, pooling all the women, they make up 12 percent. (See E. Pukhova, "Ravnye Prava, Ravnoye Uchastie," *Kommunist*, 1987, no. 10). In science, the most "advanced" sphere, the picture is as follows: about half of those employed are women, but 40 percent of them are laboratory assistants, 28 percent are among the "candidates of science," doctors of science number 14 percent, and professor/academics 1 percent (*Zhen-*

shchiny v SSSR, Tsifry i Fakty. Moscow: APN, 1985). From 1985 to 1993 this situation has worsened.

No one in Russia has taken up the study of management style, its relationship to gender, and its effect on the fluctuation of prices characteristic of the micro-climate of the collectives. But quite a number of Western experts think that women's management style has its advantages. Until the rise of the neo-feminist movement, the issue had all but died out in the patriarchal society, and women, as a rule, found themselves marginalized and deprived. This problem can be exposed as a social and not a personal issue only by breaking some conservative rules.

The ergonomics of women's working conditions deserves special attention, yet the manufacture of equipment, instruments, and machine tools has thus far never taken into account the physical and dynamic considerations peculiar to women. Work tools are made for men, even though women make up 97 percent of weavers (who work in noisy and polluted conditions, 90 percent of janitors, around 70 percent of warehouse laborers, and 90 percent of workers at conveyor belts. No attention is paid to the fact that the female organism reacts sharply to the monotonous rhythm of the operational, vibration, and temperature fluctuations of such jobs. Nor are the life cycles of women taken into consideration in the organization of their work. What is considered important is the demand of routine at each stage of production, and not the reproductive systems of women which need to be protected from harmful conditions. In the long run, existing practices benefit neither industrial productivity nor the family, especially when, in the home, male alcoholism leads to domestic violence. E. Gruzdeva, E. Chertikhina, and some other women economists believe that perestroika's message did not follow up questions in these areas with enough concrete proposals. Employers and their employees do not adhere by mutual agreement to legislation on the protection of labor. Many women who have an unfortunate home situation go to the jobs that have dangerous production conditions, and they do so consciously—in order to receive benefits, such as extra rubles, or additional time off to spend with their children, which they gain at the expense of their health.

IN THE SERVICE OF THE GENERATIONS

Contrary to Kollontai's statement that "the family is ceasing to be a necessity," many Russian sociologists subscribe to the view that "Kollontai stood like most Marxists on all points except on the future of the family. History has proved her wrong on this." Marilyn B. Young adds ironically: "In philosophic moods, Mao was to speculate on the ultimate disappearance of the family altogether—in 1000 years, perhaps as part of the ongoing evolution of human society" (*Promissory Notes*, New York: Monthly Review Press, 1989), p. 246.

In the service of the race, woman agrees to create new generations, in acquiescence even to those who consider it their right to decide women's fate. The contradictions between the individual and the social maintenance of everyday functions today are especially intense. With the destruction of the old system of family relations, the mother is the main (and often the only) parent. Moreover, the problem is not just that of broken families, but of hidden fatherlessness. In contrast to the past, even in families that stay together, the father's role has narrowed, and his authority has become diminished. Men's drunkenness and irresponsibility have left the woman/mother in charge of correction functions and of coordinating educational efforts in social institutions.

Housekeeping has always provided continuity in the material and social reproduction of people and their living conditions. However, with women's entry into the paid workforce, together with the backwardness of social services and the scattering of the nuclear family, yet new tasks have been created for women. Numerous statistics support women's great physical exertion. For example, Polish sociologists calculate that a woman buying groceries for a family of four carries home 2 to 4 tons in the course of a year; and in doing her work in the home, a woman walks 12 to 13 kilometers a day. According to the Institute of Physical Labor in Dortmund, West Germany, the energy expenditure for housework (even using modern appliances) and for work requiring heavy physical labor is about the same. These enormous physical and nervous strains distort women's personalities. What is more, their ties with their children are reduced to those of service attendants. Evaluation of solutions is difficult, but the reconstruction of the family—without the return of women to the home where they are exploited—appears to be an urgent necessity. "First, it is necessary to return fathers to the upbringing of their children. Second, the social prestige of motherhood must be strengthened in all sections of society," writes Olga Voronina (*Sotsiologicheskie Issledovaniya*, No. 2, 1988).

In her article "Madonna with a Crowbar," Larisa Proshina writes about the hypocritical exaltation of the "Madonna" image on International Women's Day, March 8, as contrasted to women's experiences during the other 364 days of the year:

> The nightingale's singing dies away. Already by March 9, "Madonna," in filthy pants, has dragged a bucketful of dye, has stood in a queue trying to press back another "Madonna," racking her brain about whom to leave her child with in order to run that evening to the Institute, how to feed her husband. . . . Of course, she thought about how to have a good night's rest at least once a week . . . and so it is, year in, year out (*Nedelya*, September 1989).

Half of the women in Moscow, after the birth of their first child, terminate

subsequent pregnancies; and every fourth woman interrupts her first pregnancy with abortion (*Argumenty i Fakty*, No. 16, 1989). M. Gor'kaya proposes "to organize the publication of special medical literature and brochures for masses of readers, to increase the production of contraceptives, and, in addition, to adopt some of the practices of foreign lands in family planning." In recent times demand for condoms has increased not only as contraceptives, but also as a means of preventing the spread of AIDS. MinZdrav intends to bring out condoms in 3 million copies. Although it is not known whether this will be sufficient, since no one has figured out the extent of the need.

On the subject of AIDS, Yevgenia Albats in her article *Diary of a Pregnant Woman* complains of the humiliating conditions women are subjected to in gynecological consultation rooms where each pregnant woman is asked for her passport and her AIDS test results. Men, as a rule, do not go through this procedure (*Moskovskie Novosti*, No. 29, 1989). In writing about her sad experience when she had an abortion, Ekaterina Nikolaeva backs up Albats's depiction of the poor conditions in gynecological clinics. However, with the help of the women's movement, twenty-three Moscow clinics have at last begun to adopt the long-promised vacuum method of abortion during the early stages of pregnancy (the so-called mini-abortion), without the use of surgery. This procedure is much less dangerous for women.

The St. Petersburg Public Procurator's Office is concerned about the growth of crime among minors and the spread of teenage pregnancy. A 32 percent increase in the number of adolescents involved in serious crimes indicates a doubling of the number involved in robberies. One crime in five is committed by children. "It is not children who are difficult, but we who become difficult to them. We deceive them. We do not love them." This accusation rang out from the leading children's psychologist of St. Petersburg, L. Rubina, in an address to adults in 1989. She called for the creation of a network of psychological/educational services which would also provide night shelters for children who find it impossible to go home, and a round-the-clock confidential telephone service where children who are having conflicts with parents (especially in families of alcoholics), with school, or with their peers can call. It is time, she said, to create counseling centers for adolescents and their parents. In conclusion, Rubina declared: "Choose what is less expensive. Spend money on work with children. If you don't, you will have to support prisons for them." (*Vecherniy Leningrad*, October 14, 1989). In 1992 juvenile crime rose by 30 percent compared to 1985.

Parenting functions rightfully belong in equal measure to women and men. New demographic policies could develop from such a sharing, directing all possible social support to the family as a whole, except where the different biological needs of women and men must be considered.

FEMALE AND MALE ROLES

Today in Russia we face the task of redefining gender roles in the face of obsolete perceptions that are fixed in cultural and, to some extent, in legal norms. In the changeover process, the "specific need" can become another "specific freedom." In their regulation of labor relations, legal norms must promote freedom of choice, so that regulations enhance freedom rather than diminish it. Increased freedom of choice is expected to encourage taking personal characteristics into account in the working environment. It is important to expose and eliminate any legal norms that lead to direct or indirect discrimination against women in the work sphere and against men in the family sphere.

N. Zakharova, A. Possadskaya, and N. Rimachevskaya have proposed supplementing Article 35 of the constitution with a section in which not only women but also men are guaranteed the possibility of combining parenthood and paid labor ("How We Resolve the Woman Question," *J. Kommunist*, No. 4, 1989). They make predictions for the 1990s, calling this decade the transition period from the patriarchal type of mutual relationship to equality. These experts at the Institute of Socio-Economic Problems of the Population, Russian Academy of Sciences, foresee some difficulties in the changeover period, when the old laws are *already* inactive or only weakly active, but the new intermediary laws are *still* not active or insufficiently apparent. They speak of the Soviet government's mistakes in its approach to the so-called woman question and of the discrediting of feminism in the Soviet Union. A number of viewpoints in one way or another affect every part of the problem.

The first viewpoint, a straightforwardly patriarchal one, is based on the idea that society is stabilized on some foundation and to violate the foundation is dangerous. This approach often finds indirect expression in the appraisal of heroes by writers, journalists, and the like. In the history of patriarchal thought, the tendency has been to see only negative effects arising from women's entry into social production, such as the destruction of the maternal instinct and the assumption that it leads to the feminization of men. Supporters of the patriarchal viewpoint demand the application of such definitive measures against women as a deprivation of their parental rights, placing on them criminal responsibility for prostitution, the creation of special courts to monitor women's morality, and payments for motherhood as socially necessary work. Many women are also drawn to these ideas, exhausted as they are by a double workload. However, judging by the results of the sociological research conducted by N. Rimachevskaya, only a small proportion of women would agree not to work at all, even if they received full material benefits. This proportion drops even further as women's educational levels rise.

A second viewpoint, an exclusively economic one, is represented by sociologists who analyze the human factor in intensive production. Instead of

promoting new technology in fields where women work, the advocates of the economic theory support cuts in "ineffective" work-forces (mostly women). These economic experts do not see in women's labor rich resources for saving the economy.

For the third viewpoint, an exclusively demographic one, the characteristic approach to the woman question is primarily from the necessity of producing a new generation. Demographic changes supposedly threaten CIS with depopulation unless far-sighted special measures of demographic policy are taken. In their practical recommendations, the supporters of the demographic conception, like the "economists," join with the patriarchal supporters, urging the simplification of the situation and the veto of the new phenomena.

The patriarchy's resistance to the evolution of a humane society has at times led to great excesses. Some men express their resistance to any restraint on their power through sexual violence; there may well be a connection between rising male anxiety and an increase in reported rapes in Russia in recent years: a 35 percent increase from 1989 to 1992 in Moscow and St. Petersburg. (*Pravda, Vecherniy Leningrad*, 1991, 1992).

CONCLUSION

A new, more egalitarian relationship between the sexes is supplanting the traditional patriarchy in the former Soviet Union. The new relationship is based not on the relations of "master and slave" which had seemed to possess the status of a natural law, but on mutual respect and equal participation in the private and public spheres. This new viewpoint will have moral, economic and demographic consequences for every member of society, which can be realized only if there is more freedom of choice, objectively and subjectively, in personality development. In these surroundings, both material and spiritual, free of prejudices and discrimination based on class, sex, age, or politics, only personalities will be significant, and a person's character will be judged on its merits, not according to some previously set scale. That is the conclusion of women scholars in the former USSR.

The new government in Russia is clearly trying to regain control over women. "Thus one cannot begin to understand the phenomenon of radical left politics combined with social conservation without looking at the strong influence of petty-bourgeois ideology on the left in South Asia" (Kumari Jayawardena, *Promissory Notes* [New York: Monthly Review Press, 1989], p. 364). Alas, this holds not only for South Asia: we also discovered it in Poland, as the Polish feminist newsletter *Amazonka* proves, and in Hungary and Czechoslovakia as Anita Balaton and Eva Bartova said at the International Interdisciplinary Conference on Women in 1990.

But at least now this new openness may give us an opportunity to learn from each other.

(Adapted from lectures given at Manhattan Community College, 1992, and Fairleigh Dickinson University, 1993.)

20

A Little Faith

The Russian film *Little Vera* can be considered a reflection of glasnost. Natalia Negoda, who played the leading role, was the cover girl for the May 1989 issue of *Playboy*.

The action takes place in a small provincial town and starts off with a panoramic view of the industrial town with its belching smokestacks. I first saw the film with Gloria Steinem in New York, as she correctly remarked, one senses the influence of Antonioni in the work. Italian neo-realism is stamped on the character of the heroes who make no attempt to control their emotions. They scream, curse, weep, and insult each other from the beginning to the end of the film. And yet it is a very Russian film in both atmosphere and environment — no less so than *Dark Eyes* in which the Italian world perception was fully blended with the Russian.

I view *Little Vera* as practically a documentary film about working-class life in the former Soviet Union. It gives us pictures that we know from real life but never saw before on film. Of course, it is somewhat exaggerated, and I have to acknowledge my feelings of embarrassment throughout the film. On the screen they showed all the things that I tried to avoid and escape when I was living in St. Petersburg: the boredom, the monotony, the loss of faith in the healing strength of the word. The main heroine believes in nothing and aspires to nothing. On the beach when Sergei tries to make not only sexual but spiritual contact with her, she answers him with "our aim is communism," sounding very cynical. She needs no goal because for her everything has been decided from above, by those who manipulate power. This social illness paralyzes the soul. Government in the role of father is feared but not believed.

Vera is 17 years old (Natalia Negoda is 25) and started smoking at 14. Her father, a smoker himself, urges her to give it up. She also drinks like him. Her mother's role does not appeal to her: cooking, cleaning, washing, and working as a dispatcher in a clothing factory. Her father has no authority over Vera either. He is a chauffeur and an alcoholic. So it is that she decides that it's easier to do nothing. Vera pities her parents, but she is ashamed of them. She puts her drunken father to bed so that her mother won't be upset when she comes home from her job. Her parents evidently quarreled continuously throughout her childhood. She sees no escape; nor does Sergei, who is older than she, having already finished college. He moved from the dormitory to their small apartment, waiting to marry Vera. The hostility between the two generations tightens the chain. The wedding itself is a source of conflict. "Do it without us," Sergei lashes out at Vera's father — meaning this is his tradition, not theirs. Sergei says that they long ago lost their chastity: "We need neither a bridal veil, nor a car with a doll tied on it."

Very soon the chain of conflict breaks into a clash between Sergei and Vera's father. "You eat my bread — you listen to me," shouts her father at the table. Sergei locks the "head of the family" in the toilet. When Vera finally releases him, her father in a fit of violence injures Sergei in the stomach. Thankfully, the creators of this film do not show blood flowing, although, in general, naturalism is the rule. Returning to the association with neo-realism, we can point out that Italian cinema is more artistic than *Little Vera*, and has more symbolism and poetry.

This Soviet movie contains no romanticism whatsoever. Vera's relationship with Sergei is raw sex. We don't remember a single kiss or any kind of tenderness — only the sex act. However, Vera is not a passive woman; she is not a stereotype. She is without restraint in lovemaking, in bed taking the top position. Only in bed does she feel self-confident. This Soviet Carmen repulses, or better yet, she beats up Andrei, a classmate, when, before his departure as a sailor in the fleet, he tries to rape her. Vera also resists a policeman on the dance floor, kicking him in the groin when he tries to arrest her. In another example of her bravado, one night, feeling a bit tipsy, she climbs up the fire escape to Sergei's dormitory room. She is fearless, even foolhardy. Vera is a veritable child of the streets.

Sexual scenes, even *mat* (porno language), appeared for the first time in this Soviet film. The vehicle for *mat* is the father. "You filthy slut. You bitch," he says to Vera, "and your mother too." Vera's indifference indicates she is used to profanity. Her father does not try to be fair. In spite of Vera's rejection of the "promising suitor," the sailor Andrei, her father, in exasperation, calls her a "sailor's whore." He is ignorant and his tastes are vulgar. Drunk, he listens to songs of cant in the style of Vysotsky, *prison lyrics*. (Incidentally, Natalia Negoda was correct when she said that vulgarity is now in fashion in Russia, even among the

younger generation.) Vera's friend Lena is also vulgar. She doesn't hesitate to approach any man. In a cafe, rejected by Sergei, she forwardly begins to talk to a stranger, a man in his forties. Trying to find her "place in life," she falls into a trap, the trap of sex.

The relationship that develops between Lena and the 40-year-old stranger at the cafe is both predictable and logical, tracing exactly an almost feminist analysis. (The scriptwriter, aptly enough, is a woman.) The story proceeds with the middle-aged stranger at the cafe talking with his adolescent daughter about women in India who burn themselves to death when their husbands die. "They want to do this themselves," explains the sermonizing daddy. When Lena enters a relationship with him, he forbids her from going to college. Her fate is decided. But, actually, did she herself want it? Why does she, always so lively, fall into depression? Why does Vera too fall into depression on the eve of her wedding, a time that should be the happiest of her life?

Gorbachev's reforms were the outgrowth of the ideals of the 1960s, the hopes of the period of Khruschchev and Kennedy. Vera never knew these ideals, and the reforms have not yet reached the provinces. Vera and her generation are products of the 1970s, of the Brezhnev reaction. Vera's brother comes from Moscow and expresses some progressive thoughts. However, he does not get along with his young wife; a divorce may be in the works. How long will Vera and Sergei stay together? They first got acquainted on the dance floor. Vera, in a mini skirt, was heavily made up with cosmetics, and Sergei, certain he was irresistible, was like the 1920s poet Esenin. Even his name was the same. He invites Vera to come with him.

> "Piss off," Vera sharply answers.
> Later, when he carelessly asks, "What about marrying me?" Vera laughs.
> "Why?"
> "So we can always sleep together."
> "But I don't like always to sleep together."
> "So, you can feed me tasty dinners."
> "I don't know how to cook."

Despite her cockiness, love was Vera's only outlet.

When Sergei, in the hospital, refuses to see her, and Lena refuses to attend a telephone operator's training program with her ("Operators are popular"), Vera loses what little remains of the meaning of life. She gulps down tranquilizer pills with alcohol, and, ready to die, clasps her childhood portrait to her bosom like an icon. Her street friend has himself tattooed with a big cross on his chest. These religious reminders do not transmit any kind of spirituality, and they do not appear to be taken seriously as an opposition. They are just in fashion. Of course, Vera and

her friends, these so-called angry young people, appeared in the art of the West at the end of the 1950s. The "Lost Generation" began to be reflected in the cinematography of Eastern Europe, for example, in Polish, Hungarian, and Yugoslavian "black films" at the end of the 1960s. The isolation of Soviet society delayed the exposure of the problems of marginal people, for they had no place in the framework of its social structures. The current young rebels in Russia are just beginning to become aware of themselves and are issuing a challenge to the generation of their fathers with their shocking behavior, dress, hairstyles, and the rest of their accessories. Yesterday's stable epoch of Brezhnev has collapsed, the cost being too great for the fathers to bear.

Little Vera, rather than being a remedy, is only a diagnosis of the illness. It penetrates society like an X-ray. We see the emptiness of simple people who have lost their backbone. The enthusiasm of the 1920s seems to have disappeared without a trace. Stalinism with its everyday tyranny and fear destroyed hope in a bright future. The thaw of the 1960s didn't last long: Kennedy was killed and Khrushchev was removed. The long years of the Brezhnev stagnation covered the party slogans with mold. The "emancipation of woman" did not become her liberation; it went no further than the sexual revolution. They still do not understand there are other alternatives.

The makers of the film are shocked, and they want to shock the public. They talk about AIDS, homosexuality, and drug addicts. The mulatto child (Lena's brother) looks at television. A comic film, *Doctor Aibolit*, is shown. The well-known rhyme "Don't go to Africa to walk" changes to an entirely new sound, especially if you add that the 300 Africans, among other foreigners, in a position to have sneaked in with deadly viruses, were deported from the Soviet Union. The statistics of glasnost are discouraging: adolescent prostitution in Togliatti and similar towns is growing. In Leningrad 239 cases of rape occurred in 1988, 70 more than in 1987. The 1990s showed a further increase. But the higher statistics may reflect the fact that now "emboldened" women have begun to report the details of rape cases more frequently. Rape was a taboo subject in the Soviet Union, in spite of the law on the books mandating jail sentences of five to seven years for rape. Until recently this problem was covered up, just as the existence of pornography was glossed over. Hanging on the walls everywhere in *Little Vera* are porno calendars with pictures of naked women, obtainable on the black market. It seems that *Playboy*, with Natalia Negoda on the cover, makes pornography even more accessible; in fact, it legalizes it in the former USSR.

Television programs for women do not mention pornography. Their approach to young women simply complicates matters. The aim of one of the most popular programs "Let's Go, Girls" was designed to turn Soviet girls into good wives! (Thanks to feminist efforts it was finally canceled.)

They seek to make them housekeepers, to be exact (serving everyone in the home), and pretty ones too, of course.

Beauty contests, introduced not long ago, require prospective contestants to pay 25 rubles and submit a testimonial to their charms. However, if you are not built as beautifully as a Botticelli nymph, don't even give it a thought! Russian society is obviously oriented to measuring everything by masculine standards. It is not surprising that to her mother's question, what sex she wants her child to be, Vera answers: a boy. "But I wanted a girl, I thought she would be my helper," her mother says. Vera didn't want to be her mother's helper, observing how her mother wears herself out doing housework, serving as a dispatcher, quarreling with her drunken husband. Such a fate is unalluring, inspiring no respect. The scriptwriter Mariya Khmel'nik and the producer Vasili Pigul, make us understand this unconditionally in the film, even if they did not intend to. The death of the father at the end of the film is almost symbolic; dying, he calls Vera and her brother, not his wife.

Perestroika was a major renovation. Torn-off wallpaper, knocked-down plaster, broken glass, old furniture covered with debris, doors wide open, the corrosive smell of glue and paint—glasnost had exposed all the flaws in society. Although *Little Vera* didn't give us much hope, we want to believe that after the major renovation the wallpaper will be changed, the glass restored, the furniture dusted off, and the rooms ventilated. Ex-Soviet society needs to get over its idiosyncrasies. In the idea of the major renovation itself is the will, the wish for change, for purification. *Little Vera* dared to show the most unattractive side of Russian everyday life, and this daring speaks more of growing strength than of despair. Society, as if waking up after a long spell of lethargy, is yawning, stretching and looking at itself in the mirror of glasnost.

(Reprinted and adapted from the Davidson College Conference brochure.)

Thank you
 for morning dawn
you gave me,
Thank you
for daylight
you gave me,
Thank you
for evening stars
you gave me,
Thank you
for night dreams
you gave me,
Thank you
for life
you gave me
 back!

I have
 your portrait —
majestic and magic —
like the Universe itself.
I don't need
to know your age —
only the magma
of your soul,
only the magnet
of your beauty —
something without
aging —
your portrait
majestic and magic.

21

Ex-Soviet Porn-Talk Gets Louder

A new post-perestroika traveler, a certain Vitali, decided to experience the joys of Western life in Australia. Connoisseurs had recommended that he begin with the King's Cross red light district in Sydney — an area something like St. Denis or Pigalle in Paris or 42nd Street and Broadway in New York. A burning interest in striptease is typical for the deprived ex-Soviet citizen. Our traveler, however, was disappointed. He didn't get what he'd expected, as he lamented in his article (*Age*, November 9, 1990). The Chinese girl on stage, he said, had stripped without any inspiration at all.

She was so lazy that she didn't even try to feign embarrassment at being naked among clothed men. Vitali, on the other hand, tried very hard but was unable to experience the promised sexual excitement for which he'd paid $8 (negotiated down from $25). Other girls who appeared on the stage didn't help either.

Had there been a complaint book in King's Cross he probably would have written how badly they had serviced him. He was quite dissatisfied and condemned their behavior in his article. Had they exerted a little more effort to entertain and satisfy him, he wouldn't have minded the $8 and would have told everyone how he had taken up Western liberalization. But since they'd bored him, they merited his offended commentaries. When he touched one of the girls, he found her skin was cold and damp, like a snake's, or a frog's, and that there was nothing human about her.

An Australian feminist Elena Leonoff replied aptly to this: "It's too bad Vitali didn't save some of his revulsion for the men who run and profit from these strip joints."

The same Vitali Vitaliev spoke out in *Krokodil* magazine (November 9, 1987) to the effect that contemporary prostitution has no social roots — that it all stems from greed. The greed is that of the women selling themselves, naturally, not the pimps. Elena added sarcastically that

Vitali was not threatened with having to undress in public for $8 to earn a living. He could judge "fallen" women from his comfortable chair on patriarchy's Olympus.

Elena grew up with the feminist ideas that have penetrated Western society more and more deeply and widely in recent decades. Unfortunately, this information has been virtually inaccessible to the Russian woman, and we are seeing the consequences. Choking on glasnost, the Russian woman rushes between trying to get lipstick and trying to get married, preferably to a foreigner.

More than fifteen hundred Russian women have already paid $80 apiece to the Grooms by Mail agency in Nakhodka, set up in 1990. Each of them is hoping to wind up in America, where, they are certain, men understand women better and don't saddle them with a double burden. Galina, 36 years old, sent three photographs and went on at great length about how much she dislikes cooking and cleaning but is willing to do it for a sweetheart from the United States (*Daily Penn*, December 7, 1990).

The stereotypes and myths of a society constructed by and for men push a woman into the narrow confines of sexual service. Pleasing the gentleman becomes her goal. And instead of expressing solidarity with other women, which she can't help but feel, she competes with them. She makes any sacrifice for the sake of artificial "beauty." The eroticization of the female body for men, and even the eroticization of plastic surgery, has become the patriarchy's international norm. Naomi Wolf, in her book *The Myth of Beauty* (London: Chatto and Windus, 1990), cites an example from the Hungarian press, which did a photo layout of the breasts of local beauties side by side with the portrait of the surgeon who had created them.

The double standard with respect to female and male nudity demonstrates women's inculcated dependence on men. Female nudity, which merchants sell left and right, and which in recent times has even hung in public places as a result of perestroika gratifies men by virtue of its vulnerability. This kind of accessible nudity was also practiced with respect to slaves and Africans in slave-owning times. We all have seen the picture of black slaves, naked to the waist or wearing only a sash across the hips, who are waiting tables on impeccably dressed white gentlemen.

The film *Little Vera* in Russia was only the first sign of "sexual freedom." *Playboy* immediately seized the initiative, giving a one-sided interpretation of the nude scenes on the screen. Natalia Negoda was asked to pose undressed for the magazine. The material motive, as the actress confirmed (*New York Times*, May 30, 1989), played a definite part in her decision to offer herself as a cover girl. The patriarchy is undoubtedly teaching the young woman to be a sex object. The current outburst of pornography in the Russia demonstrates how far the maleocracy has gone.

Women have reached an impasse that forces them finally to take a

closer look at their surroundings and to resist. Some forces in place are already trying to stop this trend. In 1990 the magazine *Abroad*, among others, published research by English scholars on the influence of pornography. A direct correlation was revealed: on average, for every 2 percent increase in porno press circulation, there is a 1 percent increase in the number of rapes. Moreover, the porno press is educating man to be tolerant of those who commit these crimes. The conclusion is clear: pornography dirties the human consciousness and provokes sexual crimes.

Larissa Kuznetsova's "Open Tribune" in the Russian magazine *Working Woman* calls on women to rebel and unite against the "pornos." She talks about the rise in prostitution in Russia including for hard currency (*Conversation in Front of the Mirror*, No. 3, 1990). Her analysis rings of Western feminism: a man who buys a woman is buying power, not sex, the primitive, crude, vulgar power of one person over another. She offers the relationship between the problem of prostitution and the problem of power as a working instrument in the struggle against rape and prostitution. The St. Petersburg TV show "600 Seconds" reported the multiple rapes of one woman in the course of a single day (November 30, 1989) by four different men.

Despite the opening of several centers for female victims of rape and battering by drunken husbands, the shameful trade in the female body flourishes. Slippery, sticky "mass culture" stands offer a rich assortment of "new goods." Imported and domestic pornographic tapes are spewing forth in profusion from the thousands of recently opened video studios. The video boom is snowballing. Video syndicates have popped up all over the country, offering illegal foreign films in Moscow, St. Petersburg, Tbilisi, Odessa, and Voronezh. Hitherto provincial Voronezh did not land on this list of cities by accident; now it's the center of the state video industry. For 300 rubles anyone can acquire the most unbridled pornography from a video syndicate. Television and film are also trying to catch up with "progress."

All this began before perestroika with the rampant porno-talk that I wrote about ten years ago in *Women and Russia*, and I later gave speeches in many countries about sexism in Soviet culture (collected in *Russian Women's Studies*). What seemed to most people the harmless amusement of the male half has now led to a catastrophic spread of this contagion. Scribblings on men's bathroom walls have made the happy transition to the market of the free porno press. The "Prose of Life" column (*Ogonyok*, No. 46, 1990) finally began a discussion of this issue. There it was revealed that Moscow has about thirty open markets for printed matter of this type. They disseminate "literature" like "Sex Glasnost," "Brezhnev's Lovers, 12 Verbal Portraits," "Love in Prison," with detailed descriptions of all kinds of rapes, and "Selections from the Kama Sutra," with recommendations for applying sharp and heavy instruments to

intensify the sex act. True, the translator forgot to mention that, while entertaining himself in this manner, Prince Kuntalasa killed his not unknown wife Malaiavati with scissors; another, Prince Panshalasa, deprived himself of his beautiful courtesan Madkhavazena when he hit her too hard with an iron during sexual intercourse.

Raging "progress" isn't so easy to stop now. I foresaw this development and tried to warn of impending calamities. Few were prepared to listen. The idea of the antagonism between Russians and Americans was repeated like a broken record, keeping us from taking a good look at each other and covering many people's eyes and ears. Both women and men remained victims of the cold war, not noticing the crisis of the patriarchy—communist and capitalist alike.

Ever since the very first days of my exile from Russia and throughout the following ten-year period, I have been constantly asked at press conferences and symposia to describe the difference between Russian and American women. I answer ironically that in Russia women's consciousness lags behind the laws, and in America the laws lag behind women's consciousness. In Russia we have two sayings that speak graphically to this kind of situation: six of one and half-dozen of another; and out of the frying pan and into the fire.

An information famine has kept Russian women in the dark about their own rights. The specter of patriarchal taboos has alienated them from the Goddess of Justice—jurisprudence. Despite the fact that male terrorism has pursued all women without exception, a very small percentage of them have resorted to the judicial process in the event of rape. Thus, the five to eight legal years of prison for a rapist are still nothing but numbers on paper.

I see the societies of both the United States and Russia as maleocratic structures where the results for women are nearly analogous. I have preferred to point out the similarity in our fates—much to the consternation of both journalists and Sovietologists. Right now this similarity is becoming more and more obvious. Authorities have often used so-called differences between people to perpetuate the whole human history of separating them. I have encountered so much hostility and arrogant indifference both here and there—frequently, moreover, even among liberals of both sexes—when I have attempted to call on them to cooperate. Lacking expertise in the Western method of functioning while privately seeking funds, I held on artificially at a marginal level. Deprived thereby of the chance to communicate fully with the reader, I was unable to bring my knowledge of both systems to the broader public, both Russian and American.

At that time scandal lovers were writing articles and books, dreaming up shocking "differences" and "distinctions," as if to satisfy the curiosity of the uninformed philistine. The American novelist Francine du Plessix

Gray, for example, proclaimed Soviet women "matriarchs." I will cite just one characteristic passage from her book: "After dozens of evenings spent with distraught, henpecked men and with a dismaying abundance of superwomen, I reached the conclusion that the Soviet woman might be as much in need of a men's movement as of a women's movement" (*Soviet Women*, New York: Doubleday, 1990, p. 74). Fortunately, serious researchers and femnists have exposed Gray's oversimplified formulas and the danger behind them.

Rochelle Ruthchild and Charlotte Rosenthal, professors at Norwich University and the University of Southern Maine, respectively, consider it simply ridiculous to call ex-Soviet society matriarchal. "Women have little economic or political power. . . . Women's double burden on the job and at home often prevents them from advancing in their careers. . . . [The state's] birth control policy with its heavy reliance on abortion" shows that women have for all intents and purposes been put off from participation in the decisions of government. "If women had real power over birth control policy, the picture would be quite different" (Letter to the author, 1990).

Dr. Bonnie Marshall, professor of Russian at Davidson College in North Carolina, expresses it even more precisely: "As second-class citizens in a patriarchy, women have become accustomed to bad treatment. They have learned to deal with oppression and to thrive under it. Their spirits fail to wither. Men, on the other hand, are accustomed to being treated as privileged members of the patriarchy. They cannot cope with their wounded dignity under Communism" (Letter to the author, 1991).

Now, as perestroika and glasnost turned Russian society inside out, sexism has moved on to a more blatant, visual form. Beauty contests, or shows, to be more precise, are excellent testimony to this change. The budget for the contest finals at the Rossiya Cinema came to around 1.5 million rubles. The organizers, naturally, were counting on a substantial return. They planned to use the winners of the show for commercial purposes, which means good money, including hard currency. Thus, we have the female body transformed into immovable—or "movable"—property. Kirstin Gustafsson, a Swedish correspondent, provided her own commentary on this phenomenon: "All the girls in the finals had to answer one question from TV audiences. In this way they were given a chance to demonstrate their ability to speak and think. As for the rest, the whole contest reminded you of the cat exhibition recently shown on the "Vremya" (Time) evening news progamme" (*Moscow News*, No. 24, 1989).

The system of male superiority requires a polarization of the sexes, explains John Stoltenberg, a leading activist in the Time to Change Men organization in New York in his article in *Sexual Liberals and the Attack on Feminism* (New York: Pergamon, 1990). A real man is supposed to distinguish himself from a real woman. And if homosexuals, in their capacity

as gender dissidents, destroy this "balance," they are often severely punished. Men of this type have risked landing in jail in the USSR, and women in a psychiatric hospital. Evidently, there is still some hope of "healing" women of loving their own kind. Misogyny is vividly expressed in homophobia; therefore, men who act like women are held in contempt by the patriarchy. They are regarded as traitors to their sex. A woman who tries to overcome established canons (open traps) is punished by being completely torn away from society.

As we know, the process of society's humanization is prolonged and complex. The liberalism of the 1960s did not develop into the emancipation of woman. She was crushed by the "sexual revolution," for it fell to her lot alone to pay for all the pleasure. These days beauty shows have become the new image in Russia, not the space flights of Valentina Tereshkova or Svetlana Savitskaya. And what's happening in the backwoods? The sexism offensive is on the march. A documentary on the city of Togliatti shows that organized crime, prostitution, and pimping are on the rise as if they'd been leavened with yeast (*Volga Komsomol*, August 28, 1988).

From an explanatory note from D. Galina, born in 1973, in the seventh grade comes the comment "I was sold for 130 rubles today." Another girl, an eighth grader, reports: "I've been sold lots of times. The first time was in July 1987; they paid the guys [pimps] 50 to 100 rubles." She serviced ten to twenty clients (from a dormitory for foreigners). The pimps pick out the "weak ones," who are on bad terms with their parents and teachers. Sometimes they drag them right out of school. The girls get eyeliner and electronic watches.

Natalia Ivaniuk, a criminal investigation officer, is disturbed by the current situation, in which twenty-six girls have been detained in half a year. Two-thirds of them entered into prostitution of their own will. Pimps catch them everywhere, drive right up to the dermatology-venereal disease clinics where the girls are being treated, and carry them off to the men's dormitory. It is mostly teens who fall into the trap, girls aged 13 to 19.

Vladimir K., 20 years old; professional pimp; sold three girls in a night for 170, 60, and 130 rubles. He keeps the money, and the girls are allowed to earn inside the dormitory; as payment, they accept everything, from cosmetics to faded jeans. Another pimp raped a teenage girl and then got the idea of selling her. He made a deal for her in the men's dormitory for 117 rubles. They started dragging the girl from room to room. When she saw a police car, she threw herself out a window. She was hospitalized for a month.

From the operations report come these notices. On the morning of August 27, 1987, around the fifteenth block in a cornfield, the body of Olga M., born 1972, was discovered with two strangulation marks on her neck, puncture-stab wounds on her body, and bruises. It was brought to

light that the pimps had wanted to drown her, but the water was cold—the poor guys got tired. They beat and tortured her from three to six o'clock; she wouldn't confess that she had filed a complaint with the police. Toward evening they abandoned the girl in the dormitory. Then once again they beat her, tied her up, dragged her around. Oleg G. threw his belt around her neck—but the belt broke so he used his tie and began strangling her. The girl beat him off when he started striking her with scissors.

What is this if not a Russian "Twin Peaks"?—not yet romanticized, true. Lynch, the director of this TV series in the United States, has successfully pandered to viewers' sick interest in the repeated photograph of Laura Palmer's blue face, sprinkled lightly with sand for authenticity.

However, let's go back to the Volga and the new industrial city of Togliatti. Sveta, born 1971, recounts how she was sold at the age of 12. The pimps' conversation was harsh: "You're coming to the dorm. Period." And just try not to come. Right now they were ordering one girl. She's 13. She's afraid, she's staying home. But she's going to have to go out. "She used to 'sniff' before," explains Sveta. Many of them "sniff," starting in sixth or seventh grade. A guy gives you the solution (a narcotic substitute) for free—then you owe him. . . .

Olya V., ninth grade, told her story: "I was walking down the street. Two guys came up to me. 'Hey, call Sveta out from the fourth floor, apartment one. Why not help?' I went up the stairs and rang the doorbell. A guy opened up. Before I could blink those two behind me had pushed me into the apartment. They raped me. If they hadn't given me gonorrhea, I wouldn't have filed a complaint with the police—it's mortifying."

The mothers—the "matriarchs" of these girls—throw up their hands. Crushed by the overwhelming burden of daily life, they lose contact with their children. The domestic "paradise" to which conservatives appeal is irretrievable, if it ever existed in the first place. Moscow philologist Galina Yakusheva notes how naive it is to hope that, given the endless shortages and social injustices, women will become pure angels if only they can be torn away from their books and forbidden to go to work. "As for the obligatory hints about women's intellectual inferiority that have suddenly become fashionable, they have just as much foundation as the old arguments of supporters of serfdom, who assured everyone that peasants didn't need freedom" (*Working Woman* [*Rabotnitsa*], No. 8, 1990). Yakusheva categorically disagrees with conservatives who advise tying the woman to the family with the ruble and a piece of bread. Of course, a materially dependent woman isn't going to leave her husband, just as a passportless peasant won't leave his village!

Russian psychologists (mostly men) have showered women with recommendations and warnings: don't argue, don't get angry—agree. Be

patient—you'll get by. It is a kind of choreographed show, or to be more precise, a fixation on the false. After all, to force a woman, who received her educaiton in the same schools as a man (and scarcely with worse grades) always to pretend and to agree on everything is tantamount to forcing someone who has known how to read for a long time to sound words out syllable by syllable.

By the way, it seems that émigré Yulia Voznesenskaya is amused by the gynophobic joke spread by phallocrats about former Minister of Culture Ekaterina Furtseva:

> Furtseva is sitting in a meeting—one female among all the other male ministers. They start talking about prostitution in the Soviet Union.
> "We have no prostitution anymore. That is a holdover from capitalism," says Furtseva.
> Another minister laughs. "We don't have prostitution when all women sell themselves?"
> "What do you mean 'all'—even the minister of culture?"
> "Yes, Comrade Minister."
> "And how much do I cost, in your opinion?"
> "If you consider your age and complexion, on the one hand, and your high position on the other, I'd give 100 rubles."
> "That's all?"
> "You see, Katya? You're already haggling" (*The Women's Decameron*, New York: Holt, 1985).

Revolutionaries are out of fashion nowadays. Few remember that in the 1920s Aleksandra Kollontai's argument was given its due: patriarchal marriage differs from prostitution only in that the woman sells herself to one man rather than many. There used to be a slogan: "Fight prostitution, not prostitutes." A law was passed punishing the owners of bordellos, dens, and pimps, not the women they discriminated against. In the 1930s Stalin dealt with the problem expeditiously by sending all prostitutes to Siberia and proclaiming the curse banished from Soviet society. Brezhnev evidently didn't believe Stalin and repeated this act in 1980 before the Moscow Olympic Games.

Prostitution can be explained by the imperfection of all maleocratic systems; therefore, it is alive. The decline of a patriarchy's economy leads directly to a decline in morals. The Soviet Union is no exception. Prostitution has found expression there in many forms: beginning with the old arranged marriages and ending with the new "shared girls." Or in two main categories of "professionals": hard currency prostitutes, sometimes called courtesans or *getery*, concubines; and train station prostitutes, or *bomzhy* (derived from the acronym for "without a specific place of residence"). To a certain degree these women enter this arena voluntarily,

as is well demonstrated by the "confession" of a girl who earned her living by winding her "clients" around her little finger. Promising sex, she left them with their pants down after they'd paid her (*Week*, No. 21, 1987). Despite the fact that a chorus of Russian male sexologists explains prostitution by alleged widespread nymphomania among women, we see that not all "prostitutes" want to "service clients." Moreover, the latest information confirms the fact that 70 percent of Soviet women do not experience orgasm in the sex act with their husbands or lovers; during Stalinism this figure reached 90 percent, asserts émigré dissident sexologist Mikhail Stern.

Enough opinions, though. The radical party headed by Yevgenia Debrianskaia insists on legalized prostitution as well as legalized homosexuality. Not to lag behind the times, the magazine *Foreign Literature* recently published Nabokov's *Lolita*, as one of that magazine's editors informed me proudly. "Pornography violates my civil rights," said famous feminist theoretician Andrea Dworkin. This obviously has not penetrated through to those fighting for human rights in Russia — although, to be fair, not only Vladimir Nabokov but also Riane Eisler is planned to be published in Moscow (*The Chalice & the Blade*, Moscow: Put, 1994).

Her book asserts that not only women but men too are interested in resisting stereotypes and false myths. For consumerist ideology is already beyond the endurance of our planet, which has been depleted to the limit by harsh exploitation. The dominance of the maleocracy in both the social and economic sectors, built on the submission and cannibalization of everything living, is receding into the past. Riane Eisler argues that the evolution of human society has not always been upward; sometimes it has skidded quite low. Archaeologists' latest discoveries have revealed that a matrilineal structure existed many thousands of years on earth and that our distant past can serve as a model of justice for us. Partnership among all members of the global society, futurologists believe — as does international lawyer Riane Eisler — will be based not on submission but on concern for one another and for the earth.

I was straight
and level
and the world
was straight
and level to me
but suddenly
everything has changed
I am not
straight anymore
nor level
and the world
became
a spiral

"Je t'adore" –
my fate
was telling me
in Paris
I left her
being sure
she'll go with me
everywhere
but she stayed
there
and cried
Elle m'a dit
her real name
is Fame
and she belongs
to Paris

22

Domostroika

"The warmth of the female soul, the solicitude of wives and mothers make the Soviet family strong and good. Loving and attentive, women raise their children to be the future builders of communism — to be healthy of body and ideologically firm of mind, to be worthy citizens of the Soviet fatherland."

The phraseology in this quotation is typical of the newspaper *Pravda* before glasnost. But present statistics show women increasingly filing for divorce; 50 percent charge their husbands with alcoholism. While not denying the importance of the "dry law," the root of the problem lies much deeper.

To a questionnaire circulated by the journal *Krest'ianka*, women answered that from their point of view the essential qualities of a good husband were faithfulness and good homemaking skills — qualities that do not exactly fit the popular image of an alcoholic. Men perceive the double load on women in the family and the workplace to be of no importance.

Our samizdat *Women and Russia* suggested the renunciation of some doctrines. One of them is a coupling of the household and the workplace as the only mode of life for women. Decade after decade, Soviet propaganda instilled the thought that this combination was beneficial for the emancipation of the female personality. What did this bright path toward the "Communist Tomorrow" lead to? Orientation in the new slavery has become the reality of every woman's day, as if there were no constitutional rights. Nevertheless, all attempts to make woman's tacitly understood obligation an accepted norm have failed.

What can we say about the leading liberals? Andrei Voznesensky answered a journalist's question in an interview: "It would be more fair, of course, if in the regular order of things, the working day of each woman were cut by 2 hours, to give her enough time to do her domestic chores." The women themselves think otherwise. They do not intend to sacrifice to

domestic duties their skilled work in production and their achievements (even though relative) toward independence. They think it's already bad enough that society always expects them to be resigned to a low-paid job.

As I mentioned before, one states tht Russian women are matriarchs at home. Unfortunately, this is pure fiction. To me, they're evidently martyrs. They are very much disoriented after many years of pseudo-emancipation and a long isolation from the world. Their own history was destroyed by Stalinism, and they know almost nothing about the Russian feminist movement before and after the Revolution of 1917.

Stalinists constantly slandered feminism, and the slander is still alive even under perestroika. Actually, it is very conformist to repeat after some angry Soviet women: "We don't need emancipation," as de Plessix Gray does, instead of helping them to understand their situation. Even though Russian culture certainly has some matriarchal roots, modern Russian society doesn't keep any matriarchal connections. Most Russian women want to give birth to sons, which is very common in every patriarchal society.

The ancient pre-Christian parthenogenic structure was absolutely lost, especially with Domostroy—a strict law against women created by the Russian Orthodox church five centuries ago. Domostroy said: "Serve your husband; if not, he'll punish you!" Conservatives are now trying to go back to Domostroy. Using glasnost, they're screaming: "Women go home!" Natalya Kraminova, an editor at the *Moscow News*, proves that among the Russian women themselves, when asked if they would leave work, 80 percent say "No!" even when their families are fully provided for. The campaign theme "Women go home!" is truly sexist. I'm afraid that Gray was calling for it in her book when she spoke about the necessity for a macho movement in Russia. It would be like calling for a white movement here in America. Her statement is: Women are too aggressive, and men must become stronger. In that way, humiliated and frustrated Russian women would be even more humiliated and frustrated.

Our *samizdat*, *Women and Russia*, has constantly fought for anaesthesia in abortion clinics and for contraceptives. But some conservatives want to end abortions now, as Stalin did, so that women may become reproductive machines in Russia. On the other hand, many of those who do favor abortion use it tragically as the first and only choice of family planning methods, instead of giving women an alternative with contraceptives. "There are approximately 30 million adolescents in Eastern Europe and the former Soviet Union, most of whom do not have access to family planning education or services. More than 30 million abortions are reported each year in these countries" (*Popline*, December 1992).

Stuck in a no-win situation, Russian women became the less demanding workforce. Adapting themselves to the needs of the day, they also occupied the jobs that men didn't want. In this way men escape the lowest

wages, the worst labor conditions, blocked paths to prestigious positions, and a lack of scientific and technical equipment for another more comfortable place. It is as if women inhabited a different realm. The worst conditions are in the health and education services, where the majority of working women sweat it out. Given these conditions, more and more women whether unmarried or divorced, prefer to live alone. Each year in Russia there are around a million divorces, affecting one out of every three marriages. In addition, women are refusing to have more than one child.

The latest investigation carried out in Perm, a large city in the European part of Russia, produced surprising results: 14 percent of the births were to unmarried mothers, 27 percent of all pregnancies ended in abortion, and another 27 percent of pregnancies began out of wedlock. The irresponsibility of Russian men has led to a large number of fatherless children. Premarital sex among the young has become a general phenomenon. The lack of sexual education and contraceptives results in unwanted pregnancies, the weight of which often falls on the shoulders of teenaged girls unready for motherhood. Society as a rule treats these girls without the slightest sympathy.

An even more negative aspect of sexual activity expresses itself in the number of reported rapes. As noted earlier, however, the reason for the increase may be that women influenced by glasnost have simply begun to express themselves more openly about such occurrences. After all, discussion of many problems connected with sex, especially prostitution, homosexuality, and AIDS, were for a long time taboo in Soviet society. Now information appears everywhere. So-called high-risk groups are discussed in the press, on television, and in films. The spread of drugs has become known: Moscow and St. Petersburg vie with each other as to who has more. The number of registered drug addicts has passed the 3,500 mark in each of the two capital cities.

The speed of liberalization in Russia is increasing. In the beginning of 1993, at the Moscow restaurant "Bombay," the first male striptease club opened (like the American "Chippendales"). Married women, mostly middle-aged, began attending in growing numbers. These women bravely help the male dancers in their striptease, removing one article of clothing after another from them. The bravest ones even receive prizes. The entry ticket costs 5,000 rubles. Some other women found a bolder solution for their dissatisfaction with family life—firtual sex—a way to have many orgasms through mental telepathy. The sessions started in Zelenograd and quickly spread throughout Russia. The *libido* spirit penetrated all levels of society. *Moskovskii Komsomolets* just recently (16/2/93) proclaimed: "better lesbians than communists."

It seems that freedom calls for balance. With glasnost, porno language has come out into the open. Eastern Europe has never been exposed to so

many unprintable expressions uttered from the stage or as in the Malyi Dramatic Theatre in St. Petersburg. From the start the new sexual freedom has been, contagious. More and more theatres and bands are opening themselves to daring profanities, enriching the social palette with the performances of naked heroies.

In the meantime, the women in the Congress of People's Deputies looked pale. "They did not speak about what really mattered," remarked poet Larissa Vassileva, from Moscow during our New York meeting. "Do we see the lively female soul? No. It is not there and cannot be. Well-fed faces of functionaries? Yes. And a few excited-looking female deputies who will not dare speak out." Larissa Vassileva ironically exclaims in one of her articles, "Wait a minute, esteemed male rulers, thank you very much for your wish to help in 'Women's affairs' but may we remark that it is probably you who needs our help?"

The goal that we fought for a decade ago in the unofficial women's movement has begun: the slow, steady consolidation of women. The failure of the coup d'etat in August 1991 in Moscow showed us that women are ready for leading roles. Even though they didn't become "national heroes," we saw that they took responsibility for their actions at Red Square. We saw hundreds of them holding hands in a long chain against the Soviet military and KGB forces. We saw not only young students there putting flowers on the tanks, but also older women talking angrily to the soldiers as if they were their sons. It was an impressive picture. We saw the psychological revolution I predicted ten years ago happening. This is a great victory for us, who started the process of democratization in Russia in the 1960s.

But this does not mean that the struggle is over. Real work lies ahead in the many years to come. The spheres of economics and sociology, of creativity and power, and of ecology are uncultivated virgin soil ready for planting by Russian women. My idea of creating a feminist party in Russia is finally becoming a reality. The women's clubs are discussing the matter of a separate party in the press. A union of women cinematographers as well as a club of women journalists has been created. A council of women writers is attached to the foreign Commission of the Union of Writers. Vestnitsa, the Moscow Club of the Women of Literature, plans an all-union conference of women writers and an association for them at the Writers' Union. Women scientists, too, are consolidating. An international union called Babushki za Mir (Grandmothers for Peace) has even appeared which seeks to carry the message into national and international education.

Even though they have lived in a multinational society for many years, the people of the former Soviet Union have little knowledge of each other. In fact, they have been ethnic ignoramuses. This absence of understanding, combined with the nationalist policy, is now bearing the bitter fruit

of ethnic discord, for example, anti-Semitism or the conflict of the republics with the Russians. We are also faced with the Georgian conflict with Abkhazians, the Uzbeks against the Tatars, and the Chechentsy against the Ingushis. The interethnic animosity between the Azerbaijanis and the Armenians has even provoked to bloody confrontations. Patriarchy has led to the self-immolation of many young women in Central Asia.

Religion is most often the cause of these conflicts. For example, the Georgians belong to the Georgian church, but the Abkhazians became Muslims. As a result, two very close neighbors are failing to get along with each other. "Georgia for Georgians," says Tbilisi. From this discord a national self-awareness may well come, but it poses a setback for women. Religion is a substantial element of national traditions, however, because in patriarchal cultures religions define the interests of men; women suffer from the strengthened influence of the churches and mosques. We had observed this effect in Poland. The Roman Catholic church, joining with the National Workers movement, Solidarity, arrayed all of its strength against the right of Polish women to choice, coming out against abortions and contraceptives. Nevertheless, the process is leading to a pluralization of power and influence. Along with the patriarchal attributes, a renaissance of Russian paganism, led by the ancient matriarchal goddess Lada, is developing. A group that embraces Lada has already sprung up in St. Petersburg.

Not too long ago CIS's archaeologists found high in the mountains of Central Asia some drawings that turned out to be the key to deciphering a large collection of rock carvings in caves and in the steppes—statuettes of goddesses from the Ukraine. This find showed a whole dancing circle of pregnant women pictured in the characteristic style of ancient Venuses, with big bellies and prominent sexual features. Each of them has a distinguishing headdress that obviously testifies to their relationship to various tribes. All of this may be related to the female ancestors of the great families. Leading in this unusual dancing circle is the woman with the newborn babe. Her head is crowned with large deer antlers.

The totem ancestors of many Central Asian tribes and even the leading personages of the mythology of Northern Asia and Siberia are regarded as deer. On the stone walls from the Bronze Age housed in the museums of Minusinsk and Abakan are intricate representations of women ancestors with bovine horns and solar symbols; some even have sunrays over their heads. On the totem poles of North American Indians are depicted vertical rows of ancestors, crowned with zoomorphic symbols, usually of birds. Accompanying the totem is a mother-image, each different: a deer, an elk, and a bear for the people of Northern Siberia; an ox for the Southern Siberian tribes; and a bird for the people of Central Asia.

The key to deciphering the circle of dancing women mentioned above

was found alongside the carvings of two pyramids made of many arms and legs. The women are portrayed in such a way that the legs of the top figures are transformed into the arms of the second row. The legs of the second row serve as the arms of the third, and so on. The legs of the lowest figures are widely spread apart and bent at the knees. Between them appears an infant. Each higher woman seems to be giving birth to the lower one. It is a continuous repetition of the idea of birth resulting from birth. It is impossible to transmit more concisely the rhythm of infinity, of oneness, of the succession of generations. The mother is the source of life and the personification of the constant rebirth of nature.

The manifestation of interest in matriarchal values in Russia is tied to the ecological and peace movements, with an attempt to find a way out of the crisis in ecological training. Several journalistic publications use the heading, "The Ecology of Society and Culture." The writer, Lidiia Beliaeva, says that her gorup, Sud'ba, takes for its foundation the life-strengthening spirit of female origins.

The journalist, Olga Dmitrieva, has in Moskovsky Komsomoletz raised the question of "women as society." She believes that the resolution arose in the consciousness of Russian women and that it is now time to do something about the consciousness of Russian men. Zoya Krylova, editor of the magazine *Robotnitsa*, has affirmed that women give society much more than they take from it. Larissa Kuznetsova, a researcher at Moscow University, is not afraid to write about such "prohibited" subjects as tampons and the improvement of conditions for abortions. They all agree that women regulate the ecological problems in the home, and they certainly have the ability to expand it to the highest level.

Young men are more helpful to women than are members of the older generation. More often you may see these young men with baby carriages on the street and waiting their turn at the food shops.

Youth, in general, oppose military service and support the ideas of Andrei Sakharov, who favored a limited professional army. The military, the most reactionary force in Russia, was comprised of 5 million consumers of no use to society. Conformism, chauvinism, sexism — this is the atmosphere into which the young recruits enter. Members of the military receive significantly more privileges than pregnant women; for example, at the military cashier's booths in the railroad stations and airports, anyone with a military ID card does not wait in line; mothers with children, however, must wait in line.

Mothers and children are also crowded together in communal apartments, with several families sharing kitchens and toilets. The Russian press has dubbed it communal deadlock. The idea of communes, a feature of many utopias, is infinitely far from the reality of the Soviet communal apartments. In contrast to the voluntary communes as they were conceived of and practiced, for example, by the hippies on American farms in

the 1960s, the residents of communal apartments in Russia were always forced into communal living. The authorities pay no heed to the psychological chemistry of the lodgers. Yet, when cosmonauts fly into space, their compatibility is taken in to account, although the days in space are nothing compared to the years in the involuntary, cramped neighborhood of the communal apartment.

This chapter has outlined some aspects of the situation which women in Russia ironically call "Domostroika" and which has presented some significant stumbling blocks for their liberation. But the progressive openness of society and its readiness to recognize problems inspire the hope that equal rights on paper will in the end become equal rights in actuality. Russian women are obviously encouraged by the examples of Corazon Aquino in the Philippines, Benazir Bhutto in Pakistan, Takako Doi in Japan, Mary Robinson in Ireland, and others, and they are not satisfied with their secondary roles. We have reason to expect some decisive action from them in the future.

(Adapted from lectures given at Harvard University, 1990; University of Arkansas, 1991; and University of Idaho, 1992.)

I saw
high light
of love
behind this door
when guests
came out
saying "good night"
I knocked
being cold on the street
but the hostess
was tired already
and turned off
the high light
of love

You're gold
never old
never cold
I'm silver
like a moody
river.

Dying of dining
with screaming
diamonds
Crying of crime
and dreaming Crimea —
o mama mia!

Recommended Reading

Adleman, Deborah. *Children of Perestroika*. Armonk, N.Y.: M. E. Sharpe, 1993.
Atkinson, Dorothy, Dallin, Alexander, and Lapidus, Gail Warshofsky, eds. *Women in Russia*. Stanford, Calif.: Stanford University Press, 1977.
Attwood, Lynn. *The New Soviet Man and Woman, Sex Role Socialization in the New USSR*. London: Macmillan, 1990.
Baranskaia, Natalia. *A Week Like Any Other: Novellas and Short Stories*. Seattle, Wash.: Seal Press, 1989.
Battersby, Christine. *Gender and Genius*. Bloomington: Indiana University Press, 1989.
Berberova, Nina. *The Italics Are Mine*. London: Chatto and Windus, 1991.
Berry, Jason. *Lead us not into Temptation, Catholic Priests and the Sexual Abuse of Children*. New York: Doubleday, 1992.
Bohachevsky-Chomiak, Martha. *Sergei N. Trubetskoi: An Intellectual among the Intelligentsia in Pre-Revolutionary Russia*. Springfield, VA: Norland Press, 1976.
Bohachevsky-Chomiak, Martha, ed. *Feminists Despite Themselves: Women in Ukrainian Life, 1884-1939*. Edmonton: Canadian Institute for Ukrainian Studies Press, 1988.
Bohachevsky-Chomiak, Martha and Rosenthal, Bernice Glatzer. *A Revolution of the Spirit: Crises of Value in Russia, 1890-1924*. Translated by Marian Schwartz, 2d ed. (New York: Fordham University Press, 1990.
Bonner, Elena. *Alone Together*. New York: Vintage Books, 1988.
Buckley, Mary. *Women and Ideology in the Soviet Union*. Ann Arbor: University of Michigan Press, 1989.
Buckley, Mary. *Perestroika and Soviet Women*. Cambridge: Cambridge University Press, 1992.
Christian, Barbara. *Black Feminist Criticism*. Elmsford, N.Y.: Pergamon Press, 1985.
Chukovskaya, Lydia. *Sofia Petrovna*. London: Collins Harvell, 1989.
Cole, Susan. *Pornography and the Sex Crisis*. Toronto: An Amanita, 1989.
Davis, Garry. *My Country Is the World*. Sorrento, Calif.: Juniper Ledge, 1984.

Durova, Nadezhda. *The Calvary Maiden: Journals of a Russian Officer in the Napoleonic Wars*. Bloomington: Indiana University Press, 1989.

Dworkin, Andrea. *Mercy*. London: Becker and Warburg, 1990.

Eisler, Riane, and Loye, David. *The Partnership Way*. San Francisco: Harper, 1990.

Engle, Barbara Alpern. *Mothers and Daughters: Women of the Intelligentsia in Nineteenth Century Russia*. Cambridge: Cambridge University Press, 1983.

Engle, Barbara Alpern, and Rosenthal, Clifford N., eds. *Five Sisters: Women Against the Tsar: The Memoirs of Five Young Anarchist Women of the 1870's*. Boston: Allen and Unwin, 1987.

Feffer, John. *Shock Waves: Eastern Europe after the Revolution*. Boston: South End Press, 1992.

Feshbach, Murray, and Friendly, Alfred, Jr. *Ecocide in the USSR: Health and Nature Under Siege*. New York: Basic Books, 1992.

Fowler, L., and Fowler, D., eds. *Revelations of Self*. Albany, N.Y.: SUNY Press, 1990.

Hannson, Carola, and Liden, Karen, eds. *Moscow Women: Thirteen Interviews*. New York: Pantheon Books, 1983.

Hubbs, Joanna. *Mother Russia: The Feminine Myth in Russian Culture*. Bloomington: Indiana University Press, 1989.

Kappler, Susanne. *The Pornography of Representation*. Minneapolis: University of Minnesota Press, 1986.

Keenan, D., and Lloyd, R. *Looking for Home*. Minneapolis: Milkweed, 1990.

Khanga, Yelena (with S. Jacoby). *Soul to Soul: The Story of a Black Russian American Family 1865-1992*. New York: W. W. Norton, 1992.

Kruks, Sonia, Rapp, Raya, and Young, Marilyn B., eds. *Promissory Notes: Women in the Transition to Socialism*. New York: Monthly Review Press, 1989.

Lapidus, Gail Warshofsky. *Women in Soviet Society: Equality, Development and Social Change*. Berkeley: University of California Press, 1978.

Leidholdt, D., and Raymond, J., eds. *The Sexual Liberals and the Attack on Feminism*. Elmsford, N.Y.: Pergamon Press, 1990.

MacKinnon, Catharine A. *Toward Feminist Theory of the State*. Cambridge, Mass.: Harvard University Press, 1989.

Mamonova, Tatyana, ed. *Women and Russia: Feminist Writings from the Soviet Union*. Boston: Beacon Press, 1984.

Mamonova, Tatyana. *Russian Women's Studies: Essays on Sexism in Soviet Culture*. New York: Columbia University, Teacher's Press, 1992.

Mamonova, Tatyana, ed. *Woman and Earth*, A Feminist Magazine in English and Russian, 70 Terry Road, Hartford, Conn. 06105 (203) 226-8652, (203) 523-9571, 1992/1993.

Maxwell, Margaret. *Narodniki Women: Russian Women Who Sacrificed Themselves for the Dream of Freedom*. Elmsford, N.Y.: Pergamon Press, 1990.

Morgan, J., and Hall, C. T., eds. *Redefining Autobiography on 20th Century Women's Fiction*. New York: Garland, 1991.

Morgan, Robin, ed. *Sisterhood Is Global*. New York: Doubleday, 1984.

Pollack, Sandra, and Vaughn, Jeanne, eds. *Politics of the Heart*. Ithaca, N.Y.: Firebrand, 1990.

Porter, Cathy. *Women in Revolutionary Russia*. Cambridge: Cambridge University Press, 1987.

Rosenberg, Chanie. *Women and Perestroika*. London: Bookmarks, 1989.
Ross, Clark G., ed. *Conference on Gorbachev's Soviet Union: Reform or Revolution? 1989*. Davidson College, Davidson, N.C., 1991.
Rueschemeyer, Marilyn. *Women in the Politics of Post Communist Eastern Europe*. Armonk, N.Y.: M. E. Sharpe, 1993.
Russell, Diana, ed. *Exposing Nuclear Fallacies*. New York: Pergamon Press, 1989.
Shalom, Stephen Rosskamm. *Imperial Alibis, Rationalizing U.S. Intervention after the Cold War*. Boston: South End Press, 1993.
Sites, Richard. *The Women's Liberation Movement in Russia: Feminism, Nihilism and Bolshevism, 1860-1930*. Princeton, N.J.: Princeton University Press, 1978.
Soviet Legislation on Women's Rights. Moscow: Progress Publishers, 1978.
Sutherland, Christine. *The Princess of Siberia: The Story of Maria Volkonsky and the Decembrist Exiles*. London: Methuen, 1984.
Valverde, Mariana. *Sex, Power and Pleasure*. Philadelphia: New Society, 1987.
Voznesenskaya, Julia, ed. *Letters of Love: Women Political Prisoners in Exile and the Camps*. London: Quartet Books, 1989.
Yablonskaya, M. N. *Women Artists of Russia's New Age*. New York: Rizzoli, 1990.
Zaslavskaya, Tatyana. *The Second Socialist Revolution*. Bloomington: Indiana University Press, 1990.
Zhukhovitsky, Leonid. *The Family and Society*. Moscow: Novosti, 1990.

Index

AIDS, 30, 147, 154, 169
Albats, Yevgenia, 147
Aleksandr II, 125
Aleksandr III, 131
American Women of the Eighteenth Century, 130. *See also* Tsebrikova, Marya
Anti-Semitism, 30, 112, 115
Argumenty i Fakty, 147

Belova, Margarita, xviii
Beria, Lavrenty, 15
Bessolova, Olga, 140-41
Bestuzhevsky courses, 121, 125-27, 130. *See also* Higher Women's Courses
Between Friends, 129. *See also* Khvoshchinskaya, Nadezhda
Big She Bear, 128. *See also* Khvoshchinskaya, Nadezhda
Blavatskaya, Yelena, xviii
Bohachevsky-Chomiak, Martha, 80
Brezhnev, Leonid, xiv, 153, 164
"Bulldozer" exhibition, 56-57
Butler, Josephine, 125

Catherine the Great, xix, 123
Chernobyl, 111
Chernyshevsky, Nikolai, 122
Committee of Soviet Women, 37, 141
Committee of the League of Peace, 132

Communist party, 15, 78, 88, 141; CPSU, 36, 40, 64
Congress of People's Deputies, 5-7, 31, 36, 39, 170
Cypress Coffer, 41-42

Dashkova, Catherine, 123
Decembrists, 121
Dmitrieva, Olga, 172
Dry law, xv

Elskaya, Nadezhda, 57

"Famous Commune, The," 127. *See also* Khvoshchinskaya, Nadezhda
Fedorova, Larissa, xiv
Filosotova, Anna, 121, 124-25
First Struggle, The, 128. *See also* Khvoshchinskaya, Nadezhda
Furtseva, Ekaterina, xvi, 164

Ganina, Maya, 143
Gorbachev, Mikhail, xv, 5-6, 15, 39, 46-47, 64, 79, 88, 108-9, 117; Gorby, 31; Reforms, 154
Goriachkina, M., 128
Gray, Francine du Plessix, 87, 140, 160-61, 168

Healthy, The, 130. *See also* Khvoshchinskaya, Nadezhda

180 Index

Herzen, Aleksandr, 122
Higher Women's Courses, 125-26, 130.
 See also Bestuzhevsky courses

Intelligentsia, 9, 54, 123, 127

Jews, Soviet, 30, 112. See also Anti-
 Semitism

Kazarova, Yevgenia, xiv
KGB, 32, 49, 52, 56, 58, 141, 143, 170
Khotkina, Zoya, xiv
Khruschchev, Nikita, 45, 56, 153;
 reforms, 142
Khvoshchinskaya, Nadezhda, 127-30,
 133
Kibbutz, 115
Kiparisovyi Larets. See Cypress Coffer
Kiseleva, Valentina, 142
Kollontai, Aleksandra, xvi, 135, 164
Komsomol (Communist Youth League),
 104
Konradi, Evgenia, 124, 134-35
Kraminova, Natal'ya, 141, 168
Krest'ianka, 167
Kropotkin, Peter, 126-27
Kungurova, Nina, 139-40
Kurkova, Bella, 7
Kuropas, Dr. Myron, 74. See also
 Ukrainian Weekly
Kuznetsova, Larissa, 159, 172

Lenin, Vladimir, 117
LOTOS (League of Liberation from
 Stereotypes), 143
Lumpen-proletariat, 100

Madman, Diana, xviii
Madonna (Christian), 146; pop star,
 75-76
Maltseva, Natalia, xvii
Marshall, Dr. Bonnie, 161
Marxism, xviii; philosophy, 93
Moscow News, 161, 168
Moskovskii Komsomolets, 143, 169
MTV Democrats, xx

Nie Zhdi group, xvi

Nihilism, 126-32
Nomenklatura, 117, 141
Nonconformist movement, artists, 55,
 57-59
Novikova, Elvira, 141-42

Otechestvennye Zapiski, 130
Ozheshko, Eliza, 133-34

Past, The, 129. See also Khvoshchin-
 skaya, Nadezhda
Pasternak, 43
Pavlychko, Solomea, 80
People's deputies, RSFSR, 65. See also
 Congress of People's Deputies
Peter the Great, xvi
PFLAG (Parents and Friends of
 Lesbians and Gays), xix, 73
Possadskaya, Anastasia, xiv, 148
Proshina, Larisa, 146

Rabotnitsa (Working Woman), 139,
 163, 172
Revolution of 1917, 37, 47, 144, 168,
 170
Rimachevskaya, Natalia, 148
Rosenthal, Charlotte, 161
Russian-American Women's Summit,
 36, 143
Russian Women's Congress, 135
Ruthchild, Rochelle, 161

Sakharov, Andrei, 41, 172
Sand, George, 129, 132
Semyonova, Galina, xix-xx
Shapir, Olga, 134
Shestidesiatnitsy (1860s liberals), 126
Shevardnadze, Eduard, 39
Shvetsova, Ludmila, xviii
"600 Seconds" (TV show), 65, 159
Skoptsova, Lidia, xiv
Stalin, Joseph, xiv, xvi, 15, 56, 71,
 164, 168
Stasova, Nadezhda, 121
Steinem, Gloria, 151
Stoltenberg, John, 161
Supreme Court, 7, 139
Supreme Soviet, 5-7

Tolstaya, Tatyana, xviii
Transfiguration (group), xviii, 42, 44
Triumvirate, 121-26
Trotsky, Leo, 117
Trubnikova, Marya, 121-22, 124-26, 131
Tsebrikova, Marya, 128-32
Tsvetaeva, Marina, 43, 46

Ukrainian Weekly, 74. *See also* Kuropas, Dr. Myron

Voronina, Olga, 143, 146
Vovchok, Marko, 133

Vremya, 65

Woman Question, The, 133-34, 148-49
"Women go home!" (backlash), 80, 141, 168
Women's Councils, 139-140
Working Woman. See Rabotnitsa

Yakusheva, Galina, 163
Yeltsin, Boris, xiv, xv, 31-32, 117

Zakharova, Natalia, 148
Zhenotdel (Women's Division), 141

ABOUT THE CONTRIBUTORS

ULYANA BOSTWICK is a lesbian activist from a Ukrainian background.

OLGA FILIPPOVA is a 20-year-old student who lives in Estonia.

REMO KANDIBRAT is a Jewish lawyer from Minsk, Byelorussia.

YELENA KHANGA is a black, Jewish, Russian-American writer from Moscow.

ANYA KIRIN is the daughter of Ludmila Kuznetsova, a dissident writer who wrote for (*samizdat*) *Women and Russia*. She died of cancer in New York City.

GALINA KOLOBKOVA is a judge who lives in St. Petersburg.

ANNA KOZOULINA is a philosopher from St. Petersburg who studies law in New York. Her young daughter lives with her grandmother in St. Petersburg.

GALYA LANSKAYA is a psychotherapist and singer from St. Petersburg.

KIRA REOUTT is a Russian who was raised in California. She is a liberal-feminist who speaks Russian and has visited the USSR.

CHANIE ROSENBERG is a British Socialist, author of *Women and Perestroika*.

KETEVAN ROSTIASHVILI is an academic who lives in Tbilisi, Georgia.

184 About the Contributors

LANA ROZOVSKAYA is a teacher from Riga, Latvia.

NARINA SAROUNOVA is a young musician from Yerevan, Armenia.

LADA SMIRNOVA is a daughter of Kari Unksova, a writer who worked for (*samizdat*) *Women and Russia* and was killed by a KGB car.

SVETLANA TABOLKINA is a technician who lives in the Ukraine.

OLGA TATARINOVA is a writer who lives in Moscow.

GALINA VINOGRADOVA is a translator from St. Petersburg.

ABOUT THE AUTHOR

TATYANA MAMONOVA was born in Russia and exiled to Europe in 1980. She was invited to the U.S. from Paris by the Bunting Institute at Harvard University to be Scholar-in-Residence. She is a public speaker as well as an accomplished artist and writer and is now publishing a magazine "Woman and Earth," in both Russian and English. Her first two books, *Women and Russia* and (Russian Women's Studies) *Essays on Sexism in Soviet Culture*, were both highly acclaimed and have been reprinted many times.